INDIA'S
RAILWAY MAN

Rajendra B. Aklekar has been a journalist in Mumbai, India, for more than twenty years. His book *Halt Station India* was nominated as the best Non-Fiction Book at the Bangalore Literature Festival 2015 and Atta Galatta Literary Awards.

INDIA'S
RAILWAY MAN

INDIA'S RAILWAY MAN

~A Biography of **E. SREEDHARAN**~

Rajendra B. Aklekar

RUPA

Published by
Rupa Publications India Pvt. Ltd 2017
7/16, Ansari Road, Daryaganj
New Delhi 110002

Sales centres:
Allahabad Bengaluru Chennai
Hyderabad Jaipur Kathmandu
Kolkata Mumbai

ISBN: 978-81-291-4521-5

Second impression 2017

10 9 8 7 6 5 4 3 2

Printed at Nutech Print Services, New Delhi

Contents

Preface

Revered by millions of Indians as a no-nonsense railway engineer and a technocrat who got work done within deadlines and budgets, despite the tangles that beset Indian bureaucracy and governance, Dr Elattuvalapil Sreedharan, has been hailed as the messiah of New Age infrastructure projects. His success stories—for there is more than one—have become railway engineering folklore and there have been calls that he should be honoured with India's highest civilian honour, the Bharat Ratna. When I was first asked to do a biographical work on Sreedharan, I wondered what I could offer the readers that would be new and different. Almost everything about him seems to be out in the public domain. There are detailed works on his life that seem to cover his professional efforts, methodology, the problems he faced, and the unique solutions he offered while completing key projects on time and within budget, and his ensuing success and glory.

He has been fiercely private on the personal front. However, some Malayalam-language biographers have managed to write a

bit on that aspect too. He has already said that he has no plans to write an autobiography; that many had approached him with a proposal to publish one, but he was never keen. Many of his colleagues who worked with him all his life are now retired or busy with some projects. However, they all have one thing in common—they respect the man.

Many of the hundred-odd officers and colleagues that I interacted with shared their respect for him and in some cases near idolization of Sreedharan and his go-getter qualities. Many gave insights on a few hidden aspects of his work and life.

During the national railway strike in 1974, for instance, Sreedharan was busy designing a metro rail network in Calcutta (now Kolkata), and refused to halt work. When the Gulf War broke out in 1990, leading to a shortage of fuel in many countries including India, the only Indian project that did not come to a standstill was the construction of the Konkan Railway headed by Sreedharan. He had factored in all permutations and combinations, insulating the project from any hurdles by setting up petrol pumps with backup supplies.

As I dug deeper, I realized that there was much that was unknown about Sreedharan. There were many hidden aspects of his life; aspects never discussed or documented in public domain, though there are some official notes and records regarding a few. This book, therefore, focuses on Sreedharan and on the little known stories that have made him what he is today. This biography is mainly based on personal interaction with Sreedharan at his residence in Ponnani in Kuttipuram, Kerala.

This book examines his love-hate relationship with the Indian Railways; the principles that he has followed all his life, and which he has kindly put down in a short chapter for future

generations to learn from.

His daughter Shanthi Menon, the only daughter among his four children, shares personal insights about her father— including how Sreedharan values family life and is involved in every small decision that is taken, paying attention to even the smallest needs of his grandchildren. Swami Bhoomanand Tirtha, whom Sreedharan considers his guru, has also penned down his thoughts—quite elaborately, I must add—on the man, and so have a few of his colleagues, co-workers and students.

A chapter titled 'Bouquets and Brickbats' has deliberately been included to offer space to not just his fans, but also to his critics. Interestingly enough, not one of them was willing to speak on record, but there were enough cases in the public domain for me to put together their point of view. Over time, his critics have insisted that he has consistently been given an unduly free hand, has violated all established norms and despite all that he has been glorified. They have also said that on several occasions he had threatened to resign to get matters done his way. A response from Sreedharan, balances it off.

Writing Sreedharan's biography has been a learning experience for me—his integrity, hard work, sincerity, professional competence, good values and most importantly, his attribute of remaining rooted to the ground while reaching for the sky, are indeed qualities to be emulated.

The long list of trophies and awards (placed at the end of the book) won by him proves it. Here is the man who, one can say, bridged the biggest gap on the map of Indian Railways, changing it forever.

This book would not have come out without the help of Dr E. Sreedharan, who patiently sat with me to clear all my doubts

after my two-year-long research on him, almost proofread the draft to correct it and offer all possible assistance, giving it almost the status of an autobiography.

One

SREEDHARAN, WHO?

Footsteps of Legends

When it comes to the railway and its beginnings, the first and biggest names that come to anyone's mind are those of the British engineers Isambard Kingdom Brunel (1806–1859) and the Stephenson father-son duo. If George Stephenson (1781–1848) and his son Robert (1803–1859) built locomotives, railway lines and ran the first successful train runs (even the one in India), Brunel is credited with the greatest railway system (Great Western), building the first underwater tunnel (Thames), the Clifton Suspension Bridge (Bristol), faster locomotives, series of steamships, the first Trans-Atlantic steamboat and much more, with designs that revolutionized public transport and modern engineering once and for all. The legacy of these engineering giants lives on as one studies the Industrial Revolution, birth of the railways, and the romantic era of steam locomotives and trains from the late 17th to the 19th century.

In the late 19th century, India too saw the birth of one great engineer—Sir Mokshagundam Visvesvaraya (Sir MV), who was

born in 1861 and lived till the grand old age of 101, passing away in 1962. Sir MV was not just an engineer, but also an administrator, adviser, and statesman. His engineering works and contribution are spread across India in the form of dams, railway lines, public works, factories, labs, steel workshops, engineering institutes and numerous such ventures. His key works include construction of the Krishna Raja Sagara Dam in Mysore and he is also remembered as the chief designer of the flood protection system for the city of Hyderabad.

Sir MV was appointed as a Companion of the Order of the Indian Empire (CIE) in 1911, knighted as a Knight Commander of the Order of the Indian Empire (KCIE) by the British for his myriad contributions to the public good, and later honoured as a Bharat Ratna by the Government of Independent India. His birthday, 15 September 1962, is observed as Engineer's Day in India.

INDIA'S MODERN BRUNEL OR SIR MV

Born in the erstwhile Malabar district of the Madras Presidency, in what is today Palakkad district in the state of Kerala, Sreedharan—like Brunel in the 19th century—has been successfully involved in multiple projects like railway lines, bridges, India's first big ship, the metro system; and like Sir MV, his work has spread across the subcontinent.

Elattuvalapil Sreedharan was born on 12 June 1932, and has lived through some of the most momentous times in modern Indian history. He witnessed Indian Independence (he was then a student in class 10), changes in society, wars with China and Pakistan, the all-India railway strike in 1974, the Emergency

and much more. However, a study of his career graph shows that he remained disconnected from such public events, always focusing on the task at hand, never deviating from it, howsoever big the event taking place around him.

This is the story of Dr E. Sreedharan—a 21st century icon similar to Brunel and Sir MV; a man who has changed the face of the railways, and of public transport in India. Two key railway projects helmed by him have changed the way India travels. The first is the 760-km stretch of the Konkan Railway, carved out of the extremely challenging terrain of India's Western Ghats—a project virtually abandoned by the British as 'not feasible'. It was completed by Sreedharan and his team within seven years, and when finished, it cut short the rail-travel distance between Ahmedabad and Mangalore by 1,218km.

The second key project is the Delhi Metro Railway, built in a crowded city with as little disturbance as possible. This also took about seven years to complete and is a successful model that offers a practical solution to urban chaos. Now being replicated in almost every major city across the country, it has proven to be the dream solution for every urban transport problem.

While these and many more success stories abound around Sreedharan, not many know of the private battles he has fought with integrity for his principles, nor have many have heard the anecdotes behind the biggest infrastructure projects he has led.

Did you know, for instance, that as Chairman-cum-Managing Director (CMD) of the Konkan Railway Corporation Limited (KRCL)—he was given an official appointment letter only two years after he joined the project, and that his take-home salary was just ₹1,080? The rationale was that Sreedharan had officially retired from the Railway Ministry and had been drawing pension

at the time he took up this Project.

It was unjust and he chose to protest; it was not about the money, but the principle. In Sreedharan's view the Railway Ministry was wrong to offer him such a low monthly salary, given his position as CMD of a corporation with an annual turnover of ₹400 crore; a salary less than what many of his subordinates drew.

Work on the Konkan Railway continued unabated, but Sreedharan pursued the issue diligently through official correspondence. The file grew thick with letters going back and forth. Close to the biggest names in the country, he could have easily walked into the Railway Minister's office at any point, but chose not to. When a long duel through official correspondence failed to elicit the required response, he approached the court, which eventually ordered the Indian Railways to pay him his dues with interest—a decade after he and his team had successfully completed the task and handed over the fully functional Konkan Railway to the Ministry of Railways.

He had fought a similar battle in the 1970s, as CMD of Cochin Shipyard, when he had been paid a salary based on the scale of a railway engineer as per years of service, despite holding office and handling all the responsibilities of a CMD— the salary was by no means a CMD-level salary.

He also narrates the story of Delhi Metro, including the overturning of his suggestion by the Indian Railways that the internationally favoured standard gauge tracks be used. He speaks of how it was made a prestige issue by the Indian Railways, which insisted that broad gauge be used, and how that decision added to time and cost overruns. He also lauds the powerful Maharashtra politician Sharad Pawar, who was

eventually able to convince state governments that metros in all states should henceforth use standard gauge tracks—a decision that holds good to date.

Ironically in 2015, when an Indian Railways Panel headed by him, came up with recommendations on a controversial rail alignment in Kashmir, the Railway Board publicly questioned his abilities as a railway engineer, stating in court that the Konkan Railway had a 'speckled safety record'—this despite having appointed him as head of the Panel and also as another one-man committee to improve its workings.

A look at his service record reveals several success stories— building India's first big ship, and reconstructing a cyclone-ravaged bridge in record time, among others. Revered and respected by students, engineers and millions of Indians, Sreedharan, now eighty-four, is still a consultant for numerous metro and rail projects. In 2015, he also serves the United Nations' High-Level Advisory Group on Sustainable Transport (HLAG-ST), by invitation of UN Secretary-General Ban Ki-moon.

He has been awarded honorary doctorates, prizes, lifetime achievement awards from institutions and colleges across the country and Indian Government's second-highest civilian award the Padma Vibhushan, as well as the Padma Shri. He has also been honoured by the French and Japanese Governments.

Despite the bouquets and brickbats, Sreedharan remains a humble, down-to-earth government service railway engineer who has stuck to his traditional values, instincts and integrity through out his career and has achieved outstanding results.

Note from Dr Sreedharan

Many friends and well-wishers have been suggesting that I share the experience and lessons learnt in my 62-year-long professional life, which they feel would provide motivation and inspiration to young professionals. I have not done this so far on the following pretexts: I don't get time to work on my memoir; I don't have the flair and patience for writing; and I don't like to beat my own drum—meaning I don't want to promote myself.

Two enterprising journalists have already brought out two books on their own about me and a third is this effort by Sri Rajendra B. Aklekar. All three authors have very sincerely and authentically projected my life and professional achievements. There is hardly anything I can supplement to what they have already written about me.

Yet, for the young generation I have the following message. You are very fortunate to be born as children of Bharat Mata. Our scriptures proclaim—*Janani janma bhoomischa swargadapi gareeyasi* (mother and motherland are superior to heaven). We

have a duty to uphold Dharma, the value culture handed over to us from time immemorial by our ancestors.

The four cardinal pillars of the value culture I practise are: integrity; hard work and commitment; professional excellence; and commitment to society.

I do hope these ethics and principles that I cherish will come through in the various incidents and anecdotes scripted in this book. In addition, I also wish to emphasize two essential attributes one must cultivate: good character and good health. The crown and glory of life is character, and without good and robust health one cannot excel in this world.

Whatever tasks are entrusted to us, we should carry them out to the best of our abilities, with total dedication and commitment, without expecting any rewards or recognition.

A Daughter's Pride

He is known as a man of steel, but there has never been a more gentle person than my father. My earliest memories of him are probably from when I was around four years old. I remember him gently brushing my hair and giving me a bath without washing my face with soap, lest it go into my eyes. He would resolve the regular mischief issues among us siblings through gentle guidance. In retrospect, I realize this is rare in parenting.

I have never heard his voice rise in agitation. He believes in dialogue and conversation, and the dining table at our home is always robust to this day, with discussions on topics that range from personal choices to parenting, and politics to philosophy!

At a time when fathers were weighed down by the anxiety of getting daughters married off at the earliest, my father dreamt of making me an architect. Well, he was partial to me, his only girl child! He has also been a loving father to his daughters-in-law, doting on them with genial fervour.

He is a master storyteller, a facet that is little known. We

grew up listening to his stories, crowding around him on the bed or the sofa in the drawing room. He remains the wind beneath the wings of each of his children.

As a father, son-in-law, husband, brother-in-law, father-in-law, uncle and grandfather he is a true Karmayogi. He has engaged in every role with passion and dedication. He has served his parents-in-law and sisters-in-law as a matter of duty that took precedence over any other commitment.

His contribution to shaping the psyche of each of his nine grandchildren cannot be undermined. From playing cricket, to teaching them the nuances of tackling the perfect football game (he was the captain of his engineering college team), to revising a question paper in Math, suggesting body-building regimes, to following their projects once they commenced their professional careers—he has been their confidant, consultant and adviser. The highlight of any evening with their grandfather are the discussions on various topics at the dining table and his animated stories.

It was this thoroughness and passion that the world outside glimpsed in his professional realm, which I believe is only an extension of his personal ethos.

Shanthi Menon
(Masters in Education)
Principal, Deens Academy, Whitefield, Bengaluru

The Family Patriarch

Today, Sreedharan is a proud grandfather of nine and he manages to make time for them from his busy schedule, whether to help with studies or storytelling.

As mentioned earlier, Mr and Mrs Sreedharan have three sons and a daughter. All are married and given below are a few details about each of them, their spouses and families.

Ramesh Sreedharan: Former Vice-President, Tata Consultancy Services, Ramesh Sreedharan is now freelancing as a life coach. He is an alumnus of IIT (Chennai) and has an MBA from Bajaj Institute of Management. He is married to Priya, a counsellor and life coach too. They have two children, son Vikram is an officer in the Merchant Navy and daughter Sharanya is completing a course in Designing.

Dr Achyuth Menon: Dr Menon is a consultant colorectal surgeon in Nottingham and has a double FRCS from London. His wife, Minna is a general surgeon who practices with the

public health services in Nottingham. They have two children, son Rahul, who is in class eleven and daughter Rithika, who is in class five.

M. Krishnadas: Vice-President with ABB, like his brother, he too is an alumnus of IIT (Chennai) and is married to Seema, a homemaker. They have two children, Malavika and Nishanth, studying in classes nine and five respectively.

Shanthi Menon: The only daughter, Shanthi has a masters in education and is the Principal at Deens Academy in Whitefield, Bengaluru. She is married to Hari Menon, the CEO of bigbasket.com. The couple has three sons. The oldest Varun, is a civil engineer, currently doing an MBA after having worked for two years with Tata Projects. The second son, Uttam, is also a civil engineer and is now pursuing a masters in civil engineering at the University of Michigan in Ann Arbor, Michigan, after having worked two years with L&T. Their youngest son Karthik, a mechanical engineer with honours from BITS (Goa), worked as a Research Scientist with Tata Institute of Fundamental Research (TIFR). He is presently at the John Hopkin's University, Baltimore, USA, doing his doctorate.

Two

EARLY LIFE

Childhood, Football and Engineering

Born to Keezhuveettil Neelakantan Moosato and Elattuvalapil Karthyayini Amma on 12 June 1932 at Karukaputhur, near Koottanad town, Kerala, India, Sreedharan's family included six brothers and two sisters. The eldest sister Narayani, alias Ammukutty Amma, was about 20 years older to Sreedharan. Younger sister Parukutty and brothers, Krishna, Padmanabhan, Narayanan, Govindan, Kesavan, and Karunakaran—all preceded Sreedharan, who was the youngest child in the family.

'Marumakkathayam' was a system of matrilineal inheritance prevalent at that time in Kerala where Sreedharan was born. He recalled:

Under the system, descent and the inheritance of property was traced through females. All of us children were staying with my mother at her house, which was run by her brothers. My father was a Brahman, quite well off, but as the tradition had it, being a Brahman he could not stay with my mother in the house. Mother's family was not

doing so well. My mother told me that one day when my father visited her, he found her weeping as there was not a single morsel of food in the house for the children. My father could not stand this. He decided to take her and the siblings to his own house till he could arrange financial security for them. Later he moved to my mother's house and built a small abode for himself. He did not live with us as such, but stayed on the same premises. It was from there that the family's real growth began.

My father was very particular about giving all his children a good education. People used to suggest that he buy another plot of land instead, but my father spent his savings to educate his children in the best possible way. It is from there that we got the real values of education and integrity.

Sreedharan today carries the torch. He founded a Trust in his mother's memory, which funds the education of underpriveleged children.

He also recalls that from early childhood, 'I used to be fascinated by trains, and I remember my very first train journey from Pattambi to Payannur with my father. The station was about 10km away and we had walked the distance, staying at a friend's place to take the train.'[1] Sreedharan was just about six years old at the time. The rattling of the train's wheels and the fast-moving panorama outside the wood-framed windows of the coach they were in, mesmerized the little boy throughout the five-hour-long or so train journey across the 200km that lay between the coastal towns of Pattambi and Payannur, in Kerala. The electric surge of blood through the veins, the excitement

and ecstasy as the steam engine blew its whistle and chugged ahead was an incomparable wonder to a child who had never seen a train before; he seemed to have a strange connect with the iron road.

Having completed his primary schooling till class four at Chathannoor Government Lower Primary School near his village, his father brought him to Quilandy, where Sreedharan's oldest sister Narayani had settled with her husband. She had him admitted to the District High School. It was here in Quilandy— where a small station had opened way back in the early 1900s on the Shoranur–Mangalore line—that Sreedharan's real association with the railways began, a little bit every day. He had to cross the line every day to reach the school and occasionally, could get to touch the mighty steaming iron giants. He recalled:

> After basic schooling, my father admitted me to Quilandy Government School where I completed high school in 1940. I stayed with my elder sister and her husband. While in school there, we had a family tragedy when my other sister Parukutty got typhoid and we could not save her. I must have been in class six. At school, I was into football and the Scouts.

Recently during a visit to his school, Sreedharan spoke of pleasant as well as sad memories connected to the place, referring to his sister's death.[2] He moved on to Basel Evangelical High Mission School, Palakkad, to complete higher secondary studies, and was in class 10 in 1947 when India achieved freedom. After completing class 10 he shifted to Victoria College, also in Palakkad, to complete his intermediate education.

All his achievements would not have been possible without

focus and discipline. Sreedharan recalled a small incident from childhood as an example of how his older brothers used to discipline him:

> I must have been around four or five years old, but I remember the incident very distinctly. A barber used to come to our house once a month and one day he asked me to fetch him a beedi from my brother's pocket; he knew that one of my older brothers smoked beedis. I obeyed and got it for him. He lit the beedi and asked me, 'why don't you try it?', and so I took a puff. My mother saw that and dragged me to my elder brother and said, 'This is what happens when elders have a bad habit and young ones pick it up thinking it must be good as the elder brother does it.' My brother was shocked but did not say anything, just gave me a tight slap. It was a sharp lesson and that was the end of my beedi adventure. I have never touched a beedi or cigarette after that!

Since he had shifted so many schools, young Sreedharan had a limited circle of friends. Among them was T.N. Seshan (who went on to become India's Chief Election Commissioner, initiated electoral reforms, his major contribution being the issuance of a Voter ID Card that every Indian today possesses). They have remained life-long friends. Sreedharan recalled:

> Tirunellai Narayana Iyer Seshan, popular as T.N. Seshan, was my batchmate and friend since school days. We completed our intermediate studies together too, at Victoria College in Palakkad, pursuing what was then called the intermediate college course.

Instead of engineering, for which he had qualified too, Seshan opted for the Indian Administrative Services (IAS). During their respective professional tenures, Sreedharan and Seshan would meet when they could to catch up on old days. As Sreedharan recalled:

> We started our careers in parallel. When I was assigned to work on the Pamban Bridge restoration project, I remember Seshan was the District Collector for Madurai. When I was on the Railway Board, as Member Engineering, Seshan was the Cabinet Secretary and he had sought the help of the Railways to urgently build a facility for the forces in the North-East Frontier Railway zone. It was the job of the Public Works Department, but knowing that there would be delays and the given urgency, Seshan approached the Railways for help to get it built. As Member Engineering, I extended all possible help and the task was completed on an urgent basis.

Upon completion of his intermediate studies, young Sreedharan followed his brother Krishna's guidance and took admission at Kakinada Government Engineering College in Andhra Pradesh in 1949, staying in the college hostel. College studies and his passion for football went hand-in-hand and though not formally trained, Sreedharan went on to become the college football team's captain, an early sign of his leadership qualities.

He finished civil engineering, getting a first class with honours. Now, it was time to look for a job and he once again turned to older brother and father figure Krishna Menon, who had been always been there to give him advice. Trains had always fascinated Sreedharan, but he had never really thought of

making a career around trains till brother Krishna advised him to take up a job, and also study for the Railway Service exams:

> After I had cleared the civil engineering exams from Kakinada Engineering College in Andhra Pradesh, my elder brother and mentor Elattuvalapil Krishna Menon, who was a guiding light for me, said I should attempt the Indian Railway Service of Engineers (IRSE) examination conducted by the Union Public Service Commission (UPSC), where they selected the best of the country's engineers for railway service. No one in our family had been in the Railways but if I cracked this, I could get into what was considered a prestigious organization plus one that had very good pay scale. It would demand professional excellence whilst exposing me to the best in the field.
>
> While I prepared for IRSE, my brother advised me not to sit idle but to stay in touch with engineering studies. One should always keep upgrading their knowledge in the field, he said. I obeyed and while preparing for IRSE also took up an academic job as a lecturer in civil engineering subjects at the Government Polytechnic in Kozhikode. This way I would remain updated in my field and could use the college's excellent library for all the books that I needed to prepare for the railway exams.
>
> You may not believe it, but a complex hydraulics problem that I had explained, practised and perfected with my students just weeks before, was one of the key questions in the IRSE exam paper. I was lucky and could solve it in a jiffy.
>
> I had joined the college as a lecturer in June and

as soon as the IRSE exams were over in October, I quit the academic job and began to look for a field job in the engineering sector while I awaited the results. I got several offers from various institutions given my excellent academic record. One of these was from the Mumbai (then Bombay) Port Trust. My elder brother Krishna had already settled in Mumbai where he was working as an engineer with the then Bombay Electrical Supply Transport (BEST).[3] He suggested I take up the Mumbai Port Trust job and I arrived in Mumbai, staying with him at Mahim.

Three

CAREER: TRAINS, BRIDGES, SHIPS AND MORE

A Career Begins on an Island

Butcher's Island is a curious little island off the coast of Mumbai, India. It is breezy, gusty and off-limits for the public. It was on this isolated and breezy island that Sreedharan started his career as an engineer. He recalled:

> As I mentioned, I used to stay at Mahim with my elder brother. I would take the early morning harbour-line local train to Victoria Terminus (Mumbai VT), from there board a city bus to reach the Gateway of India from where the company ferry would to take us to the island. In the evening, the same journey would be undertaken in reverse. Starting at 5.30 a.m., I used to be back home only by 9.00 p.m. So rigorous was the routine.

Butcher Island itself is about two miles long and a mile wide, and was once used for the slaughter of cattle and goats by the British, from whence it got its name. It was also used by the British as a quarantine base for troops during epidemics.

After the British Raj ended, the Mumbai Port Trust set up

oil terminals there in the 1950s, instead of in Mumbai, so as to keep the latter relatively safe in case of any mishap. Located 8.25km (5.13 miles) from the iconic Gateway of India, Butcher's Island has now been renamed 'Jawahar Dweep', after India's first Prime Minister Jawaharlal Nehru.

Describing those early days, Sreedharan recalled:

> At the Mumbai Port Trust, they were building oil terminals for the city and there were several new recruits, including myself. We were assigned to contractors who were in the process of setting up an oil terminal at Butcher's Island.
>
> I was with the team of a Dutch company named Royal Engineering Harbour Works, Netherlands, and joined at a starting salary of ₹300. It was mainly civil works that we were involved in. It was quite an experience being there. Though it was hectic, I got to learn many new and interesting things. I must have worked there for less than a year when the IRSE railway exam results were declared.
>
> I did not realize the results had been declared because I was quite engrossed in my work. It was my brother Govindan, then working with the Godavari Sugar Mills, who called me and asked me if I had read the *Indian Express* where the IRSE results had been published a few days earlier. I rushed back to check the results. I had cracked the exam, stood seventh in the country, and was among the 18 candidates selected for the Indian Railway Service of Engineers.

In a lighter vein, the number seven seems to have played a crucial role in Sreedharan's career. As mentioned above, he stood seventh in the IRSE held by the UPSC, and completed both the

Konkan Railway and Delhi Metro in about seven years each! Ask him about the significance of number seven in his life and he just smiles at the numerical coincidence, before reverting to his reminiscences about the choices he faced as a young man who had cleared the IRSE with such a good rank. Despite the rank, he recalls:

> I was in two minds. I was doing very well at Mumbai Port Trust. But my brother Krishna Menon said I should join the Indian Railways, as it did not just have a good pay scale, but was also the best for professional excellence. He said the Mumbai Port Trust job was just for experience till I got into the Railways. I quit the job and left Mumbai. My first railway posting as a probationer was in the Southern Railway. And this is how my journey in Indian Railways begun.

Sreedharan became the first member of his family to join the Railways and remains as yet, the last one!

A little-known fact about Sreedharan is that he not only loves travelling by train but also loves model train sets. 'Wherever he goes, he comes back with trains,' says Radha Sreedharan, his wife. 'He picks them up on all his trips abroad and in India, these toy train sets. He brings them home, arranges them and then sits with the grandchildren and plays with them.'

Sreedharan admits, 'I love those train sets. I once had a good collection of the popular Marklin model trains.' Marklin is the top German toy company synonymous with model railroads.

Sreedharan is pretty up to date on railway stations too. When I showed him a photograph of an old 1904-dated rail used as a pillar at Kuttipuram railway station, the closest railway

station from Ponnani where he has now settled, he promptly explained, 'The station came up in 1861 and these unused rails are of a much later date. They must have been recycled after their utility was over as was the practice back then.' He also added that he knew the station master, 'He is a very kind man,' he noted. Even today, Sreedharan extensively travels by train whenever he needs to travel locally.

Getting on Board Indian Railways

Twenty-two-year-old Sreedharan joined Indian Railways on 17 December 1954. The British Raj in India had ended less than a decade ago, and the country was in transition. There were changes happening in every sector, and Indian Railways had just completed its centenary an year ago, with celebrations being led by then Railway Minister Lal Bahadur Shastri.

With its inherited fleet of steam-run trains, Indian Railways was looking at electrification as the future and upgrading its network and trains. Railway Archives state that by 1954, Indian Railways had been re-organized into zones and in that year took up a study to look at advanced electrification in the form of upgrading to 25kV AC power.

It was in the same year that the post of the Railway Board Chairman was given more powers and responsibility for all technical and policy matters, being upgraded to the status of Secretary to the Government of India. Third-class train compartments—yes, there was actually a third class compartment then—also got upgraded that year with the

addition of berths for sleeping.

Sreedharan was thrown into this development-oriented world and as part of his probation and training, was moved to various locations in the states that fell under the Southern Railway Zone that had been formed in April 1951. Sreedharan's first posting was to Bengaluru (then Bangalore), but he was moved from there for six months to Shoranur in Kerala, and it was there that he got the news of his father's death.

It was the end of an era, he recalled as he notes that his father made sure each of his children imbibed the value of integrity and the importance of a good education, adding that 'My father had been very happy to see me get into Indian Railways.'

Despite this emotional setback so early on in both life and career, young Sreedharan threw himself wholeheartedly into his work. One of his first major assignments was as an Assistant Engineer at the on-going construction of the 95.47km metre-gauge rail line between Ernakulam and Kollam (today known as Quilon), in his home state.

Legendary railway officer Govind Parameswara Warrier (G.P. Warrier), who later went on to become Railway Board Chairman, led the project as Chief Engineer. It was Warrier, says Sreedharan, who first identified the spark in him and always supported him professionally throughout his life. The team finished the rail section by 1957 and it was opened for rail traffic on 6 January 1958.

By October 1958 Sreedharan had been transferred to Bezawada division in Andhra Pradesh as its Divisional Engineer, one of the youngest in the field. Bezawada is the older name of Vijaywada. The series of transfers and promotions that started

from here took Sreedharan across the length and breadth of the country throughout his career, which he today dubs as 'a huge learning process'.

He remained at Vijaywada for two years before he was moved to what was then Olavakkode division (now Palakkad or Palghat), to start off proposed works that had been pending and won accolades for completing the assigned task diligently. It was while working there, around 1962, that he and his team built the Ernakulam North Road Overbridge, which was recently demolished for the building of the Kochi Metro with Sreedharan witnessing it.

Around this time he also got married to Radha, the daughter of a famous doctor from Ponnani, Dr Achutha Menon. The marriage was solemnized on 21 October 1961 and the couple moved into housing provided by the Railways. However, Sreedharan was soon sent off to Hubli—he had offended a senior officer by refusing to favour a certain set of contractors. He took his wife to Hubli, but the same senior officer had been shifted there too. G.P. Warrier, who was the Chief Engineer in the Construction Department, sensed the problem, counselled Sreedharan and asked him to join his department.

One of the key projects at Hubli was the Mangalore–Hassan railway line project, and a number of other projects were underway—including maintenance of permanent way, track doubling, and the construction of bridges and tunnels. Sreedharan recalled:

> In the first 15 years of service in Indian Railways, I got 25 transfers. Some of these were planned, as they wanted me to get exposed to various kinds of workings. The

other reason was that initially, I was handily available as a bachelor. All this helped me quite a lot—it helped me to evolve a philosophy that one should not take transfers as a punishment.

Pamban Bridge

By 1964 Sreedharan was moved once again, this time from Hubli to Bengaluru, as technical assistant to the engineer-in-chief of the Railways (Construction). While he was posted here, a devastating cyclone hit South India and cut off the rail link to Rameshwaram and Dhanushkodi by badly damaging Pamban Bridge. There was uproar in Parliament thanks to the public pressure to restore the link to the place of pilgrimage.

Railway archives state that between 1902 and 1908, the rail link between Madurai and Dhanushkodi had been completed, except for the three-mile undersea distance between Mandapam and Pamban. Pamban Bridge was built by the British for smoother administrative control by bringing provinces, towns, districts and villages together.

Pamban Railway Bridge construction began in 1911 and was completed in three years. Six hundred workers were involved in its construction and it was constructed by Head, Wrightson & Co of Thornaby-on-Tees. The stone and concrete metals used for the bridge were brought by rail from a quarry situated 270km

from Pamban. Sand came from a site 100km away. In all 4,000 tons of cement, 1,36,000 cubic feet of clay, 18,000 cubic feet of crushed metal, 1,63,000 cubic feet of sand and 80,000 cubic feet of boulders were used to construct Pamban Railway Bridge.

Pamban Bridge (now officially called the Annai Indira Gandhi Bridge) was also referred to as the Cantilever Scherzer Rolling Lift Bridge after its American-born designer engineer William Scherzer.

From Mandapam, the bridge extension follows for about two miles to its end at Toniturai point and then across the sea on a viaduct about one and a quarter miles long, constructed on the sandstone reef connecting the mainland with the island of Rameswaram. The viaduct is 6,776 feet long with 145 openings. Out of 145 openings, 143 have a span of 40 feet each, one has a span of 43 feet, and another of 44 feet.

The Pamban viaduct opens up allowing sea-going vessels to pass through. It has 145 fixed spans and one navigation span which is open for ships. The 103-foot drawbridge at the centre comprises two leaves or sections of the navigation span. It is also called the 'Scherzer' span, with each leaf or section weighing 415 tonnes.

The authority of the passage of vessels is vested in the hands of the Port Officer of Pamban. He contacts the Bridge Operator through telephone and the latter then communicates with the Station Master at Pamban and at Mandapam. The two Station Masters accord permission if there are no trains to pass.[4] Opened on 24 February 1914, it was India's first sea bridge, and it was the longest sea bridge until the opening of Mumbai's Bandra–Worli Sea Link in 2010.

Following the devastation of the Pamban Bridge by the cyclone in 1964, and the ensuing uproar in Parliament, the job

of fixing it was assigned to Southern Railway, with a six-month deadline. 'At this stage, it was Warrier who suggested my name to then General Manager Bankim Chandra Ganguli, to get me on the project,' says Sreedharan.

The following is an extract from the report on the cyclone, which passed over Dhanushkodi on 23 December 1964. It was written by Mr S. Subhiah, In-charge, Operator, H.C. & I., Dhanushkodi Police Radio Stations[5]:

> On 22 December 1964, there was a strong wind blowing at about 1800 hrs onwards from northeast side. The sky was clear. There was no rain and there was no hint of any storm or cyclone which would hit Dhanushkodi in the night... From 10 p.m. onwards, the velocity of the wind increased gradually and still there was no rain. At 11 p.m. [and] onwards, there was a high whistling sound with hissing and rain began to pour down. Due to the pressure of the wind which had by this time approached cyclonic proportions, waves were bigger and higher and at about midnight, the fourth house to mine collapsed due to water and wind...soon several huts began to collapse and people were running for shelter at the railway station and railway carriages. By this time, the cyclone was increasing in tempo and waves were rising to a height of 40–50ft and breaking on the land.
>
> Though it was dark, the white foam on the top of the high waves could be seen and that was how the height of the waves could be judged. At this time, rain was falling like a sheet of water and the wind was blowing at cyclonic speeds. Huts were collapsing and people were running

helter-skelter, to save themselves. There was no time to rescue their belongings as the water was rising high and practically everything was washed away. There are three pucca buildings at Dhanushkodi, one with a terraced roof and two with asbestos roofs. Due to the cyclone, the asbestos roofing was blown away from both buildings...the wind, rain and tidal waves continued unabated till about 6.00 a.m. At this time, wind and rain decreased a little. About 6.30 a.m., both wind and rain stopped completely within a very short time, cyclone wind began to blow from the southwest, with the same intensity but without rain. Except for a few collapsed huts near the railway station all other huts were washed away... By about 11 a.m. of 23, I could contact Madras and inform the fate which had befallen Dhanushkodi.

TRAGEDY OF TRAIN NO. 653

Until this report was filed on the afternoon of 23 December, the fate of Train No. 653, a Pamban–Dhanushkodi passenger train that had left Pamban on the night of 22 December at 11.55 p.m. with more than 110 passengers on board, remained unknown. It was only after 48 hours—when Railway Headquarters issued a bulletin based on the information given by Marine Superintendent, Mandapam—that the scale of the tragedy came to light.

The six-coach passenger train with the steam engine had been washed away along with the railway line and all the passengers.

The story goes that on 22 December, the metre gauge passenger train left Pamban at 11.55 p.m. with 110 passengers, including a group of school students, on board. The train had almost reached its destination, when the signal failed a few metres ahead of Dhanushkodi. Driving on in pitch darkness, the driver blew a long whistle, having decided to take the risk. Minutes after the train started rolling along the bridge over the waters of the Palk Strait, a huge wave smashed it, submerging all six coaches under deep water. The death toll was estimated to be anywhere between 115 and 200. The variation is due to the many ticketless travellers said to have been on board.

The railway line running from Pamban station to Dhanushkodi pier was washed away. When then Chief Minister of Madras State, Minjur Kanakasabhapathi Bhaktavatsalam, flew over the affected area later that week, he could barely see the tip of the train's engine that had been completely submerged in the waters of the Strait.

Railway officials familiar with the area also reiterated this, 'Just six inches of the steam engine's smoke stack was all that was visible,' and the section of the bridge that went over water, was missing. Assistant Locomotive Pilot K. Nagalingam, who survived the ill-fated journey on the washed-away train, spoke of his miraculous escape[6]:

> The train had halted at Kambipaadu after a signal failure, when I saw gigantic waves ripping the train's engine off the track and dragging the bogies into the sea. I and a few others managed to climb atop a parked goods train and jump into the sea to rescue a few people. The bogies had been swept into the sea, but we managed to save a

few people who stayed afloat. Even my miraculous escape
is an act of God.

Along with the train and the railway alignment to Dhanushkodi,
a one-and-a-quarter mile stretch of the historic Pamban rail
bridge that linked the Indian mainland with the island of
Rameswaram was also badly damaged—126 of its 145 girders
had collapsed, though the lift span survived.

REBUILDING PAMBAN BRIDGE

After the devastation of the cyclone, which hit the bridge exactly
50 years after it was built, Southern Railway's engineers took
it upon themselves to rebuild it. The Government was already
planning to construct a road bridge connecting Rameshwaram
to the mainland, but there was furore in Parliament and a
demand from citizens, as the railway link was the key.

Then Railway Minister Sadashiv Kanoji Patil acknowledging
the importance of Rameswaram as a pilgrimage centre, assured
the nation that the Railways would take up repairs and restore
the rail link to Rameshwaram.

The bridge used to diverge into two sections at Pamban, one
arm leading to Rameshwaram and the other to Dhanushkodi.
It was decided to abandon the metre-gauge branch line from
Pamban Junction to Dhanushkodi after the cyclone destroyed
it, and a year later the Government of Madras further declared
the town as unfit for living. The Railways gave a six-month
target to Southern Railway to complete the restoration of the
bridge to Rameshwaram.

PULLING OFF A 46-DAY MIRACLE!

Warrier was still Chief Engineer with Southern Railway's Construction Department and Bankim Chandra Ganguli its General Manager. Warrier requested the Railways to get Sreedharan on the team that would work on the Pamban Bridge restoration project.

Sreedharan, now in his mid-30s, had been posted as Technical Assistant to the Engineer-in-Chief in Bengaluru, was called in. 'I was on Christmas leave,' he recalled, 'and my wife was pregnant when I got the call at home. I joined, and Warrier sent me to meet the General Manager.'

The GM, B.C. Ganguli, told Sreedharan he had just three months to restore the link, and not six. Sreedharan could not say no and walked out quietly of his cabin, as both Ganguli and Warrier were his icons. From there, he went straight to the site to assess the damage.

He took over the project in Ramanathapuram and found that it was practically impossible to get steel girders to replace the washed away ones within reasonable time, as moulding and casting them alone would take months. He recalled:

> Of the 146 spans, 125 had been damaged or washed away.
> We urgently needed metre-gauge girders (support beams)
> to build the bridge. We sourced them from states as far
> as Punjab, Assam and Rajasthan, but there was still a
> shortage.

Being a seaman and having worked at the Mumbai Port Trust in his early days, he decided to take a boat ride to the damaged area and seek information from the local fishermen. It proved

to be a sound decision, because they told him that the sturdy girders of the old bridge had sunk nearby and could still be salvaged. This would help in a big way, if they could pull it off.

Next, he decided to use traditional methods and expertise and brought in hundreds of Mappila Khalasis to the site. This community has a history dating back to over 2,000 years, most of it involved with boat building and boat repair using simple but cleverly designed equipment and devices put together in a manner that leverages muscular strength quite amazingly. They have been historically linked with Beypore town in Kozhikode district of Kerala, a centre of overseas commerce since ancient times. Sreedharan narrated:

> Thankfully, the fishermen in Pamban came to our rescue. They had spotted many girders that had been swept away in the cyclone and were lying 40 feet below, on the seabed. We salvaged those and worked at breakneck speed to complete the restoration. We had steam cranes in those days and if done at normal speed, we could deal with one girder in five days, from salvaging it to putting it up in place.
>
> I designed a special type of a pontoon crane (a crane floating on a flattish boat) and it salvaged those girders lying in the sea. My experience along with my friends at the Mumbai Port Trust, were greatly helpful with regard to this.
>
> The next thing I did was to design a special type of launching gantry for girders. Its utility was such that the girders were launched simultaneously from both ends of the bridge as work progressed. It used to take us three

days to launch one girder, but soon as the work gathered steam, we were launching a girder a day.

On the last two days, we launched eight girders. Even as we launched girders, I got another team to simultaneously build rail tracks so that when the bridge was ready, the ready rail tracks with sleepers could be just placed over the bridge and bolted. This did the trick and a bridge with rail tracks was ready in no time.

It took Sreedharan and his dauntless team just 46 days to complete the bridge and flag-off the first train—much ahead of the targeted date given by Ganguli. Sreedharan said with pride:

> Giving a status update of the project, Railway Minister S.K. Patil announced in Parliament that work on Pamban Bridge was progressing very well and would be opened soon.

The bridge opened the same night and the radio broke the news. The next day the newspapers did so too, and everyone, including the Minister, was taken by surprise. Senior officials in the Southern Zone had never expected the work to be completed so quickly, and had failed to update themselves and the Minister on the progress. Nor was the work was done in haste—it had been executed in a professional way with the Commissioner of Railway Safety inspecting and approving it.

Sreedharan was given the Minister of Railways' Award in 1964 for swift completion of the bridge—the first official recognition and award in his life. He had not just built a bridge, but a reputation for himself. G.P. Warrier had acknowledged Sreedharan's feat in his autobiography, *Time, Tide and My Railway Days.*

On the personal front, Sreedharan said, it was a tough battle:

My wife was pregnant with our daughter when I was informed about the cyclonic damage to the Pamban Bridge. I was on Christmas leave in my hometown in Pattambi, while my wife was at her maternal home in Ponnani. I didn't have the time to meet her before heading to Pamban and commencing work on the bridge. A few weeks later, I came to know that we had been blessed with a baby girl. However, I was unable to go see her as my presence was needed at the bridge at all times during the ongoing restoration work. Finally, after we had put the bridge back in operation, I was able to go home and see my daughter for the first time.

After completing the Pamban assignment, Sreedharan was back in Bengaluru at his post as the Technical Assistant to the Engineer-in-Chief.

Today, Pamban Bridge has been converted to a broad-gauge line as a part of Indian Railways' uni-gauge policy, the decision had been taken to construct a new bridge that would meet broad-gauge standards.

Global consultancy tenders had been called for and multinational organizations duly submitted tenders to carry out the construction of a new bridge at an estimated cost of ₹800 crore (8000 million). However, Railway Engineers—along with technical experts from IIT Chennai and the Government of Tamil Nadu—conducted a detailed survey and recommended the conversion of the existing Bridge to broad-gauge standards as it was found to be strong and sturdy.

Accordingly, strengthening, replacement and improvement

works on Pamban Railway Bridge were carried out at an approximate cost of ₹24 crore (240 million). To avoid mishaps, an anemometer was fixed on the 56 pier on it to record the velocity of the wind. Whenever wind velocity exceeds 58km per hour, trains are not allowed on the bridge.

Upon completion of the gauge conversion works, the Manamadurai–Rameswaram broad-gauge section, in which the historic Pamban Railway Bridge is situated, was opened for traffic on 12 August 2007.

Centenary celebrations were conducted in 2014 in the presence of former President of India, Bharat Ratna Dr A.P.J. Abdul Kalam, at Pamban Railway Station. On his visit during the centenary celebrations, Sreedharan said it was time to replace the century-old bridge:

> As the bridge is situated in a marine environment there is corrosion of the steel girders and they require periodic replacement...perhaps even replacement of steel with pre-stressed concrete. The Scherzer's has completed its life span and we need to evolve another suitable cantilever structure that will allow ships to pass under the rail bridge.

A new challenge for the new century.

Sreedharan's Icons

It would be apt at this point to mention a little more about the two senior Indian Railway officers Sreedharan looked up to, in fact still does—Govind Parameswara Warrier (G.P. Warrier) and Bankim Chandra Ganguli (B.C. Ganguli). Both were officers of the prestigious IRSE, the same as Sreedharan—one of the oldest civil services in India. In fact, it was under both these men that Sreedharan worked on the Pamban Bridge Project.

It was Sreedharan's first posting as a probationary Assistant Engineer in the Southern Railway after clearing the IRSE in 1953. Warrier was then Deputy Chief Engineer with the Construction Department of Southern Railway, and Ganguli was the Southern Railway General Manager.

Ganguli later went on to become Chairman of the Railway Board (7 January 1970 to 12 October 1971), as did Warrier (1 May 1975 to 31 August 1977).

Warrier is known for his pioneering roles in the construction of the Kollam–Ernakulam Metre Gauge railway link opened in 1958 that he, at his own risk, made fit for even broad-gauge

trains to pass over. He also played a key role in bridging the Ashtamudi and Paravoor Kayal lakes along the stretch. Ganguli is well known as the brainchild behind the high-speed Rajdhani trains in India and the laying of tracks in eastern and north-eastern India during the Second World War.

Both officers were known for their engineering and management abilities, professionalism, unmatched intelligence, diligence and knowledge, as also for their pioneering roles— qualities Sreedharan picked up.

GOVINDA PARAMESWARA WARRIER

Warrier acknowledges Sreedharan's role in the restoration of Pamban Bridge in his autobiography, *Time, Tide and My Railway Days*:

> The unprecedented tidal wave in February 1965, 14-feet high, washed off a passenger train running between Rameswaram and Dhanushkodi at 10 p.m... The tidal wave also cut off all connections between the mainland and Rameswaram Island by putting Pamban Bridge out of use. On this long railway bridge all the 144 steel girders were washed off... Sreedharan, one of our outstanding engineers, was in charge of the (restoration) work and it goes to his credit that he completed this very difficult task in just a short period [...].

The present generation of Warriers do remember Sreedharan coming to their house to meet his role model and consult on various matters. Seventy-year-old P. Balachandran Warrier, the son of late G.P. Warrier, is Chief Executive Officer of the

Manipal Foundation, the charitable arm of the Manipal Group in Bengaluru. He recollected:

> I remember Sreedharan very well as he was during father's stint as Chief Engineer (Construction) in Chennai, his most trusted and able lieutenant. He was then the Executive Engineer and worked directly with my father. We were living in Sterling Gardens, the railway bungalows in Chennai, and Sreedharan was a regular visitor there.
>
> About the Pamban Bridge reconstruction, I do not remember my father talking to us particularly about it, except that he was one of the young engineers who maintained it originally I understand, because I have seen photos of him and a couple of his colleagues swimming in the sea, near the bridge location. By the time we grew up and were working, Sreedharan was posted on deputation to Cochin Shipyard as Chairman and Managing Director. I used to remember him coming to meet our father often to discuss issues related to unions, handling the local and state governments.
>
> To us, his five sons and a host of his nephews and nieces, our father G.P. Warrier was a role model. To my mother's mother, who used to live with us, he was a true son—his own mother had passed away when he was very young. When we were young, we hardly ever saw him as he was constantly 'On Line'—at different construction sites. He used to come back fully tanned, otherwise a fair, handsome young man. In fact, our mother used to tell a story that my elder brother, when a baby, refused

to go to him, as he was unrecognizable under the survey hat and tan!

In 1977, my father was Railway Board Chairman and during a big function at Kochi for the opening of the broad-gauge railway line on the Ernakulum–Kollam section in the presence of Prime Minister Indira Gandhi, the Minister of State for Railways Mohammad Shafi Qureshi revealed an unknown fact that when my father as a young 35-year-old Executive Engineer, had taken a major risk by constructing all the piers for the bridges of that metre-gauge section designed for taking broad-gauge trains, and praised his foresight and visionary planning. Otherwise the conversion would have taken many more years and crores of more funds.

These are the very qualities that Sreedharan picked up. Says Sreedharan, 'G.P. Warrier was my role model. He was a people's man and commanded great loyalty. At the same time, he was very strict. He was my inspiration and still is. Such an upright man!'

BANKIM CHANDRA GANGULI

The other towering personality that Sreedharan looks up to is B.C. Ganguli, who was a visionary, strict disciplinarian and no-nonsense railway officer. It was Ganguli who, as GM Southern Railway, called upon Sreedharan and shortened the six-month deadline of restoration of Pamban Bridge to three months. Sreedharan, who had immense respect for Ganguli, did not say no and completed the project within 46 days.

Sadly, Ganguli's case turned out to be a gloomy one in the annals of the Indian Railways due to his dramatic dismissal by the Railway Minister in 1971. Rarely has a top Government official been given the boot in as bizarre a fashion as was in the case of Ganguli, then Chairman of India's Railway Board.

There had been differences between Railway Minister Kengal Hanumanthaiya, a Karnataka politician, and Railway Board Chairman Ganguli. As time went on, the differences grew and the gulf between the two widened.

On 8 October 1971, Ganguli boarded an air-conditioned inspection saloon coach at Sarai Rohilla along with his wife and personal staff, to commence a scheduled a nine-day-long inspection tour of Gujarat. The coach was attached to a train that was to leave for Gujarat. Minutes before the train's departure, station officials received a communication from the Minister's office to detach the coach. An angry Ganguli called a press conference on the station platform and stayed in the coach in protest for six days. On 12 October 1971, the Government issued an order to forcibly retire Ganguli, and officials—in no mood to hand the note to their leader—tucked the note to the side of the coach in which he was protesting.[7] It was sad to see how an officer of outstanding merit, with 34 years of glorious service, was dismissed overnight. It left the nation and the country's bureaucracy in shock.

India's First Metro

Meanwhile, after the Pamban Bridge project and accolades, Sreedharan was back in Bengaluru where he soon received a promotion to the post of Deputy Chief Engineer. But Southern Railway had no vacancies for a Deputy Chief Engineer; the only post available was in Kolkata. Though a bit reluctant, Sreedharan moved there with his family. Even as the children's school admissions were completed and he was getting settled, he received another transfer letter, this time posting him to Bilaspur. So he went to Bilaspur alone, leaving his family in Kolkata as he did not want to relocate them again.

Sreedharan recalls that he went to ask G.P. Warrier, who by now was GM Eastern Railway, if he could retain the quarters at Kolkata for his family. Warrier told him that the Metropolitan Transport Project General Manager had just come to his office and was looking for suitable candidates and would he be interested? Sreedharan was reluctant, but Warrier convinced him. He said, 'I must have worked at Bilapsur for about two

months, when I received a letter posting me to the Metropolitan Transport Project, Kolkata, popularly known as the Calcutta Metro Project as Deputy Chief Engineer (Planning & Design).' This was in 1970.

Sreedharan recalled:

> The construction of Kolkata Metro proved to be an unpleasant experience for the whole country because a 17-km line took 22 years to complete and the cost went up by 14 times! It was a learning experience for all and that is the reason when we took up the Delhi Metro project, we decided to do it in a very different fashion.

It was India's first metro rail experiment and a separate department called the Metropolitan Transport Project (MTP) had been set up under the Eastern Railway. Railway Archives state that the Calcutta Rapid Transit Line or the Calcutta MTP, was originally an idea floated by the second Chief Minister of West Bengal, Dr Bidhan Chandra Roy, in 1949. He conceived the plan of building an Underground Railway for Kolkata to solve the increasing traffic problems of the city. A survey had already been completed by a team of French experts, and in 1969 Indian Railways took up the MTP as an alternative solution after another set of detailed studies.

By 1971, the MTP had finalized a master plan for construction of five rapid transit lines for Kolkata, totalling a route length of 97.5km. Of these, the highest priority was given to the busy north–south axis between Dum Dum and Tollygunge over a length of 16.45km and the project work was sanctioned on 1 June 1972. Sreedharan noted:

I remember the last section of the Tokyo–Osaka Shinkansen Bullet Train project was on and there was an International Tunneling Seminar in Japan. The Chief Administrative Officer (Railways), MTP, Kolkata, J.N. Roy was invited to attend it, but he refused. He said he was to retire in two years and that Indian Railways should send a young engineer who had enough service and who could grasp everything. And then he recommended my name. In those times going on a foreign tour was a very prestigious thing for anyone. I was surprised. How could he refuse the offer and recommend someone else! It is rare to find such people today. I felt happy and responsible. I took full advantage of it and went for the three-day seminar.

After the seminar was over, it struck me that Tokyo had a good metro line and it could be of help to my organization. I decided to spend a few more days there and meet their engineers and operators. But this would cost money as Indian Railways would not fund me beyond the seminar and I had run out of money. But being in Tokyo was a never-before opportunity and I did not want to miss it. I called up one of my nephews in the US and requested a loan. The kind person readily agreed and sent me about US$300 at my hotel and I spent the next four days extensively travelling and studying the Tokyo Metro.

Then I went a step ahead. I met senior engineers and operators of the Tokyo Metro Line, introduced myself and managed to take the engineering drawings of the Tokyo Metro and the network. This was an asset. Any engineer will tell you just how important such drawings with all specifications and dimensions are. I got the drawings and with them, came back to India and gave them to my bosses

at the Kolkata Metro. The drawings now just needed to be translated and customized to Indian specifications that we were planning.

The masterstroke had worked. Indian Railways later sent two teams on foreign visits for six weeks each, to study many other metro rail systems abroad. While the first team was concerned with study-cum-observation of foreign metros, the second team was concerned with the design of the rolling stock (trains) and its procurement aspects. The first team, a seven-member team, was headed by J.N. Roy, Chief Administrative Officer (Railways), MTP, Kolkata, and the second six-member team was headed by S. Sarath, Chief Electrical Engineer, Western Railway, Mumbai. The first team went abroad the same month the project was sanctioned, in June–July 1972, to the erstwhile USSR, Sweden, United Kingdom, France, West Germany, Hungary and Japan. Sreedharan was a part of this team. The second team left a bit later, by September–October 1972 to Japan, United Kingdom, France, West Germany and Sweden.

Speaking to the Parliament, then Railway Minister Lalit Narayan Mishra said[8]:

The teams observed the various aspects of construction techniques, system selection, equipping and operation of foreign metro systems. From the experience gained and knowledge obtained from abroad, the teams are confident that the Calcutta Rapid Transit Line (Dum Dum–Tollygunge section) and its operation has been planned according to the modern trends prevailing abroad. The teams also feel confident that it would be possible to implement the project successfully.

Meanwhile, Sreedharan's masterstroke had already led to significant completion of the drawings and plans. Once the teams were back with their expertise and everything was set for the project, the foundation stone was laid by then Prime Minister Indira Gandhi on 29 December 1972 and construction began in 1973–74. However, from the beginning of construction the project faced various problems such as non-availability of sufficient funds, shifting of underground utilities, court injunctions, irregular supply of vital materials and other problems.

By 1975, after spending five years there, Sreedharan saw that work was not gathering pace; it was demoralizing to stay. Fortunately for him, he received his next transfer order, to Mysuru as Divisional Railway Superintendent.

Back in Kolkata, the project that had begun in 1972, went on slowly. The first stretch of 3.40-km line with five stations, between Esplanade and Bhowanipur (now Netaji Bhavan) was ready for use only on 24 October 1984, and went on opening in phases with the entire line between Dum Dum and Tollygunge (now Mahanayak Uttam Kumar Metro Station)—a combination of elevated, ground-level and underground lines—becoming operational only by 27 September 1995.

Sreedharan says the project should have been built differently and not as a departmental project. It was due to this that it suffered the lack of a regular supply of adequate funds, leading to stagnation and massive delays. As a final caveat, he adds, 'Indian Railways built Kolkata Metro using railway technology, not metro technology. It doesn't have much of a future unless the system is upgraded and modernised completely.'[9]

From Railways to Shipping

From the Kolkata Metro project, Sreedharan was shifted as Divisional Superintendent in Mysuru for two years, and then sent back to Kolkata again as Chief Engineer (Construction) Eastern Railway for six months. From here, the Indian Railways recommended his name to the Ministry of Shipping, which was looking for a suitable candidate for the post of Chairman and Managing Director (CMD) for Cochin Shipyard. Sreedharan recalled his astonishment, 'When I got a call asking me to go for an interview, I was surprised. I said I had not applied. But then I was told that the Railways had suggested my name.' He was selected and appointed as CMD, Cochin Shipyard, and was back in his home state.

When he took charge in October 1979, Cochin Shipyard was undergoing its own teething troubles as it was just taking shape. Its first CMD, Vice Admiral Nilakanta Krishnan, had just retired. The shipyard had been conceived in 1969 after a team had surveyed various locations in India for the launch of the first Greenfield shipbuilding yard in the country. The Project

commenced in 1971 with then Prime Minister Indira Gandhi laying the foundation stone for a hull shop in April 1972. Work began with a technical tie-up with Mistubishi Heavy Industries of Japan. [10]

Vice Admiral Nilakanta Krishnan, DSC, PVSM, Padma Bhushan, a war hero,[11] had been appointed as the first CMD on his retirement after 40 years in the Indian Navy in 1976. Krishnan, one of the most decorated Flag Officers in the Indian armed forces, had been responsible for the conduct of all sea and seaborne air operations throughout the eastern theatre of war during the Indo-Pakistan war in December 1971, resulting in the liberation and creation of Bangladesh, and oversaw surrender of all Pakistani forces on the Eastern front, for which he was awarded the Padma Bhushan. At Cochin Shipyard, he was leading the charge when work on building the yard's first ship—the biggest-ever in India, a 245-m long, 17,260 tonne *Rani Padmini*—had just begun.

Taking over in October 1979 from Vice Admiral Krishnan, it was Sreedharan who made sure that *Rani Padmini,* was completed within a year while he was CMD, fighting battles and strikes with trade unions, disciplining workers and setting an example. An old employee recalled, 'The shipyard had become a den of indiscipline and Sreedharan brought in discipline among the ranks by personally walking down the shipyard early every morning and catching those who took voluntary half days, and issuing charge sheets.'

Developing a one-to-one rapport with employees and mingling with them, he heard grievances and started weekly Monday meetings called 'darbars' where employees could directly share their grievances with him. 'The Monday darbars

meant that I was directly in touch with all employees. Anyone could meet me during that time without any appointment and I would be available to hear their grievance,' he said. This led to changes, the employees were happy that they had a boss who heard their side of the story and fixed their problems. But this also led to imbalance as the powerful trade unions that were the traditional forum for such issues were losing their platform.

Former Cochin Shipyard employee and trade union leader Vijayanathan Pillai said the shipyard, first headed by Vice Admiral N. Krishnan, had its share of teething troubles and acknowledges Sreedharan's contribution. 'It was the arrival of E. Sreedharan, who helped the shipyard turn around. *Rani Padmini* was launched under his leadership. But he had a bitter time at the shipyard as some vested interests wanted him out,' according to Pillai.[12] When Sreedharan suspended a few employees who had got into a fight, the trade unions jumped in and called a strike until the suspended employees were called back to duty. Sreedharan refused. He meant to send out a loud and clear signal that no indiscipline would be tolerated. This led to a long stalemate, which was eventually resolved by the intervention of then Kerala Chief Minister Erambala Krishnan Nayanar.

However, this was not the only battle that Sreedharan had to fight as CMD of Cochin Shipyard. The Ministry of Shipping insisted on paying him a salary based on the scale for Railway Engineers, and not a CMD's salary. The Ministry's contention was that it could not pay him a salary greater than his pay scale at this level of his career, though it did provide him a bungalow and other perks.

Sreedharan disputed this from the very onset, saying if this was the case, he was not interested in the post and should be

sent back to his parent body, the Indian Railways. Thereafter, the Ministry of Shipping and he engaged in a long correspondence in this regard. At the Shipyard, he also continued to fight trade union opposition, but made sure work did not suffer. It is to his credit that *Rani Padmini* was ready by January 1980 and trial-sailed by October that year.[13]

Then, as though to coincide with the trial sailing of the ship, a tele-printer message arrived in October 1980 from the Joint Secretary at the Shipping Ministry directing him to immediately hand over charge as CMD to D. Jayachandran, who was then with Bharat Heavy Electricals, Tiruchi. Employees were shocked that Sreedharan was removed so unceremoniously just as the shipyard was about to deliver its first ship, *Rani Padmini,* to its client, the Shipping Corporation of India (SCI).[14] They said that the shipyard had progressed more than ever before under Sreedharan's year-long stewardship.

The ouster was a shock to everyone. Management-worker relations were at an all-time high, there was no stagnation of work as had been the case when the shipyard had been a hot-bed of rival union activities, delaying commissioning of ships. Sreedharan left Cochin Shipyard in November 1980 and a number of protest telegrams from the staff began to reach the Ministry of Shipping. Even, the then Chief Minister of Kerala, E.K. Nayanar, requested the Ministry to reconsider Sreedharan's transfer. The Ministry tried to save face by spreading the word that Sreedharan was not willing to serve at his current scale of pay and cited the correspondence that had been exchanged over the pay scale.

The actual reason for his ouster though, was a recent difference of opinion with the Ministry over the selection of

firms to provide the costly engines for ships to be built by the shipyard. There were two companies in this race, one a Polish firm and another, a German firm. Sreedharan recalled:

> The Polish engines that were actually from a Swiss-based company, were found to be suitable and affordable. German engines were double the cost and there were issues. My board of directors and I decided to go in for the Polish firm, which came in for half the cost. But there were calls from the Shipping Ministry. They wanted me to disqualify the Polish firm and go in for the Germans. The Shipping Minister and the Secretary did not like what we had done and I was repatriated to the Railways. Later, the Government too found merit in my decision and went in for the Polish company for ship engines. But, by this time, I had moved on.

The delays would also cost the shipyard. The first ship, *Rani Padmini*, was about to be commissioned and the next ship was to be floated by March 1981. Orders for nine more Panamax class ships were to be fulfilled, and if things went on at the same pace with two ships completed every year, the shipyard would have pulled itself out of bad days, achieving its full capacity by the time the fifth ship was launched sometime by 1983. The pace of completion was, thus, very important to the well-being of the shipyard—however, the politics that routinely plagued public sector companies, threw a spanner in the works.

Chennai, Mumbai, and Retirement

CHENNAI AND MOTHER'S DEATH

After the somewhat bitter experience at the Cochin Shipyard, Sreedharan was brought back to his parent Ministry, the Railways, and was promoted to Chief Engineer (Construction) at Chennai. Sadly, it was while he was posted in Chennai that his mother fell seriously ill and passed away at the age of 92. Sreedharan spent a month at her bedside during her last days at a nursing home in Trichur.

Work-wise he undertook several projects, including the construction of a suburban railway station in 1985 at a location where the former Moore Market used to function. This was also the time the Chennai MTP was being planned for construction. The Planning Commission had set up a study team on metropolitan transport as far back as 1965 to assess existing transport facilities in Kolkata, Mumbai, Chennai and Delhi, and to recommend phased programmes for development

of transport facilities.

The results of this study team had finally been taken up for implementation. Sreedharan, having already been involved with the Kolkata MTP on an earlier posting, now got involved with Chennai MTP too. Later, post-retirement, he would move to Delhi to set up the metro there. So, with the exception of the Mumbai metro, he has been involved with all of the Railways' MTP projects.

MUMBAI, THE VASHI BRIDGE, AND RETIREMENT

In 1986, Sreedharan was once again promoted and transferred to Central Railway (Mumbai), as Chief Administrative Officer (Construction) where he was initially reluctant to go, but where he eventually moved to. He recalled:

> Khanna, then GM Central Railway (Mumbai), was promoted as Railway Board Member (Staff) and I handled additional charge as GM for three months till the new GM, Vijay Singh took over. In fact, after Singh took over, he met with a small accident that put him out of action and I had to hold the charge as Central Railway GM again for another three months.
>
> When I was at the Central Railway as Chief Administrative Officer (Construction) in-charge of projects, I undertook a review of the projects. I found no development on the construction of a railway bridge at Vashi, which was part of the Mankhurd–Belapur Railway Project. When I took up this issue with City and Industrial Development Corporation of Maharashtra (CIDCO), the

local development body along with which Indian Railways was doing the project, I was told by CIDCO that it had already deposited the required money with the Railways and that work had not begun despite that.

The Mankhurd–Belapur Project was very crucial to the city of Mumbai. New Bombay (Navi Mumbai), a planned township had been mooted in 1971 by the Government of Maharashtra. To give this new township connectivity with the existing suburban railway network was important. This bridge at Vashi would have offered that much-needed connectivity. To give a push to the project, I called a meeting of all the stakeholders. At the meeting, officials of CIDCO, Central Railway, the team from the construction company Afcons, and the German consultants involved—were all present.

'You are a very rich country, it seems,' said the German consultants to me. When I asked them how, they said 'Only a rich country like yours can afford to delay the project by so many days.' This taunt hit me hard as the project had indeed been delayed despite all approvals and money to start the project. Working with the team, I ensured that I kick-started the project and though later transferred to Western Railway, I kept an eye on it.

This is how Mumbai finally got its rail link to Navi Mumbai, from drawing paper into reality. The Mumbai VT–Belapur Railway Project expanded the city's horizons. The rail bridge today remains one of the most crucial links with Navi Mumbai for millions of commuters. Sreedharan added:

From here I moved on to the Western Railways as GM. During my tenure in there the key things that I would say were done was a focus on punctuality of trains, and the taking up of a number of electrification projects.

Indian Railway Archives state that for the years that Sreedharan was GM, a beginning was made in the use of fibre-optic cables between Churchgate and Virar, at a cost of ₹10.3 crore, and on the first Auxiliary Warning System (AWS)—a system that enables a suburban train to automatically come to a halt in case it crosses a red signal.[16] However, according to Sreedharan, 'Fibre-optic cables were really tried in a big way by us during the Konkan Railway Project. That was a real breakthrough.' Undisputedly, both, the Konkan Railway Project and the AWS today are the safety backbone of suburban railway networks on Indian Railways.

In July 1989, Sreedharan was elevated to the post of Member Engineering, Railway Board & Ex-officio Secretary to the Government of India during the tenure of Railway Minister Madhavrao Scindia. The Railway Board is the highest decision-making body, which approves all the policies and projects pertaining to Indian Railways and Sreedharan was Railway Board Member (Engineering).

The Engineering Department of Indian Railways is responsible for maintenance of all fixed assets such as tracks, bridges, buildings, roads, and water-supply, in addition to construction of new assets such as new lines, gauge conversion, doubling and other expansion and developmental works. Major policy decisions of the Engineering Department are taken by the Railway Board under supervision of Member Engineering

who is assisted by Additional Member (Civil Engineering) and Additional Member (Works) and Advisor (Land & Amenities). Sreedharan recalled:

> There was one bold decision that I had taken, which was generating a lot of discussion. As Member Engineering I decided to discontinue the use of CST-9 or cast-iron sleepers on Indian Railway tracks, as they were a nuisance on the tracks.[17] My decision was purely based on merit, as cast-iron sleepers were technically proving to be unfit and we had decided to upgrade to concrete sleepers, which would improve the overall quality and life of rails. After I took the decision, all hell broke loose. There were many attempts to convince me to undo it. Many of my deputies, officers tried to tell me that there were tenders in waiting. CST-9 was a big industry based in West Bengal and that there would be immense losses and that I should reverse the decision. I stood firm.
>
> The matter went up to Railway Minister George Fernandes and he called me to ask what the matter was. He too said that it was wrong and I was depriving the livelihood of so many people. I explained to him that the decision was purely based on merit and it would improve the quality and life of rails and riding quality of trains. He heard me out patiently and said technically if I felt what was being done was correct, to please go ahead. Such a gentleman was he that he refused to interfere.
>
> During the period, I distinctly remember one Saturday when I had finished work, returned to the railway rest house where I was staying and just eaten lunch. A

servant came up to me and told me that a gentleman wanted to see me and I met him in the visitors' room. The gentleman was standing with a suitcase and he said he had come from the industry. I immediately knew, which industry and what was in that suitcase. In those days, there were scandals, with suitcases being exchanged by ministers. I got so angry that I started shouting at him. My wife Radha came running from inside to see what had happened. Even she got frightened. By that time, I had shouted the gentleman out of my house. This proved to be the death knell for CST-9 sleepers on Indian Railways.

A year later, Sreedharan was put in charge of planning and implementation of Konkan Railway by George Fernandes. However, Sreedharan had officially retired from the Indian Railways after thirty-six years of service in June 1990. He was nevertheless asked to take over the Konkan Railway Corporation as its CMD.

Four

POST-RETIREMENT MARVELS

The Konkan Railway Project

THE HISTORY BEHIND THE RAILWAY

John Chapman, the founder of the Great Indian Peninsula Railway, had described in his 412-page report in 1851, the onerous and difficult terrain of what was then known as the 'Great Western Ghauts'. An extract:

> The Syadree range, better known as the Great Western Ghauts, runs north and south, at distances varying from 30 to 60 miles from the western coast of India. The eastern side is higher by 1,500 or 2,000 feet than the western. The low country, to the westward, bears immense mountain blocks and some ranges, while smaller hills, encumbered with jungle, and taking almost every direction, break up the surface into intricacies of every kind.[18]

India's first ever passenger rail lines opened 162 years ago in 1853, a British enterprise, built for British benefit, by the best

British engineers and mostly of British material that came in ships across the seas.

Called majestically the Great Indian Peninsula Railway, the construction and opening of the first railway in India was a world event when the first passenger train in the subcontinent actually ran between the 34-km (21 miles) stretch of Mumbai and Thane on 16 April 1853. British rail engineers were praised in journals and newspapers for how a line was built in a tropical country abounding with snakes and wild animals, with embankments built over difficult stretches, and tunnels to cut through mountains.

Beyond the comparatively simpler 34-km stretch to Thane, lay very difficult terrain—the Western Ghats (or 'Ghauts' as Chapman referred to them)—where rail lines would have to cross the Sahyadri mountain range into the interiors of the country. The alignment of the lines had been selected carefully and the risk of running trains with passengers safely was considered high.

Thousands were killed and maimed during the construction itself due to accidents, illness and dangerous and difficult working conditions. And once built, the lines had to be sustained with equal amount of attention with meticulous effort, more so after the monsoon season when small streams turned into waterfalls and landslides.

The popularity of the first lines can be gauged from the fact that while just a 21-mile railway was opened to public in 1853, in a period of ten years by 1863 about 2,507 miles of lines were ready, with about a 1,000 miles more under construction.[19]

The network of the steel rails kept growing north, south, east and west, but somehow the western coast of India remained

disconnected. The terrain remained difficult with the vast Arabian Sea on one side and the mountains on the other.

Records at the Maharashtra state archives suggest that it was first in 1866, 13 years after the country's first train run, that an idea to build a railway along those Western Ghats in the Konkan was first proposed. The 1866 survey proposed a line from Hog Island, an island in the Arabian Sea east of the Elephanta Caves, to Khopoli. The line was taken via the Chowk, Panvel Valley with an alternative line from Khopoli via Apta Valley. It never materialized then, but was revived in 1882. [20]

Commissioner of Customs (Opium and Akbari), C.B. Pritchard, in April 1882 suggested construction of a cheap light branch line from Parsik Point on the GIP Railway to Panvel and Pen to dispatch salt. He was backed by the GIP Railway stating that such a line would be of considerable value with the railways' Acting Chief Engineer, discussing the pros and cons of two routes: the first from Parsik Point to Panvel and Pen, and the second the Khopoli branch to Panvel and Pen. About the same time, the government had received a request from the Nawab and Sardars of Janjira for improved communication with Mumbai, for which the government had proposed a mail steamer service.

The correspondence was picked up by Acting Assistant Collector of Kolaba W.F. Sinclair, and examined in detail offering full support, writing a detailed letter from Camp Khandad in January 1883. Complaining of bad communication in the Konkan District south of Mumbai, Sinclair led this proposal writing a series of detailed letters, suggesting construction of a Railway from Mumbra or Kalyan to Mahad and perhaps further on.

The proposal further moved ahead with the Commissioner,

Northern Division, stating in February 1883 which he referred to as the 'Southern Konkan Railway' had already been included among the routes of railways suitable for construction under famine relief work. But he added that the rainfall in the Konkan region seldom failed so famine on a large scale was not anticipated. Therefore, he asked the Collector's office to have statistics of the existing traffic prepared to make a good case for a railway line.

The Commissioner of Customs (Opium and Akbari), Pritchard, strongly supported the proposal in the interest of traffic of native passengers and transport of salt, because communication by sea between southern Konkan and Mumbai was cut off entirely during the monsoon.

The first hurdle to the scheme came from H.F. Hancock, Joint Secretary Public Works Department of the Government of Bombay, who was controlling authority of the GIP Railway. He, in a letter in April 1883, pointed out that the scheme was unproductive and called it absurd, and rebuked Acting Assistant Collector of Kolaba Sinclair for his proposal.

But 10 days later, the Governor-in-Council, backed the proposal stating that the proposed line (from the nearest convenient point on the GIP Railway to the last point of the Thane creek to Panvel, Pen, Nagothana and thence to Mahad) would indeed create traffic, suggesting collection of correct statistics of goods traffic on the proposed line based on: the full collections on the Fitzgerald Ghat and other roads leading to Mahad; information to be gained from the local authorities and merchants at Mahad, Dasgaon, Mangaon, Indapur, Nagothana and other coastal towns; and returns furnished from the coast salt works.

He further proposed that the Agent of the GIP Railway be requested to depute one of his engineers to ride along the proposed line of railway and submit a report on the subject. He also assured that he would consider the question of a grant of ₹10,000 to meet the cost of a more detailed and extensive survey, on receipt of the report.

As suggested, the Revenue Department forwarded statements showing the import and export traffic by sea and land at the ports of Mahad, Nagothana and Pen. But then the matter was left pending again, guess why? A letter from the Public Works Department (Railways) tells us the GIP Railway could not spare an engineer and that the survey would be conducted by a (new) government establishment which was yet to be organized. The papers were found recorded with such remarks on 16 February 1884.

That same year, the governing body of the local coastal township of Pen adopted a resolution demanding a train service for better communication with Kasu and Nagothana stations. But things did not move much. There were more proposals and surveys in 1890s, and then in the 1920s, but steamers leaving from various ports in Konkan region remained the main source of transportation to Mumbai, which remained inaccessible during the four-month-long monsoon. A steamer called *Ramdas* that sunk off Mumbai harbour in July 1947, perhaps woke up the government as it led to construction of fair weather roads and the National Highway 17. But the topography, narrow roads, curves and inclines ensured the journey was a difficult one.[21] Down south, the railway lines had reached Mangalore as the mainline terminus from Chennai via Shoranur as early as 1907.

The efforts of late chief draftsman of the Bombay Baroda

and Central India Railway (presently Western Railway) Arjun Balwant Walawalkar, to build a railway line in Konkan, are laudable. Considered to be one of the pioneers of the Konkan Railway Project, Walawalkar who had joined the Railways in 1922, was the one who originally took up extensive tours in the Konkan region and drew up a detailed proposal in 1952, publishing a booklet—*Konkan Railway Project*. He wrote a number of articles, organized conferences, seminars and exhibitions, called on the successive Railway Ministers and Chief Ministers of the concerned states. Even public ridicule and criticism did not deter him from his dream project. But he passed away in December 1970 before any formal plan could materialize.

Local representatives of Parliament and politicians took it up from there, with Rajapur MP, Barrister Nath Pai, pushing for the Indian West Coast Railway in the Parliament. T. Panampilli Govinda Menon, who was the Railway Minister from 1969–70 suggested the idea of extending it southwards for what he called the 'Western Coastal Railway'. The Ministry of Railways had taken up the proposal, commenced work and opened the Diva–Panvel line in 1966 (for freight on 31 January, and for passenger trains on 9 April), taking it further by 80km till Roha (opened in May 1986) in the next 20 years, as Prof. Madhu Dandavate, Minister of Railways from 1977–79.

The Central Railway had completed one cursory survey till Mangalore between 1971 and 1973 and another in-depth one between Dasgaon and Ratnagiri between 1975 and 1977, but it was in October 1984 that the Railway Ministry authorized the final location engineering-sum-traffic survey for the West Coast Line, linking Roha on Central Railway with Mangalore on Southern Railway. Mangalore already had a broad-gauge line

linking Cochin down south, since 1907. Southern Railway was entrusted with carrying out an in-depth survey for this and in March 1985, it was decided to extend the line over the entire stretch of the West Coast till Roha, where it would connect with the existing line to Mumbai. The final survey report was completed in 1988.

On 2 December 1989, George Mathew Fernandes took charge as Railway Minister. Hailing from Udupi on the Konkan coast, he had a passionate desire to see the Konkan Railway Project through. The Konkan Railway link was one among the first two projects that he was keen to complete, the other being the Chithoni-Bogha link in Bihar crossing the formidable Gandak River. He had discussed both these projects in his first meeting with Railway Board Members in December 1989. As Member Engineering, Sreedharan should have been present, but he was away on a 10-day leave. He heard about the Minister's determination to accomplish them on his return.

When he paid a courtesy call, the Minister mentioned about his two pet railway projects—the West Coast railway connecting Mumbai to Mangalore and a railway link between Chithoni and Bogha in Bihar crossing the mighty Gandak River. Fernandes said he would like these projects to be given the highest priority and said to Sreedharan, 'As Member (Engineering), I will depend upon you for realizing these two projects.'[22]

Years later, popular television presenter Chris Tarrant, who takes epic and treacherous train journeys across the world for his TV series *Extreme Railways*, had this to say about India's Konkan Railway:

In the days of the Raj, the British built railways all

over India, except in the flooded wild land between the mountains and the sea, so India's west coast became increasingly isolated.

A hundred years after the British gave up, some enterprising young Indians built a line themselves. They needed not only 2,000 bridges and 93 tunnels, but permission from the owner of every parcel of land they passed through—42,000 signatures in all. There were accidents, avalanches and derailments. Many died of malaria and snakebite... The 'enterprising young Indians' that Tarrant mentioned were led by E. Sreedharan. This is the story of how he managed to fill in the 760-km long (472 miles) crucial missing link in the subcontinent's railway network, using his own methods and work culture. The impossible task was finished in just seven years, overcoming difficulties and challenges.

Sreedharan recalled meeting the Railway Minister a day or two after the second meeting:

> I checked up the records and the first project that he mentioned at Chithoni was an already sanctioned project, but languishing very badly for want of funds. It was a joint project between the Railways, the state governments of Uttar Pradesh and Bihar, and the Ministry of Water Resources. All four agencies were required to contribute funds for the success of this project. But money was not forthcoming.
>
> Sreedharan put forward this point to the Minister and told him, 'If you really want to go ahead with this project, you must get the cooperation of the two governments fast and they should pay their share of the project cost.' Fernandes saw the point. Sreedharan said, 'In my presence,

he called up then Uttar Pradesh Chief Minister Mulayam Singh Yadav and Bihar Chief Minister Laloo Yadav, getting an immediate assurance from them.'

Political will was in place, now it was just a question of how to get it done and Sreedharan had shown the way. Things went ahead as planned and the date to lay the foundation stone for the Chithnoi–Bogha Project was fixed as 7 January 1990. The Minister's first dream project was getting built, but to make it really practical and useful for the local citizens something more needed to be done. The project would have just built a rail bridge to ferry a few trains back and forth, but Sreedharan thought that it would not be really useful to the locals unless they could use it too at all times to go back and forth, by foot if needed.

A day before the foundation stone was laid, George Fernandes and he flew down by a special state plane to Lucknow that was sent by the Chief Minister to fetch them. While Fernandes stayed at Raj Bhavan, Sreedharan was at the Railway Officers' Rest House. Sreedharan could not rest that night as he somehow had to convey his thoughts to the Minister about the project and early next morning rang up Fernandes, telling him, 'Before we proceed to the function site for inauguration, I would like to have 15 to 20 minutes with you for discussing certain important issues.' Fernandes agreed and met him over breakfast. Sreedharan recalled the meeting:

> I met him about 7.00 a.m. and said today one of your dreams is going to be fulfilled. The Chithoni railway link is really a bridge across the Gandak River. At this bridge location, Gandak River is as wide as 8km between the

two flood banks. The river used to meander every year causing a lot of destruction to the fields and to adjoining areas. With great difficulty we have been able to make a start on this project. But a railway bridge alone across the river is not going to give much benefit to the local people. A few trains will run only occasionally and most of them will be freight trains.

This is one of the most backward areas in the country and all the villages around are very poor. Unless you make this a road-cum-rail bridge, it is not going to be of any use to the local people. In any case, this river, which is about 8-km wide at this location, we are training it for the railway bridge, narrowing it to almost 800m. With a marginally extra cost, we can make this a road-cum-railway bridge, provided the state governments agree to fund the additional cost involved. This way people would be able to use it all the time.

The idea appealed immensely to Fernandes who managed to get the consent of both Chief Ministers for additional funding before the function began. The project took off and not only was the Minister's dream achieved, but was also made practical enough for citizens to enjoy it for generations.

The Minister's dream meant that there was politcal will, and Sreedharan's expertise and foresight—on behalf of those not as richly blessed as he was—ensured that politcal will was converted into a multipurpose railway project. The bridge was completed 11 weeks ahead of schedule[23] and proved to be helpful to one and all.

THE KONKAN RAILWAY TAKES SHAPE

Fernandes' first dream project was done and he was thankful to Sreedharan for his practical and implemenatable ideas, and relied on him more now. The Minister's focus was now on the Konkan Railway Project, the bigger challenge. Sreedharan told him that he had a two-pronged strategy to get the project off the ground:

> At that morning meeting I mentioned to him [that] your first dream has come true. The next project, that is the West Coast Project—at that time, the word 'Konkan Railway' was not coined; we used to refer to it only as the West Coast railway line—if that project is to be done, it cannot be done in the normal course. You are aware that normally all new railway lines in the country are constructed with budgetary support. Generally, the Planning Commission allocates about ₹250–300 crore (2,500–3,000 million) every year for new-line projects.
>
> There are already about 20–25 new railway-line projects sanctioned in the Railway kitty, due to which each line will get hardly ₹4–5 crore (40–50 million) as allocation. At this rate, if the Konkan Railway is to be constructed, it would take anything from 25 to 30 years. If the project is to be completed in a time-bound manner, we have to follow an entirely different approach. One is a very bold and innovative funding approach, and the other is a special purpose vehicle to be formed; a special corporation or a special authority to raise funds for executing this project.

Forming a special body was not a problem, but funding was and Fernandes wanted to know how to realistically garner funds.

Sreedharan said he had a lot of ideas. He said it was a highly viable project, financially very attractive, because it reduced the distance and time between Mumbai and Mangalore considerably. Once the project was complete, the railway distance between Mumbai and Mangalore would be cut by 1,127km—from 204km to 914km, saving 26 hours of journey time. And, he pointed out:

> Because of this tremendous advantage, it should not be difficult to raise money from the market. The special body should be a joint sector company, with a majority share with the Railway Ministry of 51 per cent and the remaining 49 per cent share to be taken by the four beneficiary states of Maharashtra, Goa, Karnataka and Kerala and money could be raised from the market.

Well, Sreedhaan had nailed it. It suddenly seemed like the fog shrouding the method of implemenation and completion of this ambitious project had been lifted. There was after all a way to do it. The political will was in place and now all that was left was the question of turning it into reality. Sreedharan said:

> The concept appealed to Fernandes so much that he said he would immediately take this matter to the Prime Minister, to the Planning Commission and to the Finance Minister and get their clearance. He promised to get back to me within about 48 hours. Precisely, within 48 hours after he got back to Delhi, he summoned me to his chamber and said, 'Today I met the Deputy Chairman of the Planning Commission. They have together gone to the Prime Minister and recieved verbal clearance for the whole Project.'[24]

Dr Bimal Jalan, then Chief Economic Adviser gave shape to the idea and suggested that Fernandes float a corporation under the Companies Act. The corporation could be under the administrative control of the Railway Ministry, the states of Maharashtra, Goa, Karnataka and Kerala, being beneficiaries could jointly contribute to its equity, and the corporation could arrange the remaining funds by raising loans through the issue of tax-free bonds.

Sreedharan said he was stumped when Fernandes told him, 'The Government has in principle agreed to take up the Konkan Railway project the way you have suggested. Please start working on the details and come up with all the other details needed for this project.' The project then became a challenge for him. The first task, in order of priority, was to get the support of the beneficiary state governments.

Fernandes initially thought it would be easy, and indeed Maharashtra Chief Minister Sharad Pawar—though belonging to the opposition Congress Party (with the Janata Dal government at the centre)—readily agreed to support the project. Goa Chief Minister Luis Proto Barbosa was part of the party that ruled at the centre, and also readily agreed. Two states were in the kitty, but the other two—Karnataka and Kerala—proved to be a political problem. Things were not moving and Fernandes looked at Sreedharan for an answer, who said, 'I told Fernandes let us not tackle the state governments of Karnataka and Kerala at the political level, please leave it to me. I would like to take it up at the bureaucratic level.' Fernandes agreed and Sreedharan took on Karnataka first and flew to Bengaluru. He recalled:

I met the Chief Secretary and Transport Secretary, put across to them the idea of Konkan Railway, advantages of the scheme that could be realized with their minimal financial participation and managed to crack them. They saw the merit of the scheme and together went up [to] their Chief Minister and managed to convinced him. Ultimately, I got the nod from Chief Minister Virendra Patil.

Kerala was the last to fall in line. Sreedharan took a similar trip to Thiruvananthapuram and convinced the bureaucrats first— the Chief Secretary and the Transport Secretary. Then together they went up to Chief Minister E.K. Nayanar, explained the project to him and made him realize the immense benefit that would flow to the state with minimal financial participation, and thus, convinced him. Sreedharan recalled:

Mind you, the Konkan Railway does not go into Kerala at all. It stops short of it, but Nayanar realized the immense benefit that would flow to the state and he readily agreed. He was the first Chief Minister who gave in writing, 'Yes, we will participate in the Konkan Railway project.'

Nayanar had been supportive of Sreedharan since the latter's Cochin Shipyard days. Sreedharan further recalled:

Getting all states on board was a big challenge, but we managed it. A lot of formalities had to be gone through, once all the states had agreed. I called a meeting of all the Chief Secretaries at Mumbai, where we worked out the modalities of the agreement to be signed between the state governments and the Railway Ministry. Everything

was finalized. I am happy that at that time Maharashtra Chief Secretary D.M. Sukhtankar was very positive and constructive. He played a major role in finally resolving the conflicting issues.

Meanwhile, Fernandes issued instructions to all directorates of Indian Railways to spare no effort to ensure the completion of this important project within a period of four years. He sent a note signed 14 July 1990 that read:

> All directorates in the Ministry may be specially instructed to note the target date and ensure papers concerning the Konkan Railway are dealt with most expeditiously. At no stage the delay should be more than 24 hours in any department. If need be, files should be marked prominently 'KONKAN RAILWAY IMMEDIATE'. The Railways should be instructed to render all-out help and assistance to Konkan Railway Coporation for speedy execution of the Project. I shall view avoidable delays and negative approach at any level very seriously. [25]

As things moved rapidly, the Planning Commission too gave its clearance and on 19 June 1990, the four Chief Ministers and Railway Minister Fernandes, in the presence of Chief Secretaries and Railway Board Members, assembled at Karnataka Bhavan to sign the historic agreement taking up the Konkan Railway as a joint sector project.

But there was a problem. In 11 more days, on 30 June 1990, Sreedharan—the driving force behind the Konkan Railway Project, who had cut through all the red tape this far and put it on the fast track—was to retire after 36 years of service

from Indian Railways. How the Konkan Railway Project was to move ahead from here, was the question. It required innovative ways and dedication to proceed. Which other officer would fit into Sreedharan's shoes and continue his legacy of laying the foundation innovatively and, thereafter, personally monitoring developments? According to Sreedharan:

> A week before my retirement, Fernandes made a statement to the Press at Chennai that I would head Konkan Railway Corporation Ltd. (KRCL) as Chairman-cum-Managing Director (CMD). I was taken by surprise as he had not consulted me before making the statement. He then called me and said, 'You are retiring. But, I would like you to take up the project and complete it, I told him I had no hesitation about doing so, provided I was given a near blank cheque to organize the project and execute it. I did not want interference, either from politicians or from bureaucrats. He said, 'Here is the blank cheque for you, please go ahead.'

Even before Sreedharan's retirement, and much before he was selected by the Public Enterprises Selection Board and appointed by the Appointments Committee of the Cabinet, Fernandes announced that E. Sreedharan would be heading KRCL. And up to the point that Sreedharan was formally declared appointed as KRCL CMD, Fernandes had appointed him as Chairman of a one-man committee to take all the preliminary steps required for organizing the project.

WORK BEGINS

Konkan Railway Corporation Limited (KRCL) was registered formally as a company on 19 July 1990 and work—managed by Central Railway in the Northern sector up to Panaji and by Southern Railway up to Udupi—was transferred to the Corporation on 15 October 1990. Sreedharan took charge as CMD on 30 October 1990.

This, in fact, was the same day that BJP leader Lal Krishna Advani's controversial 'rath yatra' was supposed to reach the violently disputed mosque/temple site at Ayodhya. The procession was blocked by the National Front Government led by Prime Minister V.P. Singh and this led to the BJP's suspension of support to the National Front Government. Within a week or so, the government collapsed.

George Fernandes was no longer Railway Minister and there was political uncertainty in the country. But the idea of Konkan Railway had been insulated from the political turmoil. It had been set in motion with all the legalities and framework in place. The project was scheduled to be completed in seven years. The subsequent target of five years was even tighter—considering the fact that long tunnels had to be dug (total tunnelling was over 80km, and 20km of bridges had to also be built at various points. It had been decided to launch the project in phases from either end progressively, so as to get rid of as much load on the central part as possible. Also working in phases would provide the Commissioner of Safety much-needed experience in handling safety inspections on such unique terrain. This was a unique project and nobody was taking any chances with safety.

The task was formidable. With 1,880 bridges and 91 tunnels

to be built through forested hilly terrain containing many rivers, the project was the biggest and perhaps most difficult railway undertaking of the twentieth century, at least in this part of the world. And Sreedharan and his team had yet to get a first-hand experience of the kind of terrain they would have to battle. He explained:

> Before we take up any railway project, it is a practice to carry out the final location survey, locate the railway alignment on the ground, estimate the project cost very precisely and estimate all the technical problems involved. I started almost from scratch with the surveys, the final location, then administrative arrangements for the lands to be acquired, geo-technical investigations, hydraulic investigations of the rivers, location of the tunnels, location of the bridges, all these have to be gone through. All the work was put in motion at the same time.
>
> In fact during the survey of the lines, we upgraded the technical standards of the line and in the process reduced the length from 837km to 762km, a saving of 75km. [26] We had stiff targets. The Railway Minister had announced in Parliament that the Project would be completed in five years. This meant that preliminary surveys had to be conducted, land acquired, so many tunnels and so many bridges constructed—a lot of things had to be done in five years.
>
> In the 36 years of my professional life in the Railways, I had very many ideas, which I could not put into practice, merely because of the steel frame of governmental working and strict procedures to be followed. I thought, here was

an opportunity where all my ideas—how a project is to be organized, how a project could be executed, how a modern type of railway line could be brought in—could be tried out for the first time.

The first thing that Sreedharan did was to build an organization that differed from the existing railway set-up:

We brought in an almost paperless type of functioning. The whole work of the administration was on the basis of trust. Powers were delegated on the basis of trust, mutual trust. I made it sure that the background of anyone who joined the organization, would be gone into thoroughly and only persons with impeccable integrity were brought in. If there was any doubt about a person's character, they would not be part of our organization. They were all hand-picked and brought in. That is how it was a very small team, but it functioned extremely well.

It was also a lean and effective team, and officers were selected from Sreedharan's network of trusted team members. At the peak of the construction period, there were no more than 2,400 personnel, starting from the lowest rung to the CMD. The staff consisted of hand-picked and trusted, working or just-retired officials from Indian Railways. They concentrated only on core areas of safety, guidance, management, payment to contractors and that sort of thing. The rest of it, small things could be done by others so that the core team's focus remained undisturbed. The 760km railway line would pass through three states and seven revenue districts. According to Sreedharan:

We decided that the whole line would be divided into seven zones, each zone almost concurrent with a revenue district, and a Chief Engineer was posted for each zone. The jurisdiction of the Chief Engineer was something like 100 to 120km. My philosophy was that a railway line of about 100 to 120km could easily be completed in five years time. That has been our practice. If each Chief Engineer can do his portion in five years time, the whole project would be ready in five years.

The reason why Sreedharan wanted a Chief Engineer for each revenue district was that it would be very easy for him to deal with the Collector, and Superintendent of Police concerned, because everything was within his reach and that worked wonderfully well. This was the first time that the Railways had given up its bureaucratic structure for a project and assimilated with the state government's bureaucratic structure so that decisions could be taken faster and work could move on speedily. In addition to this, there was ample delegation. Delegation of powers to the Chief Engineer and below meant they did not depend on the corporate office for day-to-day decisions. This gave them freedom, but with responsibility.

Chief Engineer of Goa, Bojji Rajaram, took another innovative step to speed things up. He recruited some four hundred young engineers and ordered several Kawasaki bikes, modified to carry equipment such as levelling instruments. These young engineers were given ₹100 per day and petrol, neither of which they had to account for, so long as they produced a certain amount of work every day. Of course the targets that were set resulted in a 14-hour day. But they felt

empowered, and so they gave their best. It helped that despite their inexperience, they were given the official designation of an Engineer, a title they could flaunt with pride.

Rajaram's smaller core team took satellite images, made topographical maps with high accuracy, and sent out survey teams on motorcycles. Thirty such teams in Goa worked on 16 different alignments and data was analysed, often way past midnight, on an assembled computer that Rajaram had bought in Bangalore. This approach meant that survey work was done at 10 per cent of the cost that it would have normally involved.[27] Rajaram recalled, 'We managed to complete the project within seven years, as we made the responsibility and authority centre the same. Empowering at executive level with a high degree of trust both in engineer and contractor, with transparency, is always important.'[28] Bojji Rajaram later went on to invent the Skybus, an anti-collison device technology and subsequently became the Managing Director of Konkan Railway.

Meanwhile, Sreedharan focused on establishing an excellent communication network. It was a very difficult terrain and communication was quite difficult. To reach Ratnagiri from Mumbai took hours. The KRCL hired DOT lines and then established a good communication network with the headquarters of each of the Chief Engineers. They were all given fax machines and computers. Computer networking ensured that everybody could access any information from anywhere and any message could be passed on in no time. So, the communication problem was sorted out right at the beginning, which resulted in quick decision-making and prevented stalling of work. Sreedharan explained:

We were constructing a railway line for the next hundred years. So we planned it as a modern line, a high-speed route. We decided to have at least a minimal speed potential of 160km per hour. I said, the line itself should be capable of carrying trains at 160km per hour. In those days, there were no engines or coaches, which could run at that speed. But the country would definitely progress and the day would come when we would manufacture high-speed engines and high-speed coaches. So, the lines should be planned and constructed for a minimum speed of 160km. This was the first decision we took.

The organization had to aquire land from some 40,000-plus landowners. This was one of the most difficult tasks, as enormous difficulties were involved in acquiring land. The Railway Minister had announced a five-year target. Sreedharan adopted an entirely new strategy by selling the project idea to the people of the area and getting them on Konkan Railway's side. Then, if there were difficulties for landowners, the KRCL team saw to it that these were immediately redressed. Sreedharan said:

In many cases, we had to demolish houses. We requested owners to hand over the house and move into any other house they wanted. We said we would pay the rent for that house for the next one year, or one-and-a-half years, until a new house had been built with the compensation we gave. We also told them that they could dismantle their own house and retrieve whatever they could for the construction of the new house. This practical approach clicked and within eight or nine months, the entire land required for the project was in KRCL's possession.

I feel that this was a very mighty achievement. Local officials also provided immense assistance in acquiring land. Coincidentally, Ganesh Walawalkar—son of Arjun Balwant Walawalkar, who had once made his life mission to build a railway in the Konkan region—was then the Collector at Alibaug and helped us acquire land between Roha and Natuwadi. KRCL engineers personally visited each house to see if there was any way it could be saved. In many cases, we found a way out. That's why Goa has the maximum number of curves on the alignment. Even the Mandovi bridge is on a curve. As a result of this careful appraisal, only 35 houses were disturbed in Goa where the population density was highest. And faced with the pressure from local residents, the Konkan Railway team found its engineering skills sharpened.

Then, to get this project completed in five years' time, I thought that a very dynamic and transparent style of project management was necessary. The essence of this was that everybody should know what they were expected to do, what their deadlines were, and how much time was available for each task. So, we laid down a three-point Corporate Mission, which clearly defined what exactly was expected of the Corporation. I laid down ten aspects of Corporate Culture needed to achieve the Mission. So, everybody had the same work ethos, same approach and same Mission.

Given below are the three-point Corporate Mission and the ten aspects of Corporate Culture, laid down by Sreedharan as necessary for finishing the project on time and in a thorough fashion.

KRCL'S CORPORATE MISSION:

- To complete the Konkan Railway project by October 1994.
- The Project to be completed without cost overruns (except for annual inflations).
- To make it a model project with high technical standards and quality of construction.

KRCL'S CORPORATE CULTURE:

- Total dedication and commitment to the corporate mission should be evident in whatever we do and say.
- Integrity of our officers and staff should never be in question.
- Punctuality is a virtue and a necessity. Target and time schedules are sacrosanct to us.
- Austerity and economy should be apparent in all our activities.
- The organization has to be lean but effective.
- We must have a high-profile image for efficiency, decency and a 'we mean business' approach.
- We must maintain excellent public relations. Our construction activities should not inconvenience the public.
- All our structures should aesthetically merge with the beautiful Konkan surroundings.
- Our construction activities should not degrade the ecology and the environment.
- The welfare of the workforce is our responsibility.

The means used were novel, Sreedharan said:

We made everybody time conscious. The time available

for the completion of the project was exhibited in every office, in the form of a countdown clock. Every office had one of these and each day the clock came down by one day. Everybody was on their toes, be it the contractors, executives or workers. A similar clock, I am later told, was followed in the Delhi Metro Project also.

A change in the way the Finance Department was handled was another crucial step. If any government organization wants high-tech equipment and the best stuff in the market, the major challenge it has to face is interrogation by the Finance Department. The KRCL overrode this aspect by redesigning the role of the Finance Department. According to Sreedharan:

> If you have been associated with the Railways, or have worked in the Railways, you would know that Finance has a very major grip on every decision taken, which naturally delays the decision processes. Finance has control over everything but does not have the responsibility for results. I said that this would not work. Finance would only give advice. The Executive would have the power to either accept the advice or go beyond the advice. That power was given to the Executive and the system worked excellently. We had taken on some very enterprising and smart finance officers from the Railways. They fine-tuned the system so well that there was no difficulty in any department functioning properly and I never saw a clash between a finance officer and the Executive at any stage of Project implementation. So, this sort of congenial atmosphere was brought in.

Konkan Railway was one of the country's first government organizations to bring in a number of front-line technologies during its construction, and also for regular use in operation of a railway system—technologies that are quite common now. They brought in technology for tracks that were fit for 160kmph train runs, the incremental launch technology to build bridges, use of welded steel triangular girders for bridges over water bodies, ventilation technology in tunnels (Konkan Railway has long tunnels, including one that is 6.5-km-long) and ballastless track[29] in tunnels. Sreedharan explained:

> The main technology was to cater to the high-speed route of 160km per hour. The other was incremental bridge launching technique, which we brought into the country for the first time to cross a very deep viaduct. The highest viaduct on this project had 68m high piers, just 4m short of the Qutub Minar. Such tall piers cannot be supported from the bottom of the bridge. In this method the whole bridge is built from the bank and pushed forward to the full length. We later adopted the same technology for constructing the Delhi Metro Bridge near the Inter-State Bus Terminus (ISBT).

About 11 to 12 per cent of the Konkan Railway passes through tunnels. It is difficult to maintain tracks inside tunnels so another innovative technolgy, ballastless track, was used as it requires no maintenance at all. Said Sreedharan:

> Our idea of using ballastless track inside tunnels was also a resounding success. Similarly, we went for high-speed turnouts which allowed by adopting a thicker web switch

that allowed a train to negotiate the turnout at 50km per hour, whereas the normal speed permitted in Indian Railways at that time was only 15km. So, high-speed operation was possible even on a turnout on our railway.

There are 8,000 bridges across the entire 760-km stretch of Konkan Railway, of which 179 are major bridges. The longest bridge in the section is more than 2km in length. Sreedharan said, 'We decided that all bridges should be built with a ballasted deck, so that maintenance of the permanent way could be done mechanically by tampers.'[30] So, all the bridges were designed with concrete decks, except for three spans in Goa—two across the Zuari River, and one across the Mandovi River—where navigation of ships had to be permitted. At these locations, the Konkan Railway went for steel girders, where a span of 125m was necessary. And for these steel girders too there were novel designs, explained Sreedharan:

For the first time in India, welded steel triangular girders were designed and installed. These girders have Neoprene bearings, again for the first time in India. Neoprene bearings had not been used for steel girders in India so far. This has a Teflon bearing surface where friction is highly reduced. So, a new type of bearing was designed by us and was put into practice.

Similar new technologies were used in rail welding to reduce vibration and noise:

The pressure gas welding that we adopted, needed import of special machines and we also had to get our people trained in Japan for this purpose. The advantage was pressure gas welding could be done at site itself, as in

such a difficult terrain, you cannot weld rails in advance, somewhere in a central welding workshop.

Another innovate step was the adoption of fibre-optic based telecommunication network, what was an entirely new area at that time for Indian Railways, 'There was a lot of opposition from Indian Railways,' Sreedharan recalled, 'though today it has become a common thing. But we persisted and that has been again a great success.' New technologies were also adopted in bridge foundations and tunnel ventilation systems. Sreedharan explained:

> There are at least four tunnels longer than 3km—one is 4.5km, another 5km, and the longest is 6.5km. What about ventilation inside these tunnels? When the train moves, the exhaust fumes from the diesel engine should not suffocate passengers. Tunnel ventilation was an entirely new field in this country. We sent our engineers to other countries and got the expertise, which is today being borrowed by many organizations, including Indian Railways. Today, apart from Delhi Metro Corporation, KRCL is the only organization in this country that has expertise in tunnel ventilation.

New technologies, planning, land acquisitions—all of this can be done, but the most difficult task always remains of getting the work done. Sreedharan realized early on that the contractors, who would handle many of the tasks the core team would not, were a very important part of the KRCL team. He said:

> A railway project is essentially a civil engineering job. So, many odd jobs were executed through contractors. We

realized right from the beginning that the success of the Konkan Railway would depend upon the success of its contractors. So, we brought in an environment in which we made the contractors succeed.

Contractors were all selected from a pre-qualified list and KRCL gave them very good terms and liberal advances as a contractor usually fails due to lack of adequate cash flow, or due to delay in decisions. It was made sure that any decision or plans needed by contractors were available on the spot, immediately, even if it means that the CMD had to rush to the site and give a decision. Sreedharan said:

> Yes, I was available at the site for any major decision. In a complex project like this, when work on so many tunnels was going on, when work on so many bridges was going on, so many decisions were required at every stage— particularly with regard to the tunnels. For instance, we would suddenly come across a difficult geological stratum and have to decide how to deal with that particular area. This way we could sort out the problem then and there, and not halt the progress of work. We gave an assurance to the contractors that any decision they sought would be given in 48 hours.

Tunnels were a critical part of the project. As a number of tunnels had to be completed in a short time, the project required quite a lot of hi-tech, high-speed tunnelling equipment. The Konkan Railway imported them and gave it free to their contractors, not even charging them for the hire. According to Sreedharan:

This helped. The contractor did not require to run from pillar to post to find out what sort of equipment was needed. We knew what was necessary and imported it from Sweden. Fortunately, we were able to get an interest-free loan from the Swedish Government. All the machinery was made available to the contractors even before they were on the field.

Another change that the Konkan Railways brought in was with regard to the billing and paying system for contractors, deviating from the normal railway system. The contractors had to prepare the bill and about 75 per cent of the payment was guaranteed within 48 hours and the balance amount within one week after a proper check had been conducted. Critical items where contractors usually get stuck—like the supply of cement, steel and different types of explosives (as there are very rigid laws on the transport or use of explosives)—were handled by KRCL, including setting up its own petrol pumps all along the line with the cost to be deducted from the contractors' next bill. Sreedharan noted:

This arrangement was very helpful to us when the Iraq–Kuwait War (Gulf War) started and the country went dry in petroleum products. It is not an exaggeration to say that Konkan Railway Project was the only one moving ahead at that time, as we had sufficient stock in our own outlets and the work did not suffer.

And finally to take stock of the project, Sreedharan started a novel experiment to keep everybody well informed. He elaborated:

Every Monday, we had a Heads of Department meeting, where all the problems connected with the whole Project were gone into. We analysed the slippage in the previous week and then decided what was required to be done in the week ahead. On the first Monday of the month, field engineers were also brought in. I insisted that no minutes be recorded as I believe it is a waste of time and paper. We knew what was happening every day and everybody was involved. This sort of very transparent and dynamic approach to problems helped considerably in completing the project on time.

In the beginning, everything was geared towards an October 1994 completion date, but the first two years saw immense difficulties in raising funds on tax-free bonds due to the stock market scam. There was also a severe agitation in Goa with demands for realignment of about 50km of the rail line. All this pushed the final target date to 31 March 1995. Soft soil tunnels caused more unexpected setbacks, and the date had to be further revised several times. Despite these problems, work went on at a frenetic pace due to well-chosen contractors and excellent equipment.

THE ORDER IN WHICH KONKAN RAILWAY LINES WERE COMPLETED

67km Mangalore–Udupi, 20 March 1993
48km Roha–Veer, 27 September 1993
33km Udupi–Kundapura, 5 April 1994
52km Veer–Khed, 25 September 1995

30km Khed–Chiplun, 23 February 1996

77km Chiplun–Ratnagiri, 16 November 1996

161km Ratnagiri–Sawantwadi, 20 January 1997

181km Kudapura–Canacona, 1 June 1996

32km Canacona–Madgaon, 5 August 1997

57km Pernem–Madgaon, 24 August 1997

22km Sawantwadi–Pernem, 26 January 1998

HURDLES AND CONTROVERSIES

Sreedharan cites three key reasons—the Goa controversy, the financial crisis due to the stock market scam, and the adverse geological conditions leading to tunneling delays. These pushed the deadline further by two years and the project was completed in about seven years' time. But considering the size of the project, the complexities involved and the difficult terrain through which it had to be built, completing this project was itself a great achievement, even by international standards.

GOA CONTROVERSY

Sreedharan elucidated on the controversy that arose with regard to Goa.

> When the project was in its second or third year, I do not exactly remember when, a decision came from the Central Government that all works in the Goa sector be stopped. There was a controversy and political interference in regard to alignment in the Goa sector. The Government of India did not want to ruffle the feathers of the ruling

party in Goa at the time. I was asked to stop the work and work was stopped for about nine months, which had a cascading effect. It had a terrible demoralizing effect on the rest of the project as well, among the contractors, managers, and the top management.

This particular decision of the government was most unwarranted. The decision was given only because of political compulsions at that time, not on technical reasons. Ultimately, the alignment question had to be referred to a one-man committee, under a retired Supreme Court Judge. This was a very clever thing the government did. The retired Judge arbitrated that whatever KRCL had decided, was the best alignment possible. Work started again only after he gave his report.

STOCK MARKET SCAM

The second cause of delay was finance and Sreedharan recalled that period:

The success of any project depends upon timely availability of funds. The government's contribution was not even one-third, but only one-fourth, by way of equity. Three-fourths of the project funds had to be raised in the market. The expectations were that we could raise the money from the internal market through bonds, either tax-free bonds or taxable bonds.

Unfortunately, that was a time when there was real convulsion in the capital market, following the Harshad Mehta scam. We were not able to raise money either

through taxable bonds or tax-free bonds. Even tax-free bonds had to be sold at a terrible discount at that time. 10 to 10.5 per cent taxable bonds had to be sold at a discount of 10 to 12 per cent to raise money, because that was the best rate available. This seriously affected the project.

Ultimately, we got clearance from the government to raise money abroad through the External Commerial Borrowings (ECB) route. We raised about ₹400 crore for the project and ultimately were able to tide over the crisis.

ADVERSE GEOLOGICAL CONDITIONS IN TUNNELS

The third factor that caused delay was the unexpected adverse geological conditions faced in some tunnels. According to Sreedharan:

> The project took off so fast that there was no time to undertake a detailed geo-technical investigation at every tunnel site. Even for one tunnel, investigations had to be undertaken at very close intervals between bore holes. For this there was no time. We encountered totally unexpected geology in certain areas, particularly in some of the tunnels in [the] Goa area. This also delayed the project. By 1997, about 650-plus km of the Konkan Railway had already opened and all that was remaining was the 111-km stretch between Sawantwadi and Canacona. The unexpected geology and soft soil in Pernem and Old Goa tunnels was leading to collapses and accidents as work went on.

The soil that in Sreedharan's words, 'became like toothpaste',

required innovative solutions. Slowly and steadily, the 544m long Old Goa tunnel could be completed by March 1997 but the 1,560m long Pernem tunnel was proving to be a challenge. Major collapses had taken place in August and again in October 1997 on the north face of Pernem tunnel, which caused a set back of about four months. Due to the frequent change of strata, the construction strategy had to be altered every time soft soil or hard rock was met. This tunnel delayed the commissioning of the Konkan Railway project by five months.[31] Overall, Sreedharan explained:

> While executing the project, naturally, I had to face very many problems, many hurdles, lot of frustrations, lots of interference, a lot of humiliation as well, and most of it from my own Minister or from the Railway Board. But I am happy to tell you that I look back on the execution of the Konkan Railway Project as one of the high watermarks in my professional career.
>
> During my tenure in KRCL, one of the Ministers wanted to get rid of me. Though nothing worked in his favour, I did think of resigning but that would have badly affected the project. Since all his attempts to get rid of me did not work, the Minister gave a statement before Parliament that lots of things were going on in KRCL that were not good for the project and that he had decided to set up a committee of MPs to inquire into these charges. He got it through and got the Committee to inquire against me.
>
> The Committee's Chairman was the Minister's best friend. The Committee came to KRCL and had three

meetings with me. They never came to the KRCL office at Belapur, but used to stay at Taj Mahal Hotel, call me there, call my officers, take evidences, inquire into them. They looked into [the] contracts awarded and appointments done. Everything had meticulously been done as per the processes. After examination, the Committee could not find anything wrong.

The Secretary to the Committee was the Railway Board's Director (Works) who was also against me. He was not happy with me for some reason. The Minister had managed to get all such people in the Committee, but despite all this they could not find anything wrong anywhere. They gave us a clean chit. We should appreciate the honesty and the straight forwardness of the Committee Chairman.

Meanwhile, the Minister who wanted to kick me out had also sent a strong letter to the Prime Minister (PM), saying that Sreedharan was doing all sorts of things and appointing the people he wants and giving out contracts he likes and things are being very badly mismanaged in KRCL and that he [the Minister] would like to have a change there.

When the letter reached the Prime Minister's Office, the Private Secretary to the PM sent for me and asked me what the problem between me and the Railway Minister was. I said there was no problem. The only issue was that the Railway Minister wanted me to do certain things, which were not in the interest of the railway line and to which I could not agree. He wanted me to quit and I did think of leaving, but later thought that if I left, the

project would never be done. So I was continuing, but under great pressure.

The PM's Private Secretary heard me out and then told me that the letter had been seen by the PM and that the PM wanted the Private Secretary to speak to me. The PM had directed him to tell me not to buckle under threats, but to do my duty. So I did not resign and stayed back even when the Minister was keen that I should quit.

When the Konkan Railway Project was finally opened and was dedicated to the nation at Ratnagiri in Maharashtra by Prime Minister Atal Behari Vajpayee on 1 May 1998, this is what George Fernandes, who was then India's Defence Minister, had to say about the project[32]:

> When the question of who should take credit for this achievement is discussed, I am of the firm opinion that if there is one person whose knowledge and dedication was responsible for the project, it is E. Sreedharan, the former Chairman and Managing Director of Konkan Railway.

And now we come to the most perplexing issue—why was it thought fit that the CMD of KRCL should take home a salary that was less than that of his own executives, whilst still carrying the leader's burden of decision-making, problem-solving, accountability and making the deadline?

A Take-Home Salary of ₹1,080!

As we know in the 1990s, pushed by then Railway Minister George Fernandes, Sreedharan had been the driving force behind the setting up of KRCL—from getting approvals of four chief ministers, to putting in place the intricacies of a Corporation. But mid-way in June 1990, as things were taking shape, Sreedharan was to retire from Indian Railways having reached superannuation stage. Fernandes could not allow this, Konkan Railway was his dream project and until the government selected him as Chairman-cum-Managing Director, Sreedharan was asked to work as Chairman of a one-man committee, taking all necessary steps to get the Konkan Railway Project going.

Railway Minister Fernandes requested Sreedharan to continue and to complete the project. Sreedharan asked for just one thing, a 'blank cheque' to organize and execute the project without any interference either from politicians or from bureaucrats. Fernandes readily agreed and made him Chairman of the one-man committee till he was declared selected by the Public Enterprises Selection Board and appointed by the

Appointments Committee of the Cabinet of Ministers.

D.O.No.90/E(O)/II/7/22 dated 30 October 1990 regarding the decision of the Appointments Committee of the Cabinet was as below:

> The Appointments Committee of the Cabinet have approved the proposal for appointment of Shri E. Sreedharan as CMD, Konkan Railway Corporation Limited in Schedule A scale of pay of ₹9,000–10,000 for a period of five years or till the completion of the Konkan Railway Project, whichever is earlier.

An order of his appointment followed:

> In terms of the decision of the Appointments Committee of the Cabinet, an order No.90/W2/KRC/1 dated 31 October 1990 was issued, which also stipulated that in pursuance of Article 65 of the Memorandum and Article of Association of the Konkan Railway Corporation Limited, New Delhi, the petitioner, retired Member Engineering, Railway Board, was appointed as Chairman-cum-Managing Director of Konkan Railway Corporation in Schedule A for a period of five years from the date he takes over or till the completion of the Konkan Railway Project, whichever is earlier.

Fernandes then formally announced that E. Sreedharan would be heading KRCL. Shortly thereafter, political turmoil in the country led to the fall of the government at the centre and by November 1990, Fernandes was no longer the Railway Minister. Nevertheless, KRCL had been insulated from political turmoil; it had been set in motion with all the legalities and framework in

place. After being formally appointed as the CMD, Sreedharan never looked back and got busy with his work.

He received his appointment letter (No.90/E(O)II/7/22) issued by Under Secretary (D), Railway Board two years *after* joining on 18 September 1992. The letter conveyed the sanction of the President of India to his appointment as CMD of KRCL with effect from 31 October 1990. However, Clause 1(iii) of the letter, mentioned that Sreedharan's basic pay would be reduced by ₹4,000/- per month on account of the pension he was already receiving:

> Clause 1(iii) Pay: Shri Sreedharan will draw basic pay of ₹9000/- less ₹4000/- as pension per month in the revised scale of ₹9000-250-10000 (Schedule A) from the date of his assumption of office as CMD/KRC.

The contention being that he was receiving pension as a retired railway employee and the amount had been deducted from his salary as the CMD of KRCL. This upset Sreedharan and on 9 November 1992 he shot off a letter to the Secretary of the Railway Board explaining that if his pension of ₹4,000 was reduced from his pay at the lowest stage of ₹9,000, he would be left with a pay of ₹5,000 only. From this, provident fund of ₹750; house rent of ₹500; car conveyance of ₹40; and income tax of ₹2,000 would be deducted and, therefore, an amount of ₹3,850 would be deducted besides other recoveries, such as electric charges of about ₹170, water charges of ₹50 and professional tax of ₹50, which would leave only a salary of ₹1,080, which would be also without the contribution towards voluntary provident fund (VPF) which is necessary to reduce the incidence of income tax.

Sreedharan questioned how the government expected him to function as Chief Executive of an important public sector undertaking (PSU) with an annual turnover of ₹400 crore, with a take-home salary of ₹1,080.

He pointed out that the take-home salary of a full-time director of the same organization was in the range of approximately ₹7,300, and the take-home salary of each of the Heads of Department was more than ₹5,000. Sreedharan wrote that the salary drawn by the Chief Executive of the said organization could not be less than the salary drawn by nearly half of the executives in the same organization. Also that he could not be appointed to a post where the salary drawn would be less than the salary he had drawn while in service.

There was no response.

So he made another representation, this time to the Department of Public Enterprises (Ministry of Industry, Government of India), on 6 October 1993 referring to his earlier correspondence. He had been keeping tabs on the correspondence, but had been increasingly busy with the project itself completing phase after phase, winning accolades.

By 1997 December, he had handed over the completed KRCL Project and had been appointed MD of the Delhi Metro Corporation Limited (DMCL).

The government filed a reply on 15 January 1998 declining Sreedharan's request, just days before Konkan Railway started officially operating on 26 January 1998; as mentioned above Sreedharan had already moved to Delhi Metro as MD.

The government's reply stated that the decision to cut the salary had been based on a guideline issued by the Bureau of Public Enterprises and the Department of Public Enterprises

in an Office Memorandum dated 23 September 1969, in respect of re-employment of retired Government Officers in public enterprises. It stated that the limits of pre-retirement pay of ₹3,000 per month would cease to apply and such retired persons would be allowed pay in the prescribed salary scale, less pensionary equivalent to retirement benefits.

An Office Memorandum of the Ministry of Industries, Department of Public Enterprises, dated 10 December 1997 was issued stipulating that in order to grant greater operational freedom to public sector enterprises and with a view to rationalizing and simplifying the existing set of guidelines to public enterprises. The government cancelled 696 guidelines issued over a period of time by Bureau of Public Enterprises and the Department of Public Enterprises on various aspects of operation by public sector enterprises. The deduction of ₹4,000 as pension from Sreedharan's salary—made on the basis of the 1969 Office Memorandum—thus, also stood cancelled.

Sreedharan's correspondence continued and there were more points raised, more circulars cited clarifying that the orders were not applicable to Central Government employees re-employed in PSUs / autonomous bodies after their retirement and also that the 1969 circular had been withdrawn. But in February 2002, the government rejected all points and said that the cancellation of the 1969 orders was not with retrospective effect and that Sreedharan had already retired from the organization when the order had been withdrawn.

Sreedharan continued to fight and filed a written petition in Delhi High Court on 12 April 2002. By this time, working at his usual speed, Sreedharan and his DMCL team had managed to complete the first line of the Delhi Metro which was thrown

open to public in December 2002—but his battle with the Railways over his salary due for his duration as CMD of KRCL still continued. The Railway Ministry replied saying the matter had been examined in the Ministry in consultation with the Department of Public Enterprises, the nodal department for such orders, and it had been decided that the pay of the petitioner had been fixed correctly. Sreedharan fought back filing additional affidavits in 2003 and again in 2006 with relevant documents.

Finally, Delhi High Court categorically stated that it could not be disputed that the KRCL was a public corporation, an independent entity and the appointment of Sreedharan as CMD was in accordance with Article 65 of Memorandum of Association. Nothing had been produced to show that KRCL, an independent corporation that had adopted the rules and orders of Ministry of Personnel, which were being cited by the government.

The Appointments Committee of the Cabinet in its order dated 31 October 1990 had also approved the proposal for 'Appointment' after retirement from Ministry of Railways to the KRCL and not as 'Re-employment' as the Government had been saying. The court responded:

> The Committee is the highest body approving the appointments and it is not expected that they would use the word 'Appointment' in place of 'Re-employment' and while approving the pay scale and fixing the pay scale, if they had approved reduction of amount of pension from the salary approved by them, not mention so.

Moreover, while appointing Sreedharan as CMD KRCL, it had nowhere been stated that the amount of his pension would be

deducted from his emoluments as CMD, leaving him with a salary that would be less than many of the directors and other employees of the same corporation. The court noted that if, as per the petitioner, no such proposal had been given to him, then it would be necessary to know what proposal had been considered by the Appointments Committee of the Cabinet.

Also, Sreedharan had superannuated from the Railways as Technical Member of the Railway Board and was not given an extension of service. For re-employment, the employment should be on the same post or similar post in the same department or in the same channel of promotion. Making matters clear, the court stated:

> In any case, if the Appointment Committee of the Cabinet had to 're-employ' the petitioner as a Chairman-cum-Managing Director of Konkan Railway, they would have specified that the petitioner is 're-employed' as the Chairman-cum-Managing Director of the Konkan Railway Corporation in their order dated 30 October 1990. Two years thereafter, while allegedly sending the letter of employment to the petitioner, the Ministry of Railways could not contend that the case of the petitioner was of 're-employment' and not of 'appointment' and that from the pay approved by the Appointments Committee of the Cabinet, the amount of pension was liable to be deleted.

The court ruled that all deductions by the Indian Railways from Sreedharan's salary as CMD of KRCL were illegal and that Indian Railways was liable to refund all the amount, directing it to pay the entire amount deducted. It stated:

The entire amount should be paid along with simple interest at the rate of 12 per cent per annum within four weeks. Considering the facts and circumstances, they shall also pay costs of ₹30,000 to Sreedharan.

This final ruling came on 5 December 2008, roughly a decade after Sreedharan had successfully completed and handed over the KRCL to the Indian Railways for operation. Thus, ended the saga. The refund received from the Railways was more than 9 lakh. Sreedharan donated 50 per cent of this amount to a charity fund.

Delhi Metro

During the time that work at KRCL was in full swing and nearing completion, about 2,000km away in the country's capital, Delhi, another battle was being fought. The city was going through a major transport crisis. With a population of 11 million, it was perhaps the only city of this size in the world that depended almost entirely on buses as its sole mode of mass transport. This, in turn, had led to proliferation of personalized vehicles and increased pollution.

To battle this congestion and pollution, a study was commissioned by the Government and completed in 1991 by Rail India Technical and Economic Services (RITES), an engineering consultancy company of the Indian Railways, specializing in the field of transport infrastructure. It had recommended a 198.5km Mass Rapid Transit (MRT) rail-based network. The Union Government, in principle, approved it on 19 July 1994, and authorized the preparation of a Detailed Project Report (DPR).

The DPR, prepared by RITES in May 1995, recommended financing the Delhi MRTS Project as a joint venture by the

Government of India and Government of the National Capital Territory (NCT) of Delhi through a corporate structure, with the equity capital to be contributed by the two governments in equal proportions. This led to the incorporation of Delhi Metro Rail Corporation Limited (DMRCL) as a company under the Companies Act, 1956. The DMRCL was accordingly registered on 3 May 1995. Things moved at a fast pace from here with the final investment approval by the Union Cabinet coming on 17 September 1996; and a loan agreement between the Government of India and the Overseas Economic Cooperation Fund (OECF), Japan, was signed five months later on 25 February 1997.[33]

The Japanese loan had a condition that DMRCL should soon have a Managing Director (MD) or the loan would lapse.[34] And so began the hunt for a dynamic officer fit to take on this challenging task.

P.V. Jaikrishnan, then Chief Secretary, Government of Delhi, knew Sreedharan and his work culture since Jaikrishnan had served as Chief Secretary in Goa when work on the KRCL had got underway. He had been impressed by Sreedharan's approach and work. It was he who first suggested Sreedharan's name. But there were problems. Sreedharan was 65, much beyond the retirement age of 58 in Indian Government organizations and he was keen to finish the Konkan Railway project (it finished in December that year) and retire to his home state Kerala. Delhi Government set up a search committee to choose a capable person to head Delhi Metro Corporation Limited. Sreedharan recalled:

I was in the search committee to find a suitable MD and a few names came from the Railways and other places,

but they said they were not satisfied. By this time, the Japanese government threatened that the promised loan would be withdrawn if we did not fill the MD post. So they (Delhi Government) did not know what to do and then decided that why doesn't Sreedharan take over as Managing Director! I was not aware of this decision of theirs until one day when Jaikrishnan rang me up and said 'we are thinking of considering you for the post of MD, Delhi Metro, because we are not able to get a suitable candidate.'

I refused outright. First, I was yet to complete the Konkan Railway Project (it finished in December that year), and there was no way I could take over the Delhi Metro. Then he suggested why don't I come over to Delhi and discuss this. I said I would. When I went to meet Jaikrishnan, he said we were going to meet the Lt Governor, Tejinder Khanna. When we reached there, I realised that it was really an interview board! Khanna was there, the Chief Minister was there, the Transport Minister was there, and Jaikrishnan was there. The four of them proceeded to interview me and then Khanna said they had decided to put up my name for the post of MD, Delhi Metro.

Again I refused outright. I said 'No way. You can't do it. The Indian Railways will never agree.' The Konkan Railway was getting ready, but not yet commissioned. And thirdly, I was 65. The Government of India would never agree for anyone to be hired beyond the age of 65. Fourthly, I had never lived in Delhi as such, except for the time when I was Member Engineering, the post from where I retired.

As expected, there were objections for my age and also from Indian Railways with whom I was doing the Konkan Railway. The Lt Governor met the Railway Minister to convince him. Ultimately, T.S.R. Subramaniam, who was then Cabinet Secretary, said, 'If the Prime Minister of the country (he was referring to Atal Behari Vajpayee) at the age of 78 can run this country, why can't Sreedharan lead the Delhi Metro? I find no objection to this.' And that went through. I had never met Subramaniam, but later came to know about this from one of his books where he has mentioned this.

A medical fitness test conducted on Sreedharan found him fit. Pushed by Jaikrishnan, then Chief Minister Sahib Singh Varma, Lt Governor Tejinder Khanna, and then Prime Minister H.D. Deve Gowda granted special permission allowing Sreedharan to take charge.

Jaikrishnan was sure that Sreedharan was the man that Delhi required. Recalled Jaikrishnan who at the time had been Chief Secretary, Goa:[35]

We were convinced Sreedharan was the one who could make it possible. There had been a political crisis in Goa in the early 1990s when the Konkan Railway Project had begun. They were years of flux as Goa saw Chief Ministers change four times between 1993 and 1994. Every change brought a fresh group of lobbyists into the spotlight for the Konkan Railway alignment. Sreedharan was a rock who was determined to get the project completed.

When Sreedharan was appointed as MD, DMRCL in August

1997, he was still struggling with Pernem tunnel's soft-soil collapses. Between August and November 1997, Sreedharan was CMD, KRCL and unofficial MD, DMRCL, and shuttled between the KRCL office in Mumbai and the DMRCL office in Delhi. On 5 November 1997, he formally joined as MD, DMRCL.

In its early days, the DMRCL office comprised two rooms in the Ministry of Railways. Sreedharan sat in one room, and his Officer on Special Duty (OSD) A.K.P. Unny and his team in the other. The Corporation had already been formed and Sreedharan's name appears in its third annual report.

Yet again Sreedharan was faced with a formidable task, and once again his only condition was that he be given a free hand to execute the project and select people of his choice, to which the Government agreed. The first major challenge for Sreedharan was to thus hand-pick the right people, so that the organization could be set up quickly and gather pace.

A selected few officers and colleagues from Konkan Railway joined Sreedharan initially in the two rooms of the Rail Bhavan. Within a week, however, a makeshift office was set up in Delhi's Lodhi Road.

The second challenge was to set in place a work culture and sense of mission and purpose, as he had at KRCL. Thus were devised the Corporate Mission, and Corporate Culture statements.

DMRCL CORPORATE MISSION

Mention that the pointers come under Phase I:
• To make the first phase of the Delhi MRTS fully operational by March 2005.

Sreedharan as Konkan Railway Managing Director in his office.
Courtesy: KR Archives

Sreedharan as Konkan Railway Managing Director with a foreign delegation.
Courtesy: KR Archives

Sreedharan with Chief Minister of Maharashtra for consultation on Metro Rail Projects in the state, in 2016.
Courtesy: Maharashtra CM Office

Sreedharan with former Kerala CM Oomen Chandy, in July 2014.

Various trophies at Sreedharan's Camp Office in Ponnani.

The first railway award—'Minister of Railways Award 1964'—received by Sreedharan for restoration of Pamban Bridge.

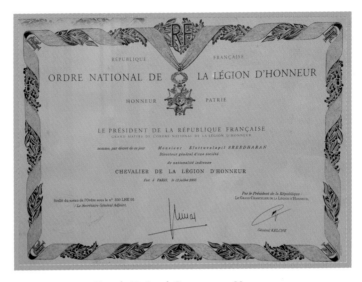

French National Government Honour

Perumbayil House and Camp Office, Ponnani, Kerala.

Sreedharan at his Camp Office.

Sreedharan with the author in Kerala.

Sreedharan during a visit to Tokyo.

Koilandy station where Sreedharan did trainspotting during his childhood years.

Sreedharan inspecting the Konkan Railway line during construction along with his colleagues.

Courtesy: KR Archives

Sreedharan inspecting a track switch during the Konkan Railway construction.
Courtesy: KR Archives

Sreedharan inspecting a tunnel during the Konkan Railway construction.
Courtesy: KR Archives

Sreedharan with Minister of Railways Ram Vilas Paswan. Inspecting a tunnel during the Konkan Railway construction.

Courtesy: KR Archives

Sreedharan welcoming Minister of Railways CK Jaffer Sharif.

Courtesy: KR Archives

Sreedharan with George Fernandes, Sharad Pawar and Madhu Dadavate during initial launch of rail line section of Konkan Railway.

Courtesy: KR Archives

Sreedharan with Minister of Railways Ram Vilas Paswan.

Courtesy: KR Archives

Sreedharan with Maharashtra Chief Minister Manohar Joshi during the launch of one of the Konkan Railway trains.
Courtesy: KR Archives

Sreedharan with Minister of of State for Railways Suresh Kalmadi.
Courtesy: KR Archives

Sreedharan giving out awards to young successful children at a local function.

Young Sreedharan during a visit to Oxford in 1960.

Old family photograph of Sreedharan

Old family photograph of Sreedharan's children

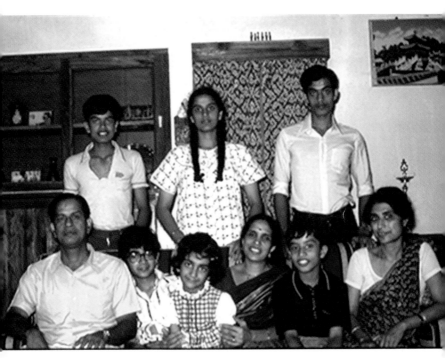

A family photograph

- To complete the project within the estimated cost.
- To make it a world-class metro; a vehicle to promote dignity and discipline in the city.

After Phase I was completed, DMRCL modified its Corporate Mission keeping in view the new requirements:

- To cover the whole of Delhi with a metro network by the year 2021.
- Delhi Metro to be of world-class standards in regard to safety, reliability, punctuality, comfort and customer satisfaction.
- Metro to operate on sound commercial lines obviating the need for Government support.

DMRCL CORPORATE CULTURE

- DMRCL should be totally devoted and committed to the Corporate Mission.
- Personal veracity should never be in doubt; we should maintain full transparency in all our decisions and transactions.
- The Organization must be lean but effective.
- The Corporation must project an image of efficiency, transparency, courtesy and 'they mean business' attitude.
- Their construction activities should not inconvenience or endanger public life nor should lead to ecological or environmental degradation.
- All the structures should be aesthetically planned and well maintained.
- Safety of metro users is our paramount responsibility.
- Their stations and trains should be spotlessly clean.

- Their staff should be smartly dressed, punctual, polite and helpful to the customers.
- Employees should discharge their responsibilities with pride, perfection and dignity.

The above tenets of both Corporate Culture and Mission were reiterated on all official files, displayed prominently at training schools, and on new-year diaries.

The style of working was gauged from the fact that the very first occupants of DMRCL moved into the new DMRCL building without water and electricity and got down to work.[36]

At the initial and basic levels of entry, Sreedharan pushed for recruitment through an all-India competitive exam, consisting of a written test, interview and a detailed medical exam based on the pattern of the UPSC and State Service Commission. This was to deliberately eliminate entry of people into DMRC, through pulls and pressures, and ensured that it got people of good calibre.[37]

The DMRCL had Mass Transit Railway Corporation (MTRC), Hong Kong, on board as Consultant for operations and construction techniques. Construction work on the Delhi Metro started on 1 October 1998. As planning went ahead, one of the biggest controversies that Sreedharan faced was the selection of the gauge of tracks for Delhi Metro. It was a crucial decision and while his choice of the internationally favoured, standard gauge tracks was overridden initially, eventually—and after many years—it was Maharashtra's powerful politician Sharad Pawar who convinced all State Governments to opt for standard gauge.

THE 'HARDEST KNOCK'

Sreedharan dubbed a veto as the 'hardest knock' of his career—a veto that slammed his recommendation for the use of the internationally used standard gauge tracks for the Delhi Metro, in favour of the Indian Railways recommendation of broad gauge tracks—a decision that made no sense either from the point of view of economics, or from the point of view of future growth of the Delhi Metro's capacity. Sreedharan explains:

> The hardest knock which I received in my 50 years of professional life was the decision of the Government of India to choose the broad gauge for the Delhi Metro instead of the internationally favoured standard gauge, which I felt was the appropriate technology for the metro rail system in Delhi. Indian Railways was insisting on broad gauge, and made a prestige issue of it.

Gauge is the spacing of the rails on a railway track. Indian Railways uses four gauges—the most common among them is the broad gauge (also called Indian gauge) which is 1,676mm (5ft 6in). This is now found all over the country and all major passenger and freight routes run on broad gauge tracks.

The second is metre gauge which is 1,000mm (3ft 3⅜in). This is said to have been introduced by Richard Southwell Bourke, the sixth Earl of Mayo, popular as Lord Mayo, the fourth Viceroy of India. Metre gauge is said to be based on calculations to allow four persons to sit comfortably abreast—it would have been 3ft 3in except that there was then a push to move to the metric system and so the gauge became 1m. The first metre gauge line was built in 1872 in Delhi.

The third is the 762mm (2ft 6in) narrow gauge line, the most well-known such track in India is on the Kalka–Shimla route. The rationale for the narrow gauge was economy in building the lines—they could be laid much faster than broad gauge lines and in more difficult terrain. It was also felt that they would act as feeder lines to broad gauge and meter gauge lines. And even more narrow (610mm; 2ft) gauge line, is the fourth variety, found on the New Jalpaiguri–Darjeeling, Neral–Matheran, and Gwalior branch lines. It is cheap and convenient to negotiate in hilly terrain.

Sreedharan did not take up any of these gauges. He selected the standard gauge (1,435mm or 4ft 8½in). His contention was that most metro networks around the world used standard gauge as it provided better speed, safety and manoeuvrability. He was right. Not only metro systems, but approximately 60 per cent of the railway lines in the world run on this gauge.

And as we see now, this was to be the new-age gauge. Even the proposed High Speed Rail (HSR) for India, popularly called the 'Bullet Train', will to run on standard gauge tracks. The standard gauge was first used by George Stephenson[38] in the Liverpool and Manchester Railway on 15 September 1830, the first rail public transport system which did not use animal traction power. In India, standard gauge was used by the Calcutta Tram Company. Citing the obduracy of Indian Railways, Sreedharan noted:

> Indian Railways represented by the Chairman of Railway Board, insisted on broad gauge. Delhi Chief Minister Shiela Dixit too wanted standard gauge, but the Indian Railways opposed it. Their argument was that Indian Railways was

following the uni-gauge policy. The Railways said broad gauge meant more capacity. They wanted to thrust broad gauge on us. I proved it to them that gauge has nothing to do with capacity.

The matter went up to the Cabinet and a meeting of a group of Ministers was held to discuss the issue. Lal Krishna Advani was the Chairman of the Committee and other members included the Minister of Railways, the Minister for Urban Development. At that first meeting, all were convinced that Delhi Metro should be standard gauge. But then Railway Minister Mamata Banerjee was absent at the meeting. So, Advani said it would not be correct to take a final decision in the absence of the Railway Minister against the decision of the railway ministry. So we postponed it to another day, when Mamata Banerjee would be available.

The second meeting too went on well and there were discussions about standard gauge. Then, a bombshell was dropped by the Railway Board Chairman V.K. Agarwal. He said, 'If you are going to have standard gauge then I must inform the honourable ministers that the Indian Railways would not be able to certify it because we have no experience with standard gauge.'

When Agarwal said this, Urban Development Minister Jagmohan was the first to say if that was the case there was no option and we must go for broad gauge. 'If we cannot get safety certification from the railways for this, we are left with no choice, because according to the legal provisions in place, Indian Railways is supposed to give safety certification to the Metro Railway,' he said. Then

everybody decided to go for broad gauge. That is how the broad gauge issue was decided. This was against the earlier decision. It was a key decision as the work went on. We had floated tenders with two options, one with standard gauge and the other with broad gauge and the companies had to give their quotations in both. This foresight helped us to save time.

After the meeting was over Mamata Banerjee came to me and asked why had I agreed to this? Why had I given in? She also wanted standard gauge. I said I had no option as the Railways said they would not certify the line. The line had to be built fast and we could not afford to delay the project—that was the most important thing. I told her, 'You can have your broad gauge, but Sreedharan will not be available for finishing the project.' She did not say anything much and did not seem too bothered, as the Delhi Metro was not directly under her purview.

Earlier, I had lots of discussions with the Indian Railways team and Agarwal himself. But it became a prestige issue for Indian Railways and they were not ready to listen. Delhi's Lt Governor knew that I was not happy with the decision and would resign. The night after the meeting, he rang me up and told me not to take any hasty action, and to meet him the next morning for breakfast at his residence. He had himself recommended standard gauge for Delhi Metro. He said, 'We all know that broad gauge is a wrong decision, but the project at this stage cannot afford to lose you and you have to continue.' I had contemplated resigning since I felt that I should not be a party to what I believed was a wrong

technical decision, but decided to stay on for the sake
of the project.

He turned to the Bhagavad Gita for spiritual guidance:

On that day in 2000, I reflected on the central theme of
the Gita, where Arjun—looking at the gathered armies—
feels despondent, drops his weapons, and tells Krishna he
will not fight. Krishna says that no matter what, Arjun
has to fulfil his duty.

Sreedharan decided not to quit, but, instead, to stay on and fight:

The completion of the Delhi Metro Project was essential
for the benefit of the city of Delhi. I took this knock in
my stride and we decided to redesign all our systems to
suit broad gauge. This did mean extra effort on our part
and extra cost for the organization, but we took this on
as a challenge and were able to overcome these technical
difficulties, which were a natural corollary of adopting a
new technology for the system proposed.

The design of the metro trains which were being
procured from South Korea had to be immediately
changed to ensure that the deadlines were met. We
immediately dispatched our engineers to Changwon,
the Rail Coach Factory of the South Korean company
Rotem, and stationed them there for three to four months
to ensure that all the designs were quickly cleared and
approved without any delay. All other technical parameters
had to be adjusted to suit the requirement of the gauge
selected.

Despite the pulls and pressures, the first line of Delhi Metro connecting eastern Delhi's Shahdara to north-central Tis Hazari was ready by 2002. Trials were flagged off by then Deputy Prime Minister Lal Krishna Advani in September 2002 and Prime Minister Atal Bihari Vajpayee inaugurated the metro for public use a day before Christmas on 24 December 2002. The response was immense with citizens of Delhi, eager to have a ride, overcrowded the station and caused the ticketing system to collapse! [39]

SHARAD PAWAR GETS RAILWAYS TO REVERSE DECISION ON BROAD GAUGE

Explaining how Sharad Pawar played a key role in the change of gauge for Delhi Metro, Sreedharan recalled:

Fortunately, after some time, Sharad Pawar became the Chairman of the Group of Ministers. I went on with my battle and said Delhi Phase I was lost, but why should we continue broad gauge for the rest of the country? I had a discussion with Sharad Pawar. He was fully convinced that it had to be standard gauge.

This was after about a year from the decision when the first meeting had decided on broad gauge. Pawar then volunteered and said he would call another meeting. So another meeting of Group of Ministers was called and it was Sharad Pawar who pioneered the decision that Metro Railways should be standard gauge.

Pawar had vision. He said why should the remaining cities suffer? He saved the day by putting across a clause that the gauge would be decided with the concurrence of

the State Governments building the Metro Railway, and not by the Indian Railways.

Then the Metro Act came in and things changed. The Railways are still there and continue to create problems, but this decision by Sharad Pawar changed everything and almost all the State Governments went in for standard gauge.

The Green Line, the fifth line of the Delhi Metro network and the first line on internationally favoured standard gauge, was opened in 2010. All the lines after this were built with standard gauge and so were the rest of metro systems planned across the country. However, due to difference of gauges, interchangeability of trains within the two sets of gauges used in the metro (broad gauge initially, and later standard gauge) remains a problem to this day.

THE 2002 METRO RAIL ACT EMERGES

Sreedharan's metro rail model brought railway trains back into fashion as local city transport. And with so many metro networks coming up across the nation, came the legal framework for it in the form of the Metro (Operation & Maintenance) Act, 2002. When it was first enacted in 2002, the Act applied only to NCT Delhi. It was amended in 2009 to permit the Central Government to extend the Act to any metropolitan city or area, after consultation with the concerned State Government, except in the metropolitan city of Kolkata. The Act governs the operations of metro rail systems in India and the law was first promulgated as an Ordinance on 29 October 2002.

DELHI METRO PHASE I LAUNCH IN 2005

Phase I of the Project was dedicated to the nation by Prime Minister Manmohan Singh on 30 December 2005 marking a watershed for Delhi Metro, and the 6.5-km-long Dwarka Extension opened on 1 April 2006. Overall, the project was completed in seven years and three months.[40] Phase I (65km) was completed in 2006, on budget and almost three years ahead of schedule. 'While the Government had given us a mandate of 10 years to build Delhi Metro Phase I, we took a decision to compress the period to seven years as Delhi required it fast,' said Sreedharan. Very rarely has a project of such magnitude and involving so many stakeholders been completed in such a short timeframe.

Anuj Dayal, quoting Satish Kumar (Director/Electrical, DMRCL), narrate an interesting, but little-known anecdote, which spoke of DMRCL's foresight.[41] DMRCL had kept an alternative power back-up arrangement available with the help of Northern Railways at an extra cost, from day one. As a result when power supply was disrupted at 10.20 a.m., just 10 minutes into the PM's inaugural metro journey, the back-up system took over within a minute, without anyone noticing the failure of the primary system, saving DMRCL huge embarrassment.

Dayal also mentioned Sreedharan's foresight—no doubt honed by more than 40 years of experience—in forming two key departments, which are normally ignored by most organizations, public relations and legal branch.[42]

> Court cases were carefully monitored, fought, and information supplied to the judiciary in detail, which helped in deciding cases. The MD himself took a lot of interest in all court cases too. On the media front, the

DMRCL sold a dream to the common man of Delhi who was fed up of standing in long queues and sweating it out in packed DTC and Blueline buses. Large-scale dissemination of information ensured that the public was well informed about the project at all stages.

Contractors were another key. Just as Sreedharan had laid down the work culture at Konkan Railway, similarly here too the DMRCL viewed contractors as partners and ensured timely payments. As MD, Sreedharan enjoyed all executive powers, which helped when it came to taking swift decisions. In fact, Sreedharan pushed for the same culture among his employees and freed them from the clutches of Vigilance and Audit Departments which are normally the monitoring bodies in any Government organization. Sometimes wrong decisions were acceptable, but not delays.

Even though some decisions may have been taken in haste in view of deadline pressures, Sreedharan did not believe in witch-hunting if it felt that the intention of the person was not wrong. The approach was to check the genuineness of the intention, said Dayal[43]:

The MD openly used to encourage officers to bring their files and issues to him for decisions. On many occasions, when issues could not be decided between different departments, he would ask for papers to be brought to him directly and would give a clear-cut decision on the matter. This helped speeding up the decision-making process.

Giving examples, Dayal mentioned bold decisions such as beginning work on the Shahdara-Tis Hazari section even before

sanction of loan. Or, during one of his initial site inspections deciding to place the metro line on an embankment rather than having it elevated between Shahdara and Seelampur—hundreds of crores were saved by this single on-the-spot decision, said Dayal.

Another significant decision that Sreedharan made, which was derived from his experience on Indian Railways, was the decision to merge the eligibility of train operators and station controllers. So in case of emergencies, station managers/controllers could drive the trains. This also led to common training and promotional avenues.

Sreedharan continued to draw flak for his working style from critics, but all said and done, he managed to complete gigantic projects within deadline and budget. By breaking rules, he broke records and delivered output. Small decisions of his, like deciding to take on the responsibility of diverting utilities, rather than waiting for respective agencies to divert them helped in saving immense time and cost.

However, the DMRCL faced its own set of crises, during the building of the metro—2008 and 2009 were particularly tough.

On 19 October 2008, a girder launcher and a part of the overhead Blue Line extension under construction in Laxmi Nagar, East Delhi, collapsed and fell on passing vehicles underneath. Sreedharan took a very tough stand on the issue with his staff and contractors, admitting he was 'very harsh' with them.

Then, on 12 July 2009, a section of a bridge collapsed while it was being erected at Zamrudpur, near East of Kailash, on the Central Secretariat-Badarpur corridor. Seven people died and 15 were injured. At 3.00 p.m., Sreedharan announced his resignation to a packed media conference. He explained why he did so:

When the Zamrudpur accident happened on 12 July 2009, I was with my daughter in Bengaluru. Early morning, I got the information that the accident had occurred. Immediately, I decided to go. I took the first available flight and after landing in Delhi I went straight to the accident site, saw the condition. In fact, during the journey itself, on the plane itself, I had decided that if it was a bad case, I would take the responsibility and resign. This was because, when the Laxmi Nagar accident happened (on 19 October 2008), I was very tough on my staff and contractors, but the Zamrudpur accident still happened. When I saw the site, I definitely decided I would resign. I did not tell my colleagues. I came back to the office about 1.00 or 2.00 p.m., I told my Chief PRO, Anuj Dayal, to call a press conference at about 4.00 p.m.

At 3.00 p.m., I called all my Directors and told them that what had happened was a very bad thing. I take the full responsibility for it and I have decided to resign. It was a shock to everyone and they said no how could I do it? I said I had made up my mind and had called a press conference to tell the press that I was resigning. Then I wrote the resignation letter and sent it through a special messenger to Delhi Chief Minister Shiela Dixit, because a Managing Director is appointed by the State Government.

I announced at the press conference that I was resigning. By the time I came back home, Dixit was on the phone. She said 'I can't accept your resignation' and told me to think it over. The Commonwealth Games were approaching and lots of work was to be done and at this

point we could not afford any change of stewardship. Till about 6.30 p.m., she kept trying to convince me. She wanted me to come over and have a talk with her. Then I told her to give me some time to think it over and I would let her know my decision the next morning.

The next morning I called her and said I had decided to stay back. I took this decision because if I went away, the whole project would have collapsed and we would not have been able to meet the deadline for the Commonwealth Games.

His family would have been happy had he retired, but Sreedharan decided to continue and complete the project at hand. Then, the following day—13 July 2009—a crane removing the collapsed debris crashed on two other cranes nearby, injuring six which was captured live on TV. Channels began telecasting it on a loop, and the incident drew heavy criticism in the media and Parliament, with the media raising questions about the safety practices being followed by DMRCL.

As though all of this were not enough, exceptionally heavy rains that month flooded Metro Bhavan (the DMRCL office) and logged it for a week, cutting off electricity for the duration and forcing 78-year-old Sreedharan to climb eight floors daily to reach his office.

Overall, the stress began taking its toll.

THE HEART ATTACK

On Wednesday, 9 April 2010, Sreedharan was scheduled to board a flight for Kolkata but experienced uneasiness in the chest and

was rushed to hospital. He was shifted to intensive care unit of the Indraprastha Apollo Hospital in Delhi and a decision to conduct a bypass surgery was taken after examination as his right coronary artery was found hundred per cent blocked and the left one had some blockage too.

The next day on 10 April, doctors successfully conducted a six-hour-long bypass surgery on him, using four grafts to bypass the blocked arteries. Sreedharan, known to have a busy schedule and frequent travels to other cities as a consultant on other metro projects, was now advised rest. But after about 10 days or so, he walked out of hospital, rested for a month and resumed work on 17 May. He was able to recover very quickly from surgery due to his overall physical fitness.

DMRCL CHALLENGES BECOME HARVARD CASE STUDY

In 2012, the Harvard Business School picked up DMRCL and Sreedharan as a teaching case on leadership and project management in its Advanced Management Programme, under the discipline 'Organizational Behaviour'. Subjects included execution, leadership, organizational behaviour and project management.

The case study examined the 2009 accident when the bridge under construction collapsed killing six people and injuring 15. Despite its history of meeting deadlines and working within allocated costs, DMRCL came in for a lot of public censure. There was immense pressure on it to suspend its engineers and fire the construction contractor. On the other hand, it had to meet the deadline to make the second phase of the metro

network operational by October 2010 in time for the XIXth Commonwealth Games.

The case study focused on the challenges that Sreedharan faced as the crisis unfolded and it examined DMRCL's unique structure and management ethic that had so far enabled it to function within timeline and costs.[44]

BOWING OUT GRACEFULLY

Work on the Phase II of the Delhi metro that comprised 124.6km of route length and 85 stations was complete by August 2011 and at that point Sreedharan decided to call it a day. Fondly termed 'Metro Man' for changing the way Delhiites commute, he finally resigned on Saturday 31 December 2011, after an eventful 14-year tenure, as Delhi Metro chief.

Appointed as DMRCL's MD in 1997, originally for three years, he had altogether been given five extensions. He handed over charge as MD to Mangu Singh, one of his trusted lieutenants and left Delhi on 18 January 2012.

The DMRCL spread the metro culture in India thanks to visits by its MD to Chennai, Mumbai, Bengaluru, Kolkata, Ahmedabad, Pune, Ludhiana, and Bhopal. Sreedharan would travel every Saturday and Sunday to meet Chief Ministers and chief secretaries to convince them of the need to have a metro system in their cities. Weekends were chosen so that metro work in Delhi did not suffer.

The Delhi Metro has been instrumental in ushering in a new era in the sphere of mass urban transportation in India. Having constructed a massive 213-km network with 160 stations in record time, the DMRCL today stands as a shining example

of how a mammoth, technically complex infrastructure project can be completed before time and within budgeted cost by a Government agency.

The network has now crossed the boundaries of Delhi to reach Noida and Ghaziabad in Uttar Pradesh, and Gurgaon and Faridabad in Haryana. It is today the world's 12th largest metro system in terms of length, and the number of stations. It runs five (colour-coded) regular lines and an Airport Express line which carries 2.4 million passengers daily on an average.

Work on Metro Railways is being done in several Indian cities at a frantic pace, many of them under the guidance of Dr E. Sreedharan and Delhi Metro Railway Corporation. The metro revolution started by him and pushed across the country has won him the sobriquet of the 'Metro Man'.

In work mode:
1. Delhi
2. Mumbai
3. Chennai
4. Bangalore
5. Hyderabad
6. Kochi
7. Jaipur
8. Lucknow
9. Ahmedabad
10. Vijaywada

In planning mode:
1. Pune
2. Kanpur
3. Varanasi

4. Thiruvananthapuram Light Metro (Smaller trains for sharp curves and steep inclines)
5. Visakhapatnam
6. Ludhiana

Five

THEN AND NOW

Retirement? Work, Work and More Work

After 36 years of service in Indian Railways, Sreedharan retired at the age of 58 to work for seven years as CMD of KRCL till the age of 65.

After having seen to the successful completion of the Konkan Railway under KRCL, he then worked for another 14 years as MD of DMRCL till the age of 79, to build a world-class metro and retired in 2011. But work didn't stop following his retirement in 2011.

APPOINTED PRINCIPAL ADVISER TO DMRCL IN 2012

Sreedharan's baby—the DMRCL—acts as Consultant for metros not just in neighbouring areas such as Haryana, Noida, Huda, Ghaziabad, but also in Bengaluru, Mumbai, Navi Mumbai, Hyderabad, Chennai, the new metro lines of Kolkata, Kochi, Ahmedabad, Ludhiana, Dwarka, and a number of smaller hi-

speed networks. Sreedharan is himself occupied with the Kochi Metro and high speed railway that is to run the 550-km distance length of Kerala state, from Kasaragod to Thiruvananthapuram. The plans of monorails for Kozhikode and Thiruvananthapuram have been scrapped and a light metro will come up instead.

Given Sreedharan's expertise and demand from almost across the country to help out in building metros and rail-based transport modes, he remained affiliated to Delhi Metro which issued an appointment letter to him in 2012 as its 'Principal Adviser':

> Vide DMRC/Estt/PF/1/ES/2012 dated 13.01.2012 under Office Order No Dr/2907 The Management has decided to avail the services of Shri E. Sreedharan retired MD/DMRC as Principal Adviser to DMRC with immediate effect. Detailed Terms and Conditions will follow.

The same Order was revised on the same date, under the same Office Order and it read as:

> The Management has decided to avail the services of Shri E. Sreedharan, retired Managing Director, Delhi Metro Rail Corporation Ltd for Kochi Metro Project with immediate effect. Detailed terms/conditions will follow. He will function from Kochi/Ponnani and will look after the following works in addition to Kochi Metro Project 1. Preparation of DPR for the high Speed railway Project in Kerala and taking this project further for implementation. 2. The HSRL Project at Bangalore and 3. Prime Consultancy for Chennai Metro Project. This issues with the approval of Managing Director/DMRC.

On 9 March 2012, vide Office Order No DR/2929/2012, DMRCL delegated power to E. Sreedharan, Principal Adviser:

Kochi Metro is required to be completed in three years' time. For this, Kochi Unit is required to be provided with ample delegation of powers. Accordingly, in continuation to this office order No DR/2907/2012 (revised) on the aforesaid subject, the Pricipal Adviser, Shri E. Sreedharan, is delegated the following powers for execution of Kochi Metro project, Kerala High Speed Rail Project, and other consultancy works at Bangalore, Chennai and other cities as and when assigned 1. Kochi Metro Rail project (i) Works matters – full powers, (ii) Stores matters – full powers, (iii) Establishment matters – full powers up to and including SAG level officers (orders for appointments to be issued by Corporate Office as per DMRC Policy), (iv) Miscellaneous matters – full powers. 2. Kerala High Speed Rail project 3. HSRC Bangalore and Prime Consultancy for Chennai Metro....... This issues with the approval of Managing Director/DMRC.

As can be seen from the letters above, not only was he given full powers for the execution of the Kochi Metro project, but also for the Kerala's High Speed Rail (HSR) Project, and other consultancy works at Bengaluru, Chennai, and other cities as and when assigned.

Kochi Metro is already saving money for the public exchequer due to its innovative work and designs. Its consultant, DMRCL, completed Pachalam Overbridge as a part of Kochi Metro preparatory works in a record ten months at 25 per cent less cost than the projected estimate, despite a slew of

agitations that stalled works for nine months. The bridge and land acquisition together cost ₹39.50 crore, whereas the estimate was ₹52.50 crore. Sreedharan noted:

> The Government saved ₹13 crore. Besides this, another ₹500 crore has been saved for the 18-km-long first phase from Aluva to Ernakulam Maharaja's College ground, due to the innovative design adopted and contractors quoting 15 to 20 per cent lesser for the works tendered. The savings are from the rolling stock procured, civil works, electrical, and signalling for the 18km first reach, for which the work is on full-swing.

APPOINTED TO KAKODKAR SAFETY COMMITTEE IN 2012

The Indian Railways appointed Sreedharan on several committees post retirement, seeking his advice. One of these was as a member of the High-Level Safety Review Committee headed by Anil Kakodkar in 2012; the Committee had been constituted by then Railway Minister Dinesh Trivedi.

The Committee submitted its report in February 2012 and made various recommendations for improving railway safety, needing an outlay of ₹1 lakh crore over a period of five years.

The elimination of all level crossings from the railway landscape within five years as a measure of avoiding accidents and deaths was one of the key recommendations of the Committee.

The committee gave recommendations pertaining to general safety matters, organizational structure, empowerment

at working level, vacancies in critical safety category, shortage of critical safety spares, human resource development and safety architecture of the Indian Railways.

The Committee's report was put in cold storage for some time, but with Sadananda Gowda assuming office in 2014 and focusing on safety as his top priority, the Ministry went back to the drawing board with Kakodkar report in hand and the Ministry took it ahead.

APPOINTED AS ONE-MAN COMMITTEE BY RAILWAYS IN 2014

Four days after being appointed as India's Railway Minister on 9 November 2014, one of the first things that Suresh Prabhu did was to appoint Sreedharan as a one-man committee to suggest a, 'proper system and procedure to ensure proper accountability and transparency,' for taking all commercial decisions.

Sreedharan was given two weeks for the submission of an interim report, and a period not exceeding three months for a final report. Working single-handedly (he mentions so in the report), Sreedharan prepared interim report in the stipulated two weeks, suggesting delegation of more powers to the GM.

An order issued on 13 November 2014 said the Committee with Civil Engineering Directorate of the Railway Board as the nodal unit for recommendations, has been appointed for the sweeping reforms being worked out in the Railways to attract private and foreign investment.

Order No. ERB-I/2014/23/46 issued on 13 November 2014 by N. Soman, Joint Secretary (Gaz.) Railway Board, stated:

One-man Committee headed by Shri E. Sreedharan, former Managing Director, DMRC, to suggest a proper system and procedures to ensure proper accountability and transparency at the General Managers and other functionaries level for taking all commercial decisions, including that of tendering.

The terms of reference of the Committee were to suggest a proper system and procedures to ensure proper accountability and transparency at the General Managers and other functionaries level for taking all commercial decisions, including that of tendering and therefore, all the powers will be delegated to the operating levels so that proper efficiency in decision making is ensured. No tendering will be dealt with at Minister's level.

The Committee would suggest the system and procedure and a manual of instruction to be followed to implement the decision as above. The Management Information System to be used for proper and time-bound disposal of the cases. The Committee could, inter alia, recommend a professional organization to be engaged, if necessary, to provide an end to end solution to this process.

The Committee could co-opt any other person, if necessary. The Committee would submit an Interim Report within two weeks and a Final Report in a period not exceeding three months from the date of the constitution of the committee. Civil Engineering Directorate was to be the nodal directorate to coordinate with the Committee and its recommendations. The Committee started functioning from 13 November 2014. Meetings of the Railway Board and with general managers and

senior officials were held on 18 and 21 November in New Delhi and Chennai respectively, following a one-to-one discussion with former Financial Commissioner of Railways, Smt. Vijaya Kant.

The interim report was written and submitted by Sreedharan considering the views expressed and the valuable suggestions put forth in these meetings. The following are some of the key points mentioned in the Interim Report submitted by Sreedharan:

- There was an overwhelming acceptance to the idea of devolution of full powers in regard to tenders and commercial decisions to the level of General Managers. Everyone welcomed this idea as the very first and essential step to transform Railways as a vibrant organization responsive to people's needs and aspirations.

- General Managers have powers up to ₹150 crore in Works matters and ₹75 crore for procurement of stores, except for GM/North Frontier Railway and GM/Northern Railway, which have special powers to the extent of ₹300 crore to hasten projects of national importance given the social conditions there.

- A closer look and analysis of powers delegated to General Managers establishes that it is negative, prescriptive and restrictive. The way the powers are arranged today, Railway Board, it seems, does not trust business instincts and capability of its General Managers, the highest authority in the field. All contracts of higher value have to be necessarily dealt at Railway Board's level. There are many instructions issued by the Railway Board limiting the powers of General Manager, which all have to be given a fresh look for modification or cancellation.

- There was a common feeling among Board members and General Managers that the level of competency and experience between a GM and a Board Member is marginal, and no value addition takes place when tenders exceeding the powers of the GM are sent to the Railway Board. There was therefore a general acceptance that all tenders including Railway Board controlled items could be handled at the GM's level thus hastening the tender finalization process. If financial powers are totally delegated to GMs in regard to tenders, there is no need to deal any tenders at the Railway Board's level.

- General Managers as heads of Zonal Railways, production units and RDSO have to deal with many external factors apart from their normal duties of managing the system. These are: pressures from MLAs, MPs, organised labour, passenger associations, chambers of commerce, etc. This takes away lot of their time and energy. Now being responsible for taking all commercial decisions, getting estimates sanctioned and processing, and accepting tenders will cast enormous workload on to the post of General Managers. Therefore, a uniform schedule of sub-delegation of powers to lower levels needs to be evolved.

- All GMs' expressed confidence that they could do so provided the associated finance play their role in a more constructive and positive way, and take equal responsibility with accountability for processing and finalising tenders.

- I would here emphasise and reiterate that if GMs are to handle all decisions in regard to sanction of estimates, finalisation of tenders and to lead the railways from the front, we need entirely a different crop of GMs, which is

possible only through a positive act of selection. A system and procedure to ensure no post of GM or member remains vacant at any time has to be in place before more responsibilities are thrust on GMs.

The interim suggestions included giving zonal managers full powers in regard to works, stores procurement, service and commercial tenders, decentralisation of board-controlled items and having full powers in regard to sanctioning of estimates. Sreedharan maintains that DMRCL and KRCL are shining examples, which have registered outstanding success, as a result of ample delegation of powers to the MDs.

Sreedharan submitted his interim report on 27 November 2014 (less than a week after the second meeting on 21 November, and just nine days after the first meeting on 18 November). And to assist him prepare the final report—that would include a manual of instructions for laying down procedures to devolve powers to GMs in another three months—one of his trusted colleagues, Akhileshwar Sahay, a senior Indian Railway Accounts Service officer, who has been with him since his Konkan Railway days and later with the Delhi Metro, was appointed a day later.

The Ministry immediately got cracking on the report and on the basis of the Interim Report itself, decided on 2 January 2015 that all the cases for acceptance of works and stores tenders, (which as per extant delegations were to be referred to the Railway Board by Zonal Railways and production units), would now be dealt with and finalized by Zonal Railways and production units.

The detailed Final Report was in by March 2014, and the Ministry constituted an empowered sub-committee for

processing implementation of its recommendations and taking a final decision within 10 days. 'The final report was quite detailed and had exposed a lot of issues that affect Indian Railways. The Railway Board is yet to accept the final report though,' said Sreedharan.

APPOINTED TO J&K RAIL COMMITTEE IN 2014

On 2 December 2014, the Railways set up a four-member panel headed by Sreedharan following a Delhi High Court Order to decide on the alignment of a section of a railway link on the ambitious the Jammu–Udhampur–Srinagar–Baramulla railway link.

The Committee submitted its report to Railway Minister Suresh Prabhu on 4 February 2015, expressing concern regarding the existing alignment and the poor survivability of the tunnels, bridges and cuttings against the threats of landslides, and earthquakes. It also addressed the security risks arising out of the line's proximity to the Line of Control (LoC on the Indo-Pak border). This led to strong criticism of Sreedharan and his team from the Indian Railways.

The Indian Railways not only rejected the report findings, but also questioned the safety standards of Konkan Railway, built by Sreedharan. Questioning the Konkan Railway's 'speckled safety record', and providing a detailed report of accidents on the line that had resulted in the death of 71 passengers since it started, the Indian Railways in an affidavit in the Delhi High Court said, 'even experts can make mistakes', questioning the credibility of Sreedharan in August 2015.[45]

Looking at the project in details revealed the following: the

Jammu–Udhampur–Srinagar–Baramulla Railway Link, starting from Jammu and covering 345km (214 miles) to Baramulla on the north-western edge of Kashmir Valley crossed major earthquake zones, and was subjected to extreme temperatures of cold and heat and inhospitable terrain, making it an extremely challenging engineering project.

The terrain passed through the young Himalayas, which are full of geological surprises and numerous problems. The alignment for the line presented one of the greatest railway engineering challenges ever faced, as it had to cross the mighty Pir Panjal range, with most peaks exceeding 15,000ft (4,600m) in height.

The Jammu–Udhampur–Srinagar–Baramulla Railway Link is expected to cross a total of over 750 bridges and pass through over 100km (62 miles) of tunnels, the longest of which is 11.215km (7 miles) in length.

The greatest engineering challenges involved the crossing of the Chenab river, which involved building a 1,315m (4,314ft) long bridge 359m (1,178ft) above the river bed, and the crossing of the Anji Khad, which involved building a 657-m-long (2,156ft) bridge 186m (610ft) above the river bed. It will be the highest railway structure of its kind in the world, 35m higher than the tip of the Eiffel Tower in Paris.

While the 53km rail link from Jammu to Udhampur was completed in 2005, the 130-km link between Baramulla to Banihal was opened in October 2009, and the 25-km link from Udhampur to Katra opened in July 2014, the 148km Katra-Banihal section still remains to be constructed and is proving as one of the most difficult stretches, stuck in alignment disputes and controversy. It is expected to open by 2020. This is the most

difficult section of the rail line, with 62 bridges and multiple tunnels and also requires laying of 262km of access roads.

In July 2008, the work in some section of the Katra–Banihal section was suspended, so that a realignment could be considered. An alternative alignment proposed by the Railways reduced the length of track from 126km to 67km. The Expert Committee appointed by the Railway Board recommended abandoning 93km of the previously approved alignment.

On 12 November 2014, Delhi High Court directed the Central Government to constitute a Committee to review the 126-km long section of the rail link and submit a report in four weeks.

On 2 December 2014, the Railways set up a four-member panel, headed by Sreedharan, and which submitted its report on 3 February. This Committee expressed 'serious reservations on the safety and stability of the Chenab bridge.'

In its report submitted to Railway Minister Suresh Prabhu on 4 February, the four-member Committee unanimously stated that 'on this score alone, we are unable to endorse' the critical section across the Himalayan barrier from Katra to Banihal leading to Kashmir.

Though it was touted as a 'signature bridge', the Committee gave eight reasons regarding the 359m-high bridge's 'inadequate' safety factor. The 31-page report underscores the dangers posed to the mega-arch bridge by earthquakes, landslides and the proximity to the line of control. 'If this bridge is damaged, its restoration will take a minimum of five to six years. As a result, the link to Kashmir Valley may remain disrupted for years together,' the report said.

The Committee, therefore, recommended the scrapping of

the alignment of 126km between Katra and Banihal, skirting along the mountain slopes and geological fault lines. The biggest concern regarding the existing alignment was the poor survivability of the tunnels, bridges and cuttings against the threats of landslides, earthquakes, and the security risks arising out of the proximity to the LoC.

The alternative it suggested was a shorter and straighter alignment of 70km that will cut through the mountain ranges, shifting the location of the Chenab bridge from the gorge to the floor of the valley, thereby reducing its height from 359m to 120m.

Designed by Railways' Chief Engineer Alok Verma, the alternative alignment, 'cutting across mountain ranges and folds at right angles or near right angles and tucked deep into the mountains away from dangerous slopes is the right solution,' stated the Committee's report.

Though the practicality of Verma's alignment was questioned by engineers on the project, the Committee found it to be 'a practical and adoptable alignment, which could set the trend for similar railway projects being contemplated by the government in the Himalayan region,' adding that 'the new proposed line can be constructed faster and possibly at a lesser cost than what it would take for the balance works on the existing alignment to be completed.'[46]

The Committee stated that if 'the present pattern and style of implementation is followed,' the project already delayed by eight years, would not be completed 'by any stretch of imagination' in another eight years. It said that 'if the Government wants to complete the Project early, the present system and style of construction management will have to be changed.'

Accordingly, the Committee recommended that the execution of the new alignment be 'entrusted to a dedicated, fully Government-owned company,' which can take decisions on its own without any reference to the Railway Board. Without mentioning Sreedharan's association with Konkan Railway, the Committee recalled that a similar set up had been successfully tried for executing the Project along the Western Ghats.

Incensed, the Railway Board rubbished the report publicly in Court in July 2015, saying that the alignment suggested by the E. Sreedharan Panel was only a 'paper alignment' and required further study. It said the Committee's report did not state the proposed expenditure that would be incurred for implementing the panel's recommendations.[47] The Board also added that it was quite late to change the alignment now, as it had already spent ₹10,000 crore on the 124-km section.

It further added that the Panel's report had been scrutinized by each of the senior officials of its Engineering, Mechanical, Electrical, and Signalling departments, and each had disagreed with the Committee's findings. The Railway Board's affidavit stated that:

> Therefore, the entirely unsustainable observations made in the report by the Committee that the alignment can be surveyed, staked and investigated quickly in four to six months, is completely untenable deserving rejection at the threshold itself.'

The Railways also said the Committee had not held discussions with officials and international experts working on the project:

The Committee did not consider the voluminous documentation provided by the project team. The Committee did not allow presentations from experts, and it did not provide any technical justification and logic supported by any calculations or analysis in support of its paper alignment. The Committee had no topographic sheets to study, no geological, geotechnical, slope stability or seismic study reports to study about a paper alignment which is not even properly marked on paper. Therefore, the conclusions of the Committee are mere conjectures, fallacious, specious and delusive statements.

The Railways further questioned Konkan Railway's 'speckled safety record', providing a detailed report of accidents on the line that had resulted in the death of 71 passengers since it started, emphasizing that 'even experts can make mistakes'. It also said that 'in stark comparison to Konkan line's record, there has been no casualty in the Jammu–Baramulla line,' which was built in far tougher geological conditions.

As of now the final project deadline stands pushed back to 2020, or beyond.

APPOINTED TO UNITED NATIONS ADVISORY GROUP, 2015

His latest appointment, as of writing this book, came in 2015 (when he was aged eighty-three) appointing him as member of the United Nations' High Level Advisory Group on Sustainable Transport (HLAG-ST) on invitation from UN Secretary General Ban Ki-moon. He has been serving as a member of HLAG-ST

since September 2015 and will do so for the next three years.

The HLAG-ST will formulate recommendations on sustainable transport actionable at global, national, local, and sector levels and work with governments, transport providers–aviation, marine, ferry, rail, road, and urban public transport–businesses, financial institutions, civil society, and other stakeholders to promote sustainable transport systems and their integration into development strategies and policies, including in climate action.

It will provide a global message and recommendations on sustainable transport, including on innovative policy and multi-stakeholder partnerships, and launch a 'global transport outlook report' to provide analytical support for these recommendations.

Sreedharan said that the HLAG-ST report was submitted to General Ban Ki-moon on 27 November 2016.

The Secrets behind Sreedharan's Success

Former President of India and world-renowned space scientist Dr A.P.J. Abdul Kalam, speaking on 8 September 2012 at the 31st National Meet of the National Institute of Personnel Management, in Kochi stated, 'E. Sreedharan is one leader in India who worked with integrity and succeeded till the end.'

Completing gigantic projects within budget and deadline is not a simple task. It involves various complex facets in project management, understanding of wide-range of issues, come up with practical and instant solutions, keep the team motivated as being a team leader every move of yours is minutely observed, balancing the political and other pressures, and man-management which is itself a huge and delicate job.

Both the high-profile projects—Konkan Railway and Delhi Metro—were completed within the budget and deadlines. How can one achieve such results always, especially working in a Government set-up?

The answer to this was given by Sreedharan himself during his 30-minute speech at the Project Management National Conference 2012, a three-day professional development event, conducted by Project Management Institute (PMI), India and hosted by PMI Chennai India Chapter & PMI Kerala Chapter. The following excerpts give an important glimpse on the work culture and ethics followed by Sreedharan and his work, in his own words:

> We were able to complete the projects within deadlines because of a unique work culture that we were able to bring in and nurture in these two organizations. I think the four major pillars of work culture are punctuality, integrity, professional competence, and a sense of social responsibility or accountability.
>
> I give the highest importance to punctuality among the four of them.

PUNCTUALITY

The two projects—Konkan Railway and Delhi Metro—are meant to run trains. We realised that unless we are punctual we cannot expect our trains to be punctual. This realization came right from the beginning.

On the Delhi Metro, for example, about 3,000 trains run. World over, the metro train is considered late if it is three minutes late. If a train is late by three minutes, it is deemed to have lost punctuality. In Delhi Metro, we brought down the punctuality standard to 60 seconds. If a train is late by more than 60 seconds, it is deemed to have lost punctuality. And generally,

the punctuality of Delhi Metro is about 99.6 or 99.7 per cent.

Punctuality is also equally important for project management because we have to finish projects on time.

COUNTDOWN CLOCKS

We had a system first on Konkan Railway and later on the Delhi Metro of what is known as a countdown clock—a clock, at all offices and all the important sites, that indicated how many days were left for that particular component of the project to be completed. The countdown clock used to automatically update, every day, and was a constant reminder, a driver for everyone, for engineers, contractors, suppliers. They knew that only so many days were left for the project to be completed. And in project management, time is money. Each day you lose in the project, you are losing a lot of money. We calculated that in Delhi Metro Phase I, each day the Metro was delayed, the DMRC would lose ₹1.5 crore, and in Phase II it was about ₹2.5 crore.

The converse is also true that is if you are able to accomplish it earlier, you will gain so much of money. So time is that important in any project management.

Sreedharan recalls that he had first seen the reverse clock in the 1980s at the work site of K.C. Khanna—a technocrat and eminent metallurgist with a background of the great steel mills of Bokaro, Durgapur and Bhilai and the first CMD of the Kudremukh Iron Ore Company Ltd, a Government of India undertaking formed in April 1976 at one of India's biggest iron ore projects.

The horse-face shaped hill, Kudremukh in Kannada, on the ridge of the Western Ghats in the district of Chickamangalur

in Karnataka state had rich deposits of iron ore. An Indo-Iran agreement was signed in November 1975 for delivery of 150 million tonnes of iron ore concentrates from the Kudremukh mines to the steel mills in Iran with a soft loan of ₹567 crores (630 million) to develop the mines.

Work gathered rapid pace under Khanna. Determined to deliver on time, it was remarkable how speedily the work was progressing with even files are travelling at an unaccustomed speed. In all 23,000 workers worked round the clock in rainfall and heat. 'Ours is a 24-hour job all seven days of the week,' Khanna had told the media then. In fact, Sreedharan met Khanna at his residence in Delhi to understand the concept before he implemented it. Here is what he learnt:

> Have a strict decision-making process: Decisions cannot wait because each day you delay a decision, it costs, so decision making in a project has got to be very fast.
>
> Timely delegation of powers: You delegate powers to trusted people in charge at pivotal points. Trust them. They may make mistakes, sometimes.

Sreedharan recalled:

> I used to tell my assistants that take a decision, go forward. If you make a mistake, doesn't matter, the management will step in and immediately rectify the mistake. But don't lose a day. The decision has to be thoughtful considering all aspects, not a reckless one though. That is how we used to get things done.

INTEGRITY

When I say integrity, it is not merely honesty or lack of corruption. It includes all activities. Transparency is the main factor of this culture of integrity. Everybody who joins the organization has to adhere to a certain set of values, commit to those values and every year these values are renewed. The fact is impressed up on the employees all the time and I think this made a lot of difference. Most importantly, I found that with this emphasis on integrity, there was confidence of the two governments on the organization. They trusted the organization. Whatever proposal we made were approved by the government without questioning.

PROFESSIONAL COMPETENCE

Delhi Metro was a complex project. Many of the technologies adopted were not known to this country at all. They had to be imported. It is a fundamental fact that if you know your job well, naturally you have all the confidence to do it well. There is always an assurance in the way you conduct yourself. If you don't know your job, you must learn it. If you can't learn it, engage someone who will help you to execute the job properly. This was given significant importance in the Delhi Metro project.

The result was in the first phase we had to hire foreign consultants, but from second phase onwards, we were entirely on our own. We learnt the tricks of the trade during the Phase I itself. And today, the Delhi Metro is not only doing the Phase III, but has conducted studies and investigations for all the other metros coming up in the country. Because Delhi

Metro was able to absorb the expertise and this knowledge, we were able to have a sort of a metro revolution in the country. This is professional competence and if one organization has got such professional competence, why can't it be replicated by other organizations?

SOCIAL RESPONSIBILITY

This is a very crucial aspect for any project management organization. If professional competence is about completing a project on time without cost overruns, it is also a social responsibility according to me, particularly so in regard to Government projects where you spend government money. It is the people's money, the tax-payers' money. It has to be spent for the right cause in the right way. This is social responsibility.

Another aspect of social responsibility is completing the project with least inconvenience to the citizens. When the Delhi Metro was being done, I don't think that the city ever knew what was happening. There was very little disturbance to city life. We used to barricade the construction area, light it up well, clean the roads.

The extent of social responsibility we assumed was the way the roads were kept clean where the works were going on. We ensured that vehicles coming out of the worksite, the wheels were washed before the vehicle was allowed on the road so that the muck was not carried onto the roads. Even so in the night, we used to clean and wash the roads.

Another issue was tree-cutting. There were too many permissions required. We on our own decided that we would plant 10 trees for every tree cut as a compensatory effort. This

was not dictated by the Government, but we on our own decided about it.

Social responsibility is a very important dimension of any project and implies that society should benefit from the project, and not suffer because of it.

GOALS

At both the places—KRCL and DMRCL—one of the first things that Sreedharan did as the head of each organizations was to put down and circulate the Corporate Mission and Corporate Culture (mentioned in the sections on Konkan Railway and Delhi Metro), so that everybody could work towards specific goals with a similar approach.

Sreedharan Muses on a Few Solutions

DELHI'S ODD-EVEN FORMULA WAS A MISTAKE

I find the present concept of pollution counts wrong. Cars have gone up and so has the smoke, but the real solution would be to encourage public transport. The Delhi Metro is saturated. We can increase the frequency of trains a bit, but there is need for more capacity expansion which is happening at its pace.

What Delhi really needs is a reliable bus service at a faster pace than the current one. I think the Delhi Government has made a mistake by buying those huge Tata Marcopolo buses which get stuck in traffic and block the entire road, like elephants. What Delhi actually needs is smaller, compact-sized CNG buses that can be run at better frequency.

The other solution for Delhi is to pump in more suburban services on the Indian Railways. There is scope for that. One more thing that could be done is to penalize motorists and levy

heavy parking charges, making owning a vehicle unaffordable. If a family has more than one car, the charges could go up accordingly as per the number of cars.

And lastly one needs to clean up roads. All studies have proved that the dust level is a major contributor to the SPM levels in any pollution statistics. If roads are watered and cleaned up regularly, this can straightway bring down pollution levels drastically. There is need for action on this front! The odd-even vehicle formula, I think, is impractical.

SOLUTIONS FOR MUMBAI TRANSPORT

Expressing shock over the number of people dying on Mumbai's railway network (about 10 die every single day), Dr Sreedharan said Mumbai need alternatives and they need it fast. 'The frequency of the existing suburban train system can also be improved by getting hi-end technologies like cab-signalling. A serious thought needs to be given fast,' he said.

The solution to crowding on Mumbai's trains would also be to build more metro lines. But metro travel has to be cheap and affordable and I find that the existing fare of the Ghatkopar–Versova Metro is very expensive. It should be affordable to the common man. I had suggested to the then Chief Minister of Maharashtra that Mumbai Metro should be run on the lines of the Delhi Metro, with 50:50 participation of Central Government and State Government instead of giving it to a private operator.

What Mumbai really needs is a sturdy network of underground metro lines. The new lines are being planned, but the pace of their implementation is very slow. Things would have

been different, had they been headed by a technocrat instead of IAS officers.

KONKAN RAILWAY NEEDS ELECTRIFICATION, NOT DOUBLING

(As the Minister of Railways Suresh Prabhakar Prabhu laid the foundation stone for commencement of doubling works along with electrification in November 2015 on the 25th anniversary of Konkan Railway, Sreedharan said he was not excited.)

I believe doubling the Konkan Railway will need more than ₹10,000 crore at the current price levels. To increase the capacity urgently, four key cheaper options are available: (i) urgent electrification of the route; (ii) a few more additional crossing stations; (iii) introducing centralized traffic control; and, (iv) simultaneous reception facilities at all crossing stations.

The above steps will easily give a capacity of 28 to 30 trains each way. On the Konkan route, we will not need more than this capacity for the next 20 years and the investment for all this would be less than ₹3,000 crore.

More important is the elimination of speed restrictions on the entire route, including slowing down of trains during monsoon. These protective works could be completed within two to three years, by which time electrification can also be done. Doubling of the line will take at least ten years for completion. When we originally built the line, we had procured all the required land, but at that point of time laying a double line would have shot up the cost very much and affected the deadline schedules.

WHY KERALA HSR IS IMPORTANT

Kerala has the highest road density in the country in terms of route-length per sq.km. It also has the highest vehicle density, if metropolitan cities like New Delhi, Mumbai and Chennai are excluded. Kerala also has the highest road accidents per sq.km, with fatalities touching 8,000 per year.

The state has a north-south orientation, 580km in length with an average width of 68km. It is heavily inhabited presenting an urban touch and flavour over the entire length. With the capital, Thiruvananthapuram, located almost at the southern end, and commercial capital Kochi in the centre, the travel pattern in the state is predominantly in the north–south direction.

The two corridors of transportation now available, the railway line and the national highways, have not been able to handle the heavy traffic. Railways are already doubled and almost fully electrified and line-capacity utilization is more than hundred per cent on many stretches. The north–south national highway has only two lanes for the most of its length and all efforts to widen it to four lanes have met with severe resistance. To augment the north-south capacity, there was a proposal to construct a separate eight-lane motorway from Kasargod to Thiruvananthapuram which had to be abandoned due to opposition to public opposition to land acquisition.

It is in the above context, that an HSR Line was considered by the Government from Thiruvananthapuram to Kannur, which could later be extended to Kasargod and Mangalore as well. A feasibility study was carried out by DMRCL and a report submitted to the State Government in September 2011.

Subsequently, the report was accepted and DMRCL started preparation of a detailed project report (DPR).

The main advantage of the HSR over the eight-lane motorway is that the carrying capacity of the HSR is almost double that of the motorway. The effective cost of a motorway, if the capitalized cost of its maintenance, cost of maintenance of road vehicles together with the fuel cost is taken, it is bound to be double that of the railway line. The fuel cost for carrying a passenger per km is only one-sixth the cost in road transport. Further, there will be no pollution, no road accidents and the travel time will be one-fourth of that by a motorway.

When the speed of a train exceeds 200km/hour it is called a high-speed train. Train speed on the existing railway tracks is limited to 80–100km/hour due to sharp curves and weak formations. The speed on the existing tracks therefore cannot be increased and HSR trains cannot run on existing tracks.

Similarly, all along the national highways on both sides there is heavy habitation and widening of these roads will meet with severe resistance. The route of the proposed HSR line has therefore been selected away from these two travel corridors, further to the east, mainly traversing through sparsely occupied areas.

The HSR will have a speed potential of 350km/hour, and the distance from Thiruvananthapuram to Kollam could be covered in 20 minutes, Thiruvananthapuram-Kochi in 53 minutes, Thiruvananthapuram-Kozhikode in 98 minutes and Thiruvananthapuram-Kannur in two hours.

Trains have to be planned to run every 15 minutes during peak hours and every half–an-hour during non-peak hours, although the line will have a capacity to run trains every

three minutes if needed. Of the total length of 430km from Thiruvananthapuram to Kannur, the railway line will be elevated over 190kms, underground for 146km and partially in cutting or bank for remaining length. The land width to be acquired for laying the HSR Line will be only 20m.

The detailed survey has shown that the total area to be acquired will be 600 hectares, of which private land accounts for 450 hectares. The total number of affected structures will be only 3,868 along the entire length, and affected trees about 37,000.

In the opening year of the HSR, about one lakh passengers per day are expected to travel, which will go up to 1.25 lakh per day by 2025, and 1.75 lakh per day by 2040. The level of patronage can make the HSR financially self-supporting.

The technology for HSR is now not available in the country. For the proposed Thiruvananthapuram–Kannur line, we need a strategy in line with the MoU signed by the Central Government with the Japanese Government for the Mumbai–Ahmedabad HSR line.

In that case, about 85 per cent of the project cost and technology could be sourced from Japan, with a moratorium of 10 years and repayment period of another 30 years on a low interest rate of only 0.3 per cent. Then, the investment of the Central Government will be only around ₹10,800 crore, and that of the State Government also about ₹10,800 crore.

It is expected that the HSR line would bring down road accidents by almost 30 per cent, saving around 2,400 lives every year. This alone is ample justification for opting for HSR. With more than a 1,000 vehicles being registered in Kerala every month, one can imagine the traffic congestion and spurt in road accidents in the future. Introduction of bullet trains between

Tokyo and Osaka in 1964 changed the very face of Japan and increased economic activity. I am of the view that an HSR line from Thiruvananthapuram to Kannur would change the face of Kerala, ushering in a new era of economic development in the state.

PUNE METRO SHOULD GET A DEDICATED TEAM

The latest metro railway to get approval of the Central Government in December 2016 is the 31.2km Pune Metro in two corridors. As per the decision, the existing Nagpur Metro Rail Corporation Limited (NMRCL), which is a joint Special Purpose Vehicle (SPV) of the Central and Maharashtra Governments, will be reconstituted into the MAHA-METRO for implementation of all state metro projects, except the Mumbai Metropolitan Region. Sreedharan said, 'The Nagpur Metro has a lot of work to do for itself and looking after Pune Metro will be an additional task for them. It will be taxing and could affect the prospects of Pune Metro. Pune should have had its separate and dedicated team.'

OHE VS THIRD RAIL

For high-capacity rail line, the overhead wire (OHE) system is best suited. If it is a small system, the third rail option can be worked out. It depends upon the carrying capacity and the aesthetics. Many people don't like the masts jutting out. In Bengaluru, our original proposal was with the OHE system and that time the MP from Bengaluru South, Ananth Kumar, was also the Urban Development Minister. He said, 'I don't

want the posts every 40–50m and hence we went in for the third rail. Most cities, however, have gone for OHE-based Metro systems. Only Bengaluru and now Kochi Metro are the ones that have the third rail system.

Sreedharan on Three Projects He Would Undo

If I can undo a few of my works, these three come to my mind immediately, of which one is already down.

CHENNAI STATION

Chennai Central Suburban or the Moore Market Complex was built around 1985. I was the one who built it as the Railways' Chief Engineer (Construction). But today, when I look back I think it could have been aesthetically better, something that would have been in sync with Chennai Central Station.

There is nothing wrong as such with the building, but instead of just the ordinary concrete structure with offices, it could have been more elegant and in a similar architectural style as Chennai Central Station. At that time, I did not think of it and built an ordinary concrete-type building. Given a chance, I would knock this building down to build a more elegant one in its place.

ROAD BRIDGE ON GURUVAYOOR RAIL LINE

Back here in Kerala, every time I travel by road and cross the road overbridge on the Thrissur-Guruvayur railway line, I find it always has traffic jams and is overcrowded. When we were building the railway line, the road was a single lane and the road over the bridge was built for two lanes. But now when I look back, I think, we could have built a wider road bridge so that it would not have got saturated, leading to road bottlenecks. This is another one that I would like to pull down and build a wider one.

ERNAKULAM BRIDGE

This is already down. The Ernakulam North road overbridge near Ernakulam Town railway station, popular as Ernakulam North, had been built by me as Divisional Engineer in 1962 in the then Olavakkode division (today Palakkad or Palghat).

It was recently brought down and reconstructed as a part of the Kochi Metro preparatory works. I was there to witness its demolition. The reconstruction was not in the original plans, as the metro alignment was to bypass the existing overbridge but since it would have involved land acquisition and demolition of buildings, the DMRCL, that is the Consultant for Kochi Metro, proposed rebuilding the bridge with four lanes and integrating the metro structure so that it passed along the median of the newly constructed overbridge.

Six

ENGINEERING AND BEYOND

Weaving Spirituality into Daily Life

Said Sreedharan:

> Usually, there is a feeling that project management brings
> lots of pressure, lots of stress. People always complain of
> stress levels in project management. It can happen, I am
> not denying that, but there is a remedy for it also. And
> that is, I think, a touch of spirituality. A spiritual attitude.
> I can recite one shlok from Bhagavad Gita which brings
> out your attitude in handling a major project:
>
> *Mukta sango nahamvadi dhrty-utsaha-samanvitah*
> *Siddhy-asiddhyor nirvikarah karta sattvika uchyate.*
> —*Chapter 18, Shlok 26, Bhagavad Gita*

This is a very important shlok for any project manager. It says
if you want to be a virtuous doer, you must not have too much
attachment to the work that you are doing. You must be very
efficient, very bold, energetic and very enthusiastic about the
whole project. You can still have all of that without having

attachment to the project. Then you should not bother about the results, whether it is a failure or success. If you are able to assume that state of mind and execute the project, I think you can never fail.

> I think this is a beautiful message from Bhagavad Gita for any project management expert. I have tried to practice these not only in Konkan Railway and Delhi Metro, but on my earlier assignments as well in the Railways.

Sreedharan is a living example of how the ancient religious text of Bhagavad Gita can be practically implemented in life. Studying Bhagavad Gita and reciting passages from them, he says, 'It is gospel for administration. It teaches you how to execute your business. This is not a Hindu text, and in my opinion Gita should be taught in schools without giving it a religious colouring.'

He has been learning Sanskrit after retiring retirement from the Indian Railways and has completed a correspondence course in Sanskrit from the Vishwasamskrita Prathistanam Samskrita Bharathi in Kerala. 'It is only after retirement that I got time for my personal interests,' he says, which is remarkable considering the amount of work he has packed in post retirement! In addition to spirituality, Sreedharan's day starts with the Yoga. 'A disciplined and a focussed lifestyle leads to success,' he adds. A look at his schedule is indeed inspiring. He gets up every day at 4.00 a.m., does some Pranayam, after which he recites or reads 45 minutes from the Srimad Bhagwatam. This is followed by 45 minutes of yoga, breakfast and then he heads for the home office he has created. In addition to this, he walks at a brisk pace for about 45 minutes in the morning in summers, and in the evening in the winters. His diet is strictly vegetarian without any kind of

milk products. In the afternoon after lunch he takes a 15-minute nap. This was his schedule even as MD of DMRC for 14 years.

As the MD was himself in his 70s and rarely took leave, employees followed his footsteps feeling embarrassed to ask for or take leave for common ailments such as fever, headache and bodyache.

Sreedharan's spiritual readings are also reflected in the work culture of the organizations he has been headed. All officers in the executive cadre of the DMRC are even today given a copy of the Bhagavad Gita, called Gita Makaranda written by Swami Vidyaprakashananda of Sri Suka Brahma Ashram of Sri Kalahasti in Chitoor district of Andhra Pradesh. In this, each stanza of the Gita is very well explained for the lay reader. Making a conscious effort to not allow power to go to his head, Sreedharan had a metal plaque inscribed with the following words and hung on the wall in his office at DMRCL, behind his chair:

> Whatever is to be done I do *(Karyam Karomi)*
> But in reality *(Na Cha Kinchit)*,
> I do not do anything *(Aham Karomi)*

This saying he had taken from Yoga Vashistha, a Hindu text ascribed to Valmiki narrated as a discourse of Sage Vasistha to Prince Rama. Its teachings explain the illusory nature of the world and the principle of non-duality.

It was very essential for him felt Sreedharan, as he had almost spent 20 years of his 50-year career as the head of an organization. In such positions, there is a natural tendency for sycophants and herd followers to hero worship and flatter, which can go to the head of any CEO and also prove dangerous for him/her and the organization.

Sreedharan on His Guru

I had heard about Swami Bhoomananda Tirtha and his religious spiritual lectures. One day I read in the newspaper that Swamiji was giving a lecture at the Federation of Indian Chambers of Commerce and Industry (FICCI) Auditorium. So I simply went there out of curiosity to listen to him. I didn't know him at all. I heard the lecture and liked it so well that I attended all his lectures over the next three days. On the final day, he was distributing prasad and I went up to him and I was introduced to him by Kishan Chandra who was Member (Engineering), Railway Board when I was Chief Engineer, Southern Railway. He was very fond of me. He was also a devotee of Swamiji and he introduced me to him.

Swamiji then said, 'Why don't you come to the ashram?' From that day I became a devotee of Swamij. This was in October 2002, just before the formal opening of the metro. In fact, Swamiji came to the metro before it was opened. I took him for a ride on the metro train too.

Swami Bhoomananda Tirtha has been known for his talks

and discourses on Vedanta, Bhagavad Gita, Upanishads and Srimad Bhagavatam, and their practical application in daily life. He has also organized various movements to end unlawful rituals practiced by some Hindu temples. Born in 1933 in the village of Parlikad near Wadakkanchery in Thrissur district, in present-day Kerala, he has his headquarters at the Narayanashrama Tapovanam, located at Venginissery village, 10m southwest of Thrissur city.

The Ashram conducts classes, workshops, discourses, interactive satsangs etc., to explain the messages of Bhagavad Gita, Srimad Bhagavatam, Upanishads and other spiritual texts, highlighting their application in practical life situations. The Ashram's knowledge dissemination centres—called the Centres for Inner Resource Development (CIRD)—are located in Delhi and Jamshedpur in India, Vienna (Austria), Virginia (USA), and the Society for Inner Resources Development (SIRD) is based in Kuala Lumpur, Malaysia.

FOUNDATION FOR RESTORATION OF NATIONAL VALUES

Established as an independent society, with Sreedharan as President, the Foundation for Restoration of National Values (FRNV) has an Advisory Board including Sreedharan, former Chief Justice of India, M.N. Venkatachaliah; Tata Group Chairman, Ratan Tata; former Central Vigilance Commissioner, N. Vittal; former Chief Election Commissioner, T.S. Krishnamurthy; and Educationist and former Chairperson National Commission for Women, Vibha Parthasarathi. The FRNV has filed several public interest litigations and taken up

electoral reforms and police and administrative reforms too. Says Sreedharan:

> The idea of this Foundation took shape in the ashram of Swami Bhoomananda Tirtha, whose disciple I am. The compulsion for starting an organization like this stemmed from the rampant corruption taking place in the country— India is ranked 85th in Transparency International's Corruption Index.

In 2009, Sreedharan along with FRNV General Secretary Bharat Wakhlu met then Prime Minister Dr Manmohan Singh and held deliberations at the National Summit on Values, and discussed the emergent steps arrived at to redress the value-crisis. Appreciating the efforts of the Foundation, the Prime Minister expressed that political parties which benefit from corruption and black money, would have to take the lead in eliminating the malady. He said that citizens must collectively raise their voice in favour of representatives who are ethical and free from taint. Towards this, Sreedharan suggested formation of an Electoral Reforms Commission.

Sreedharan on Money and Charity

By the time I retired from the Railways, I was left with no money; almost nothing, one could say. Getting transferred across the country and using up most of the money for the children's education etc., I was never able to save anything. Now that I was retired from the Indian Railways, I decided to settle down in Chennai and with the help of my son Krishna Das, bought a small flat after procuring a loan from the LIC for about ₹7 lakh. But then the Konkan Railway happened and I could never go there. From there, I took over the Delhi Metro project. And recently, when we planned to settle down in Bengaluru, we sold off the Chennai flat and got about ₹40 lakh for it. But my wife's mother had been unwell and we had to come down to Ponnani, Kerala, to look after her. Since then, I have settled here and now after the stints in Konkan Railway and Delhi Metro, I have enough money. I do not know what I would have done, if Konkan Railway offer had not happened.

After I started getting awards—and many of them had cash components—I started a trust in my mother's name, the Smt

Elattuvalappil Ammalu Amma Memorial Charity Trust, and put all the money there. One of my first cash awards was in 1992 and the money from that award went to this Trust. I do not publicize much about this, but the Trust, with all family members as Trustees, today has a corpus of over ₹1 crore and helps needy students.

In fact, in the last few years before I retired from Delhi Metro, I started donating about 10 per cent of my salary to charity. Slowly, the sum increased and a few months before I retired, my entire salary used to be donated for charity purposes. The charity work is going on very well. In fact, just yesterday we helped a girl student from Dindigul, who would have had to abandon her engineering studies had she not paid her college fees. It was a question of ₹21,000.

The girl—whose parents were very poor—had been a topper all the time at the college and needed to pay fees of ₹21,000 to appear for her exams. A group of citizens who know I do charity work approached me here at Ponnani and I extended help. If the fees were not paid, a bright girl would have had to abandon studies and lose a bright future.

We have our own ways to verify facts. If required, I send someone to physically check things out and the money is released only after we establish the facts. We also encourage school and college students who excel in studies, and I visit institutions to talk to them.

Guru, Swami Bhoomananda Tirtha, On Disciple Sreedharan

INTELLIGENCE, INTEGRITY, AND INDUSTRY: THE THREE I'S OF SUCCESS

Harih Om Tat Sat. I have been visiting the National Capital since 1965 consecutively for the annual Jnana Yajna, (spiritual discourses), which have great relevance for administrators, corporate executives, educationists, householders and others. It was possibly Krishan Chander, a longstanding disciple and former Railway Board Member, who took me to Sreedharan's heart.

Sreedharan began to attend my discourses in Delhi. He came to meet me for the first time in October 2002 at the Centre for Inner Resources Development (CIRD), located in Vasundhara, Ghaziabad, and the association grew steadily, leading to his receiving Brahmavidya deeksha from me.

INTELLIGENCE: THE EPITOME OF WORTH AND ABILITY

Mind and intelligence are resources a distinguished performer should cherish. They alone will make any performance facile, swift and creditable. When one's mind is qualitative, organized and disciplined, whatever one does will also be equally meritorious.

Discipline, loyalty, fondness for the nation, and professional propriety irresistibly reflect in whatever Sreedharan does.

When Delhi Metro faced a serious girder collapse resulting in loss of lives, Sreedharan was greatly hurt. He rang me up, and said, 'I propose to resign my job.'

I agreed, adding, 'in case the Government wants you to withdraw the resignation, do not resist.' He also said he would have to take some hard decisions following the accident, to ensure all-round alertness, attention and circumspection.

I stated that any administrator, to be effective, would have to take hard and even painful decisions. In fact, Bhagavad Gita deals with the problem of fighting one's own kith and kin, making Arjuna's mind reconcile spiritually with the painful task; preparing his mind to meet the challenge with composure, stability and resolve.

INTEGRITY: SUPREME MANAGEMENT QUALITY

I used to enquire about DMRCL projects and extensions, and once expressed a wish to visit DMRCL. He arranged the visit and in the conversation that ensued en route, I asked him: 'Will you tell me the qualities or merits that distinguish your performance?'

He replied, 'Integrity is the quality that makes the Government of India entrust me with this ₹10,000 crore project.'

During conversations I have heard him say, 'This is a promise DMRC has given to the people, the nation. And we cannot fail in it.' Professionalism, competence, commitment and accountability are the other watchwords he used to emphasize during some of the meetings, in which I was present.

Having been born in a good family, coupled with a good upbringing, with occasion to see how elders heed and uphold values, is the greatest grace bestowed on anyone aiming to grow and achieve great tasks for society and the nation. Sreedharan is blessed with such a birth and growth, empowering him with an inner personality to take up any task with confidence and achieve it with distinction.

INDUSTRY: NATIONAL SERVICE IS NO CONFLICT TO SPIRITUAL PROGRESS

Later, when the Government asked him to continue for another three-year term, he came to me and said he wished to retire, so as to devote more time to spiritual pursuits and scriptural studies. I told him:

Accept the three-year extension. Your spiritual interests need not stand in the way. I shall look after them and give you the necessary guidance. There is no conflict between spiritual growth and professional pursuits. It is the mind that matters. Mahatma Gandhi's words come to mind, 'I am striving for the independence of India. But it is for me a full-fold sadhana.' Any such striving brings more and

more inner purity and expansion, which are the essentials of spiritual sadhana.

Any work, more so national service, if done with dedication, becomes equally a spiritual sadhana, one significant effect of which is inner expansion, generating more and more of dedication and sacrifice. Yours is a national mission, and its pursuit is no doubt a spiritual sadhana too.

A spiritual mind will continue to remain so, in profession and home alike. This is the secret of true spirituality. Did not Arjuna fight the Kurukshetra war, as part of his spiritual sadhana? The entire dialogue of Krishna was meant to transform the war into a full spiritual sadhana. Let the same Gita make your professional life also a sublime spiritual pursuit. This consists in ensuring that this is your true spiritual life, growth and enrichment.

How insightfully Sreedharan built a special reserve of ₹1,500 crore in DMRCL for use by the metro any time! How, in critical moments, he invested the share contributions given by the Central and State Governments and ran the establishment with only the interest the deposits fetched, to the surprise of the Minister and others concerned! It is an illustrious chapter in his dedicated administrative career, a lasting lesson for those aspiring to be prudent administrators.

How happy I was when I heard DMRCL could make its financial contribution to its second phase of expansion and construction. By the time additional lines were commissioned, DMRCL had started making an operational profit of ₹1 crore a day, something every Indian was proud of.

The triumph of a leader also consists in identifying and grooming a competent successor. Sreedharan proved his mastery in having trained Mangu Singh, who heads DMRCL, which has subsequently doubled its operational profit per day.

KONKAN CURSE VS DMRCL GRACE

I wanted Sreedharan to document the highlights of his professional life, revealing the challenges he faced and persecutions he underwent, during his tenure in the Konkan Railways. It was due to his experience there that he insisted on having absolute powers, while accepting the DMRCL assignment.

People of outstanding merit and executive excellence should be given a free hand in discharging their responsibilities and accomplishing assigned tasks. By such reliance and encouragement alone, is the legacy of excellence promoted and reinforced, taking the nation to greater all-round advancement.

IAS should also identify and suggest such dispensation of powers, with fraternity and prudence. We should not precipitate any conflict between the nation's administrative cadre, and its technocrats, whose expertise is vital for performance excellence. The motto for all should be 'help and facilitate the nation's growth and advancement by ample mutual and collective spirit.'

CHARACTER PARAMOUNT IN INTERPERSONAL BEHAVIOUR

In any arduous national task, what counts supreme is the inner calibre of the functionary charged with such task—especially when his calibre has to shine despite the wishes of political

lords. The IAS nevertheless has vital responsibility. In a close interaction between the IAS officer and the technocrat, what verily counts is the personal character, as well as refinement and elegance in interpersonal behaviour and interactions that should be as sublime as possible. This is where one's inward spiritual enrichment holds sway and bestows grace. Sreedharan carries the qualities and grace of devotional fervour and spiritual refinement.

In crucial matters, warranting great insight and tolerance alike, Sreedharan admits how his earlier religious and later spiritual affinity and sadhana have stood him in good stead while taking a firm stand and keeping the national interest above all else.

Vishnusahasranama, forms part of the instructions given to his grandson Yudhishthira by the great Bheeshma as he lay dying on a bed of arrows in Kurukshetra, after the Mahabharata war. Reading the Vishnusahasranama has provided Sreedharan untold strength and inspiration to be unflinching in his dedication and resolve, invariably to the surprise of his own team as well as others. His association with me and the spiritual initiation deeksha he had into Brahmavidya, I believe, has had even a more significant role in all this, as for Arjuna in the Kurukshetra war.

Wholeheartedly pursued, integrity is unyielding to any unjust pressure from wherever it may come. In Konkan Railways, on a certain matter, there was pressure from the Railway Minister resulting in Vigilance officials telephoning Sreedharan asking for files. Subsequently he told them the files were ready and could be collected any time. The files were not collected. Instead what Vigilance officials said afterwards was surprising, 'If you have anything to say, come to our office.' Sreedharan was unshaken.

He responded, 'I have nothing to say. The files will speak for themselves.' The whole matter was put to rest thereafter.

ADMINISTRATIVE PROPRIETY VS POLITICAL VENDETTA

In DMRCL, a State-Centre joint undertaking, political interference was enhanced. Systems and procedures are the best safeguards to ensure competence, transparency and speed. Appropriate systems can reveal any omission, negligence or other lapses, equally their absence.

Sreedharan had set up a high-level committee for issuing and opening of tenders, evaluating and selecting them judiciously. Nonetheless, the political leadership was not happy when the very first major tender was awarded. They wanted the letter of intent (LOI) issued to the selected tender to be withdrawn and, instead sent to their favoured tender. They threatened Sreedharan with disciplinary action if their advice was not heeded. Sreedharan held his ground, as any such withdrawal of LOI would only discredit DMRCL's integrity, tarnishing its national and global image. The other side had to finally yield to the call and compulsion of integrity, subduing their inferior personal impulses.

In another instance, for modernization of Delhi Airport, the Government of India invited tenders for selecting a concessionaire and because of a serious difference of opinion in the Tender Committee the case was referred to Sreedharan for an objective evaluation. Sreedharan's recommendation was against what the Ministry expected. But elected minds have their own sense of superiority, and they steered the matter to the

Central Cabinet Committee. The Cabinet Committee approved Sreedharan's action with due credit and compliments.

This is a testament to how values and disciplines, such as integrity, transparency and accountability can protect, insulate and elevate a functionary entrusted with national tasks to such eminence that even the Prime Minister would find it hard to disregard or overrule his views and decisions.

KOCHI METRO EXCELS IN PRE-SCHEDULE COMMISSIONING

Tendering for Kochi Metro was deterred by uncalled for bureaucratic obstacles, although the press, political leaders and the public were vociferous with their pro-Sreedharan stand. Despite the few months lost by DMRCL in calling for tenders, the Kochi Metro trial run was due for the last week of February, ahead of schedule. I understand that in place of the projected four years, 18km of the project would be commissioned within three years.

Against the background that no metro in the world has started functioning within three years from the start of the project, this clearly proves what relentless commitment and unsullied determination can fetch even against the worst of odds.

Land acquisition is the only hurdle that even now impedes Kochi Metro. It is obvious that there should be far more public awareness and expeditious Government action if public utilities like metro have to become a reality keeping to schedules and commitments.

Sreedharan's matchless professional success is a depiction of the power and strength of integrity for people holding high

responsibilities, aimed at enriching and empowering a huge nation of 1,250 million people. It also proves that spiritual dedication and sadhana are harmonious with professional life with all the commitments it entails.

When one comes to know our former Prime Minister Manmohan Singh complimented Sreedharan stating, 'You are the pride of India,' and a 'role model for future generations to come,' one is left wondering whether Government of India has amply recognized him, beyond the Padma Awards, for the yeoman service he has rendered to the nation.

In this regard, it is worth remembering that the President of France conferred the Chevalier de la Légion d'honneur (National Order of the Legion of Honour), on Sreedharan.

RAILWAY BOARD'S ILL-TREATMENT EVOKES DELHI HIGH COURT'S STRICTURE

It is hard to comprehend how bureaucratic minds can be so malicious and insensitive in dealing with human propriety, under the shelter and reason of administrative rigidity. Indisputably, effectiveness of the administration itself rests upon the faithful performance of its officers, a fact anyone in power should be sensitive to.

When Sreedharan became MD of KRCL, a Corporation distinct from any department of the Government, the question of aggregating his salary with his Railway pension came up, for some reason. In all fairness, Sreedharan asked his officers to refer the matter to the Railway Board, as it concerned himself. The Railway Board hurriedly instructed KRCL to deduct monthly ₹4000 from his salary, virtually making the MD's remuneration

less than his Chief Engineer's. He wrote to the Railway Board representing the impropriety in the matter. Finding no response, he issued a notice, and followed it with a legal notice, which too went unheeded. He then moved the Delhi High Court. So touched by the gross injustice the Railway Board meted out to Sreedharan, that his lawyer Tarun Johri argued the case without any fee.

Pension is admittedly the reward for good and faithful service, already rendered. There is no question thus of withholding or denying it to the pensioner. The Delhi High Court ruled that Sreedharan's appointment in KRCL, 'was not re-employment in civil services, or on a post in connection with the affairs of the Union Government. If the plea of the respondents is to be accepted, then such a re-employed employee would be working without getting anything.'

The Court decreed that the entire amount with, '12 per cent interest per annum be paid to Sreedharan within four weeks,' together with costs. The Railway Board decided to appeal. But the Division Bench of the Delhi High Court told the petitioners not to harass the honest officer any more. The Court said in the event the Railways pursued the matter any further, proceedings under Contempt of Court would be clamped.

Instances of this kind should tremendously inspire honest hearts and minds, entrusted with national tasks, to be devout and relentless in their pursuit. Sreedharan says the force and inspiration behind whatever he did was *Satyameva jayate*, the Upanishadic pronouncement that truth always wins, which our country accepted as the National Motto upon Independence. Mottos are not mere words, but a living force, compulsion and commitment for those who faithfully heed them.

Insensitivity and ill-treatment like this will gravely retard the nation's progress, causing also untold loss to the Exchequer as well as general demotivation of performing officers. It also speaks strongly against the unperceptive and myopic outlook of its officials. To force an illustrious retired Government officer to approach the Court against the Government's own unjust treatment, especially in paying the pension due to him, brings disgrace to all concerned, and should be avoided at all costs. At the same time it also tells how persuasive, honest and relentless a man of integrity can be in dealing with injustice meted out by even the highest powers that be.

In this context, I am reminded of a speech I delivered to IAS trainees at the Lal Bahadur Shastri Institute of Public Administration (later renamed to RCVP Noronha Academy of Administration and Management), Bhopal, in 1975. 'How Impersonality should guide the Public Administrator' was my point of focus. Our IAS officers are selected for their intelligence, fondness for the nation, commitment and dedication, to strive for the welfare of the people. They are given special training, right in the beginning, to enrich their minds for the national task with its requisite vision and mission.

Any public administrator will function well only when he or she is able to remain impersonal and impartial in dealing with national matters. Keeping this in mind, the administrator should read and interpret the country's enactments and rules, in a manner so as to 'benefit and enrich' the people, giving them whatever is best possible, and not to 'hinder and deny' anything. This initial benevolent response is very important. It is a fundamental to be driven home repeatedly to all concerned.

Sundaram, who was heading the training programe,

conveyed to me that the young officers received the message well. 'The trainee officers appreciated your presentation the most,' he said.

Everything depends upon how an administrator looks at matters. He or she must think that those on the other side are the esteemed citizens of the country, for whose welfare are all the laws, rules and regulations of the State. No officer should deny the least and strive to do the best for the people in all matters.

In withholding Sreedharan's pension, the Railway Board officials erred grievously missing the impersonal, impartial and benevolent note, bringing disrepute to the Board as well as to their own ranks.

The country will advance and be safe only when the individual's possessiveness and allied constrictions dissolve into a national fidelity, attunement and expansion, by rightful reflection and inclusive introspection.

Sreedharan had decided not to use the Court decreed money for himself. Passing part of the money to his sons, he gave the rest to a charitable trust formed in his mother's name. All cash awards and rewards he receives for the talks he delivers on invitation, he uses for helping others.

The mind grows to such laudable philanthropic dimensions only when it feels contented with the personal and professional fronts. It is the societal bond that reflects the individual's inner predilections. Fortunately, this son of India has a contented and liberal heart, which has succeeded in acting sensitively with confidence and resolve, upholding the country and his own national commitment always.

When a student from a remote Kerala village wrote to

Sreedharan for help during her impending visit to Delhi as part of a college study tour, much against the addressee's seeming silence, his friendly and caring messenger was at the railway station to guide the team through the whole tour and give them a rewarding metro ride in the end. Sreedharan's administrative commitment and magnanimity has made him equally sensitive to the personal welfare and concern of others. This has raised him to the much coveted social pedestal he is now on.

FOUNDATION FOR RESTORATION OF NATIONAL VALUES (FRNV)

In 2007, I thought of founding an NGO to pursue administrative and other reforms, which the Parliament and Executive are somehow failing to achieve. I wanted to pursue these reforms at a high level and in an enlightened manner and had nobody other than Sreedharan in my mind as the most suitable person to head it. I proposed and he agreed to be its President.

The Foundation for Restoration of National Values (FRNV) was thus formed, with an able Advisory Body of eminent persons like Justice M. N. Venkatachaliah (former Chief Justice of India), N. Vittal (former Central Vigilance Commissioner), T.S. Krishnamurthy (former Chief Election Commissioner), Vibha Parthasarathy (former Chairperson of National Commission for Women) and Ratan Tata (eminent industrialist).

FRNV has taken up causes like Police reforms, and developing an educational curriculum focussed on national values. It has also preferred a few public interest litigations (PILs) in the Supreme Court, for improving the quality of national life and ethical standards in democratic governance. FRNV is

contemplating holding its 2nd National Summit shortly in the capital.

I wish many strive to know more about this son of India and how dearly he holds the Motherland, ever ready to offer himself in Her service. May She have more children of such calibre and dedication with such commitment and fondness for the nation. A truly enquiring mind cannot but wonder whether it is mere academic and professional skill that has made this son of India so illustrious. It is relevant to know that in anyone, mere external and objective knowledge and worth cannot result in exceptional performance and achievement.

INNER MERIT, THE REAL SOURCE OF OUTER EXCELLENCE

Human personality is far deeper and inward-sourced than what it is taken to be. Truly, when the inner mind is enriched with requisite qualities, then does one's performance become exemplary. I remember how the manager who conducted my visit to Telco, Jamshedpur, took me to the Test Track, the best then in Asia. During the talks that ensued, we slipped into the subject of organizational efficiency and precision. I remember having stated, 'When the mind is organized, everything one does will be organized. All qualities and skills verily belong to and rest in the mind. One must first enrich and empower the mind. It is only then that all he does will also be enriched and effective.'

Our body completes its growth by 21 years. The only factors then to grow are the mind and the intelligence, which constitute the inner personality. The earlier this is understood, the better. All the disciplines, values and virtues we speak about are only

to imbue qualitative enrichment to the mind and intelligence.

Sreedharan was given to this inner personality building fairly early in life. Thanks to religious routines like prayers, recitation and the like, he has always been embellishing his mind and intelligence. Maybe after meeting me, his religiosity was enriched by spiritual refinement, which fine-tunes the mind and the intelligence, enhancing meritorius performance substantially.

Sreedharan has always left the office at 5.00 p.m., holding that the rest of the day is earmarked for the family. He goes to sleep by 9.30 p.m. to get up at 5.00 a.m. or even 4.00 a.m. Whenever in Delhi, despite his busy schedule, he regularly attends the Sunday satsang in CIRD, Vasundhara. Arriving sufficiently early, I recall he used to spread seats for participants and help in other preparations.

He regularly listens to spiritual discourses and reads spiritual treatises. He has liberally gifted spiritual books to his colleagues and friends. One such gift is my book, *Divinizing Every Moment*, a value he strives to imbibe, as well as instil in others.

To think of only physical, chemical, bio-physical, bio-chemical and biological laws as the unfailing system operating in the world, is to shut the doors on greater knowledge—a travesty any rational human should resent and resist at any cost. In the human personality where sentient constituents like mind, intelligence and ego are ceaselessly at work, the spiritual laws are even more irresistible. The spiritual always transcends the rest, like the mind does matter. Spiritual laws, though invisible, are experiential, like the working of mind and intelligence—a fact rational men and women cannot afford to ignore.

Krishna presents in Bhagavad Gita the fundamental truths and values of nature, describing how the sattvik law has its

reign. Sattvik gains, Krishna says, are 'poisonous to start with, and nectarine thereafter'. This is the benign (sattvik) quality of happiness, which has its source in the inmost sovereign Self, with its unique notes of sustenance, success and fulfilment for its votary.

Integrity is a virtue, to adorn the mind and the intelligence, but governed by spiritual law. Though not accessible to objective scientific research, it is experientially proven. Despite resistance, opposition and concerted adverse efforts, if Sreedharan was able to stand the test of top administrative scrutiny as well as the circumspection of the Judiciary, it was because of his integrity as much as the inviolable spiritual law.

Sreedharan often chants *Yogah karmasu kaoushalam*, words from Gita. It means, spiritual attunement makes one proficient and resourceful in one's pursuits. As Krishna's words sustained Arjuna 5,000 years ago, so they do receptive minds even today. The battle of life is the same then and now. The Gita's words should inspire and reinforce those fostering integrity, dedication, and accountability as watchwords to attain professional merit.

The world is neither hollow nor insensitive to the good and noble. It is keen to discern and shield them with utmost care and consideration. To strengthen the good to become better, best, and then super best, the coveted goal for all is perhaps the course they choose.

Integrity, which Sreedharan always upholds, has the intrinsic power to sustain and succeed. He has used it invariably for defence against the unjust officials and jealous bureaucrats, including the selfish political heads. For any meritorious individual, in whichever position, humility, coupled with timely assertion, are the proven means to achieve the best he or she wishes to.

Conventional possessiveness of bureaucratic minds, and the subtle ways they work, is so entrenched in the administrative system that it is as hard for its owners to dispossess, as much as it is cumbersome for the others to contend with. Instead of creating a recurring conflict for the equally important technocrats as well as corporate leaders, what the nation looks for is an exemplary mutuality, whereby each complements the other, like the wings of Garuda. The country will be greatly benefited only when such cooperative functioning graces Government departments. Will this dream come true?

When DMRCL was executing its projects enviably before schedule, to the recognition of the nation and to the widespread admiration of the world, the IAS blocs began to rumble with intolerance. There was subtle cry as to why such authority should be vested in one Managing Director? The lobby for curtailment of power was gathering momentum. But Sreedharan was firm with his dispassionate resolve that he would not be able to work as desired, with a curb in authority. He was sure that the reasons for seeking absolute powers at the time of accepting the assignment still prevailed.

If such freedom is necessary for executing a national project with speed and efficiency, should not the loyal IAS, the first custodian of our nation's welfare, uphold and vindicate it heartily? When are we going to shed our selfish myopic vision to imbibe the greater assimilative expansion, which alone will make the country grow faster, make it strong, viable and worth emulating?

Then Lt Governor of Delhi (a retired IAS officer) sensing danger, intervened to ask the IAS coterie not to disturb the smooth functioning of DMRCL by raising such avoidable

questions and attempting their contemplated interceptions. With that, better sense prevailed, and the concerted move was withdrawn.

Whether it was a candid admission and prudent retreat or an imposed reticence, is the fundamental question, posing to bless or curse the nation's great projects.

TRUE SPIRITUAL INWARDNESS UNDERSCORES A VIBRANT ACTIVE LIFE

When I visited DMRCL, it was revealing to find the following lines written on the wall in Sreedharan's office: *Karyam karomi na cha kimchit-aham karomi*, the last line of a verse I recite invariably to mark the conclusion of my talks. It is from Yogavasishtha Ramayanam, a record of the 18-day Sage Vasishtha-prince Rama dialogue the transpired in the Palace of Ayodhya.

It means, 'I do whatever is to be done, but verily I do nothing at all.'

When understood correctly, this is the epitome of spiritual wisdom, of a successful spiritual life of outstanding performance and abiding fulfilment. Rama was able to do all he did in the decades to come, solely due to the inner wisdom and strength Sage Vasishtha's words had imbued and instilled in him. Mind and words can do what matter and energy cannot, in stupendous measures.

Retreat is the spiritual inwardness one should diligently practise and achieve experientially. It is inevitably coupled with vigorous performance by the gross external senses. The two are not to be in the least conflict. Instead they are the secret of enlightened harmony and integration. Sreedharan is

one perhaps, who always rejoices in these words and strives to incorporate them heartily.

Born well, graced equally with good education, Sreedharan joined the National Railway Service, rearing his professional and administrative skills, which drew him to different national fields of management, administration and large-scale project execution, each time enhancing his skill, worth and proficiency.

Concurrently, he also grew in his familial, societal and spiritual dimensions, to be a veteran householder, a devout seeker and a social contributor—a personality wherein the domestic, professional and societal facets merge beautifully, complementing one another. Radha, his life partner, has always been a silent but vibrant participant and contributor in this rare multifaceted growth and enrichment. May he have all the health and inner abundance to fulfil his life of dedication and commitment, inspiring many a soul in his or her national fondness and commitment.

<div align="right">
Antaraatma,

Swami Bhoomananda Tirtha

1st February 2016
</div>

Narayanashrama Tapovanam, Venginissery, P.O. Paralam, Thrissur, 680563, Kerala; Tel: 0487-2278363
Email: ashram@bhoomananda.org

Seven

VOX POPULI

Bouquets and Brickbats

BOUQUETS

Srinivasa Venkatraman, Senior Stores Officer (Retd), Indian Railways, born in 1923, ninety-three-year-old Srinivasa Venkatraman joined the Indian Railways in 1942 and retired in 1982 as Senior Stores Officer. Nine years senior to Sreedharan in age and service, Venkatraman, though never having met his idol, has been a keen observer of Sreedharan's railway career. He penned down his observations:

> His remarkable abilities like Pamban Bridge reconstruction, Konkan Railway or the Delhi Metro are world-known, but I know this small man through his personal secretaries like Unni and Dandapani, in his long career and this is a plus point to know him closer.
>
> It is often said that cooked rice is tested by touching

and squashing it. Similarly, I will say that this man has been tested by his qualities and values that are reflected in small instances. He shares his lunch with small persons and small secretaries, chit chatting about day-to-day working to remain grounded all the time. Many times he has washed his plates himself without waiting for his peon.

When my eighty-year-old friend Dandapani, who had been Sreedharan's close acquaintance, was leaving New Delhi to stay with his son in Kolkata and expressed desire to see him once, Sreedharan, knowing Dandapani was a diabetic and so as not to physically stress him out, himself turned up at his doorstep within an hour, gifting him a book on Swami Vivekananda. Such small gestures and his values have made Sreedharan what he is today. Dandapani expired last year.

There are many such instances of this man whose actions are tall and have left a mark on Indian Railways' history. One thing that is important about him is that he will tolerate the worst and horrible mistakes of day-to-day working, but is dead against laziness, easiness, and corruption. This sums him up.

And that is the precise reason why Railway Minister Suresh Prabhu has chosen him for a quick report on the Reformation of Indian Railways!

SHASHIKANT LIMAYE, COLLEAGUE AND KRCL ENGINEER

I met Dr E. Sreedharan for the very first time in 1984 at Chennai

where as Chief Engineer (Construction), he was in charge of a large number of the Indian Railway's construction projects in the southern region. As a Professor of Indian Railways premier training Institute, I was conducting a study tour of a group of senior engineers from Indian Railways to these construction projects.

When I entered his modest office chamber I vividly remember him getting up from the chair and warmly shaking my hands. Despite his busy schedule, he then spent almost an hour with me and the trainee officers explaining some of the unique innovations in the bridge projects at Karoor and Aroor (Kochi). He always believed in imparting the best possible training to young engineers.

Today, he is popularly known as the Metro Man of India, after a professional career that has spanned over 60 years. Belonging to the Indian Railway Service of Engineers (IRSE), Sreedharan rose to the highest position in the Indian Railways, that of Member Engineering (and Ex-officio Secretary to the Government of India) of the Railway Board in 1989.

Carrying out investigations of the Konkan Railway alignment with him through the rugged Konkan terrain spread over 740km along trekking paths, roads, boats, and even narrow canoes, was not only an unforgettable experience in itself, but also valuable training.

On many days, work timings extended from 8.00 a.m. to 11.00 p.m. I still remember our travel in a narrow canoe across the Sharavathi River from Honavar to Mavin Kurve Island. Before leaving the shores he affectionately enquired about our swimming prowess. This journey through the river went on to fix the alignment of the longest bridge along Konkan railway—

the Sharavathi Bridge at Honavar is 2km in length.

His astonishing clarity on the various components which are required to be put in place to implement large infrastructure projects, was something to be cultivated. When the Design & Planning Office of the Konkan Railway Project was inaugurated by him, he said, 'This is the nerve centre of the Project and our success will entirely depend on its performance.'

In retrospect, he could have not spoken more succinctly. He understood that adequate and accurate planning, and timely availability of designs are the key issues in any project. Alas, most of our mega projects today lag behind due to failure on these counts.

Sreedharan always handpicked his top team of officers, who were essentially trustworthy, with unquestionable integrity and a good track record of performance. He followed this up by adequate delegation of authority. He made everyone aware that decisions are always fraught with certain chances of failures/ mistakes, and that should not deter one from taking decisions. In case of any exigency, he believed in finding a quick and effective solution, rather pondering endlessly over whose fault it was. Having said that, Sreedharan was a hard taskmaster and did not deal lightly with proven and intentional irregularities.

A combination of effective management, and ensuring quality work contributed towards Sreedharan's success. His munificence in allowing even the most junior engineer at a work site to participate in any technical discussions, and welcoming suggestions from him was a mark of a true leader.

I remember an occasion when he received a prestigious award from the Institution of Engineers at Pune in 1996. While walking out of the venue, he enquired about my parents who

were present in the audience and made it a point to walk up to them, telling them, 'Your son is one of our gems.' I still consider that gesture to be the greatest award I could ever receive.

A countdown clock was installed at every office of the Konkan Railway Project, and later in the Delhi Metro—a path-breaking concept which reveals the primary importance he always attached to timely completion of every project. I do not remember Sreedharan being late for any meeting.

Patience and perseverance are two qualities which go to make success stories and when it comes to Sreedharan, there is no dearth of these. Throughout my association with him, I have hardly ever seen him losing his temper. Always calm and quiet, he rarely had pending files on his table.[48]

ABHISHEK RISBUD, CIVIL ENGINEERING STUDENT

We should modernize Mumbai's suburban trains and go in for a sensor-based signalling system that will eliminate light signals and ensure lesser gap between two consecutive suburban services.

I asked him about safety post-modernization, as how much ever technology is upgraded, safety will be of paramount importance. He said that along with modern safety equipment, training the concerned staff to maintain the right vigilance is also important.

In 2006, I undertook a dissertation as the final assignment to complete my Master's degree. The topic chosen was 'Improvement in management of suburban railways in Mumbai'. After speaking to some people who were in the field, a gentleman suggested I go to Pune and meet Sreedharan to

gain inputs on the research assignment.

The day was 26 July 2006. Sreedharan was invited to the Indian Railways Institute of Civil Engineers (IRICEN), Pune, to deliver a lecture to upcoming Civil Engineers in Railways. They were railwaymen who had recently joined. As soon as he entered the hall, you could feel you were now going to listen to an intellectual. During his lecture, he narrated his experiences right from the time he was part of the Kolkata Metro project, to the Konkan Railway and DMRC projects.

The most important thing he mentioned was that the job of a Civil Engineer was not restricted to a cosy cabin, but required a lot of movement, sometimes not even on a vehicle. Specially mentioning Konkan Railway project, he said that the walks used to last for long hours, as most of the terrain to reach the site was not suitable for a vehicle.

After the sessions and the lunch, it was time for face-to-face discussions with him at the Rest House. It seems he was visiting the Koregaon Park Railway Officers' Rest House after a long while as the wait to meet him extended beyond expectation. There were his batch mates, former General Managers of the Indian Railways, who had dropped in to meet him. Finally, at 6.00 p.m., I got an opportunity to talk to him.

I had my own set of questions relevant to management of suburban and metro trains in India. He answered them very well and more importantly, with patience. His interaction was overwhelming, since he spoke extremely politely combined with loads of relevant information. I was surprised the way he interacted, because I wasn't known to him, nor did I belong to his cadre or to his age group, yet he entertained me and answered all my questions, without bringing any protocol or

any hierarchy in the way.

This was the first occasion I had met a VVIP, but never felt like I met one, courtesy his humble and down-to-earth approach towards me. The information he provided went a long way in the acceptance of my dissertation. All in all, meeting the 'Metro Man' was indeed a brilliant experience and one that I will cherish for the remainder of my life.

AN ANONYMOUS DEPUTY OF SREEDHARAN, INDIAN RAILWAYS

I used to work with Sreedharan at the railway office and he had a novel way to check and verify the bills and records sent by contractors.

He used to come and check the transport logs of contractors which used to establish whether a particular journey had been undertaken or not to bring in the goods. This small move kept everyone on their toes and no one could fudge details and records! Never have I seen so obsessed and dedicated an engineer in my career.

BRICKBATS

Is Sreedharan Not Accountable?[49]

In the case of the ₹450 billion Delhi Metro project, the CAG [Comptroller and Auditor General] Report has pointed to the questionable standards of construction. Tragic accidents have taken place during Delhi Metro construction due to cutting costs and caring two hoots for safety regulations, but no fingers have been pointed at the culprits responsible for these unpardonable

tragedies.

Last July five workers and a site engineer were killed and a dozen injured during the work of the elevated Central Secretariat–Badarpur line near Lady Shriram College in South Delhi as the girder above crashed down bringing down with it the viaduct. Despite this tragedy, the CAG Report was not discussed in Parliament. Reason? The DMRCL has been given such uncalled for monopoly that it does not come under any Ministry, so no Ministry was ready to take it up. It's a way to hush up things and let the scoundrels scot-free to repeat even more monumental errors.

E. Sreedharan is free to work the way he wants and not be accountable to expenditure of any amount of public money. Like the CWG which shockingly rents computers and other accessories at exorbitant amounts, DMRCL too had flown the imported Delhi Metro coaches by air—one can only imagine how costly air-lifting of these coaches must have been which has been paid through our money, but Sreedharan is praised for completing the task in a record time.

Kochi Metro Controversy

A CPI-M MP has publicized a letter that Tom Jose, after he quit the Kochi Metro, shot off to DMRCL chairman Sudhir Krishna, seeking clarifications on the exact relationship between the DMRCL and 'retired Sreedharan' and questioning the extent of power he can wield in Kochi Metro Railway Limited. Brushing aside the latest jab Sreedharan says:

> Barking dogs in the street will not bother the elephant. My spiritual guru Swami Bhoomananda Tirtha says you will get the right answer if you cultivate good values within

you. I have experienced it.

Amen to that, and to Kochi Metro.[50] A website called www.babusofindia.com states:[51]

> Opposition leaders in Kerala made it a political issue raising the question whether it was a ploy to keep the Metro Man away from the project. Some believe it could be the manifestation of anger of a few IAS officers who could not digest Sreedharan becoming synonymous with metro rail projects in India. Currently, some of the metro rail projects like Bengaluru, Chennai and Jaipur are being headed by IAS officers.

Debate—IAS vs Technocrats

Sreedharan has maintained that technocrats can handle metro projects better than any IAS officer, which has ruffled the feathers of IAS officers! IAS officer Srivatsa Krishna responded strongly. Excerpt:[52]

> It is astonishing how when people are put on a pedestal, they automatically are believed to be above all law, all facts, all logic, indeed all truth. While everyone admires Sreedharan for building an excellent metro in Delhi— with the help of generous concessions from CAG, CVC and the political executive virtually exempting him carte blanche—that doesn't entitle him to either peddle untruths in the guise of arguments or tar all IAS officers with one brush. Sreedharan should understand that popularity is not a substitute for propriety, both financial and intellectual. Not is it for substance. Nor does it give him the right

to tar everyone with the same stinking brush. Especially when he has more to answer for or the same brush is coming towards him also.

Konkan Railway Could Have Been Handled Better, Anonymous Former Colleague

If millions of people are being able to travel conveniently to destinations along Konkan, it is thanks only to Konkan Railway. But even as the region has been brought on the rail map of India after mammoth efforts, whether the journey has been made entirely comfortable and safe needs a serious thought.

When George Fernandes was the Railway Minister, he called for a meeting of the Railway Board members to decide on how the rail line can be brought to fruition along West Coast of the country. The meeting ended on a note that the rail line is not technically feasible, a fact which had been arrived upon again and again in all the meetings held earlier—in fact, since the advent of railways in India. It is said that as everyone dispersed, there was one man who stayed back to give an assurance to George Fernandes that he would do the task and since that is the answer that Mr Fernandes wanted, the Project was given an immediate clearance.

The man was Mr Sreedharan who had already retired from services by then. Perhaps, history would have never known this man if he had not taken it upon himself, against the deep convictions of everyone else on the Railway Board, that a railway line had to be constructed in this region surpassing all challenges that it brought with it. Mr Sreedharan took it as a challenge and proceeded with a single aim of laying a railway track all

along the West Coast—come mountain or deep waters.

Even as this is the determination that was required to make a railway line happen, nobody paid any attention to the mountain of problems that they were creating at the same time. The focus was simply on having a rail line but no due thought was paid to at what cost it was being done. Nobody had the vision that if at all construction of a railway line is being sanctioned; the volatility of the terrain would require escape routes and alternate lines in case of any emergency situations. It is highly unimaginable that a thought should not have crossed the minds of technical brains that this is required. It is due to this that KR is today a single line section, which is its malaise of the first order. The railway route has seen many accidents and the discomfort that it has brought about to passengers with it. The rescue and relief takes hours and it takes a long time for a relief engine and ARMV and ARTs to reach the accident site, since trains start piling up all along the single route.

In a bid to showcase that India has better technical knowledge, the route was constructed in a great hurry without paying much attention as required to ensuring that the muddy cuttings were blasted away once and for all, and that deep rock cuttings were made safe. Even as the technical brains leading the project from the front failed to ensure technical stability of the route, in order to take political mileage, the route was thrown open to passenger trains first even though in railways it is the freight trains, which are first run on the new rail tracks for a few years till the route and its engineering structures settle down.

The technical marvel that was touted started crumbling from the very first year. Landslides started holding up rail traffic and passengers started paying for it. The railway administration

too paid for this. It had to bear the ire of passengers as also suffer huge setbacks, financially and to its reputation.

But the challenges were not restricted to this. In order to complete the project in a record time, funds were raised from market through borrowings. Tax-free bonds were raised and loan was taken. The Stock Scam that hit the markets in early 1990s caused tremendous financial burden to KRCL too, as interest rates shot up and project deadline got further dragged backwards. Work on the project had to be slowed down due to shortage of funds.

During the period 1995 to 1997, the Corporation had to ultimately resort to external commercial borrowings (ECBs) and raised funds against taxable bonds at higher rate of interest. The average cost of debt finance to the Corporation went up from nine to 12 per cent. The Indian Railways provided interest-free loans to KRCL up to 2001 to meet its interest liabilities and part debt redemptions.

However, in 2003 the Railway Board started levying interest at 7 per cent per annum on the loans. A project that was originally estimated at ₹867 crore, finally became a reality at a cost of ₹3,550 crore—an escalation that has put KRCL in a debt trap. Neither KR got any strategic line benefits that are extended to a new rail line, nor was it treated on par with Zonal Railways to receive funds from the Indian Railways. Neither it can frame its own rules and fare structure, nor does it get any advantages as of any other Zonal Railway. The doubling of the rail line which has been announced now, will require funds to the tune of ₹15,000 crore with additional cost and time overruns. Whether the Corporation can fund itself and pay the debts is a question that even a small child can answer in a jiffy.

No doubt rail connectivity is a must for development of any region, but the cost at which KR has been constructed and the technical, financial and safety issues which have been relegated under the carpet for last 25 years needs a serious discussion. Unless the Corporation is seen as one of the Zonal Railways and helped by the Ministry, it wouldn't be a wild guess to see how many years more the region would see a train running along the myriad mountains and rivers.

The man who is credited with construction of KR failed utterly in his vision and simply finished off the project as any manager would and not as a leader. He went on to other projects to add to his personal repute but KR project is his big failure.

Sreedharan's Rebuttal to Anonymous Former Colleague

Sreedharan has responded strongly to this Anonymous Former Colleague in a letter addressed to the author of this book. The letter is reproduced below.

Dear Rajendra Aklekar,

I don't have to defend myself. But the facts should be known to the readers—hence this clarification.

I was not present when then Railway Minister, Shri George Fernandes had his first meeting with the Railway Board. I was away in Kerala on leave at that time. But the Minister's priority to take up two nationally important Railway Projects, namely the Konkan Railway and the 'Chittoni-Bhaga' bridge across Gontak River in Bihar, was later brought to my notice.

I did then work out a practical approach as to how

to fund and execute these two schemes and conveyed to the Minister. The approach was accepted by the Minister and I had the responsibility to take them forward as Member Engineering/Railway Board. These were not proposed for my personal glory nor did I have the ghost of an idea that I would be put in charge of the Konkan Railway Project.

No detailed Field Survey for Konkan Railway was ever carried out before. While the section from Mangalore to Udupi was already then sanctioned, Udupi to Goa border has only a preliminary survey report. For the rest of the length only a paper alignment was available. The cost of the Project was therefore, wrongly estimated by the Southern Railway Survey team.

The final cost came to about ₹2,400 crore, which was very low considering the difficult terrain. Since the Government's contribution to the project was only one-third of the cost, and two-third was to be borrowed from the market, the investment had to be kept very low. For that reason, only a single line was decided initially but provision was kept for a double line while acquiring lands and for widening the bridges later. The financial problems faced by the Konkan Railway were mainly due to the inability of Indian Railways to divert six freight trains along this route which was originally envisaged in the Project Report.

Konkan Railway was opened in stages, possibly in six or seven stages. There was no hurry shown to run passenger trains instead of goods trains. As a matter of fact, I left Konkan Railway two months prior to its final

commissioning. Any new Railway line through difficult terrains will face rock falls, slope failures etc., in the early years of its operation.

During these years, the vulnerable spots have to be identified and protective works undertaken which was not unfortunately done by my successors. Today, technology is available to prevent boulder fails or slope failures and for getting fore-warnings of such incidents. Konkan Railway Corporation should be allowed to take up such works so that traffic disruptions can be avoided.

It should be remembered that even after 150 years of construction, traffic disruptions do take place on the Igatpuri and Lonavala ghats, due to rock falls and slope failures during the rainy season. A double line is not the answer to attend to accident sites. Relief trains can be stabled at nominated points for this purpose. In any case, with the National Highway running almost parallel to the Railway line, quick access to the accident sites is available.

The usefulness of this line can be gauged from the fact that during 17 years of its existence, Keralites alone living in Mumbai and beyond have saved more than ₹20,000 crore in journey costs, apart from each traveller saving 12 hours in journey time due to shorter travel distance.

A similar Project between Udhampur-Srinagar-Baramulla Railway line with a distance of 292kms, all fully funded by Government, is going on for the last 20 years and even today the section from Katra to Banihal a distance of 120km is only 20 per cent completed. It would take

another ten years for this line to get completed. Compare this with the seven years' time taken for completing 760km of Konkan Railway.

Was it therefore a foolish venture, as brought out by the critique?

Eight

INSPIRATION

A Day in the Life of Sreedharan at the Age of Eighty-four

Getting up close with him, here's a typical day in the life of Dr E. Sreedharan at the age of eighty-four (November 2016).

Ponnani, Kerala

4.00 a.m. – Wake up. (Brahma muhurta, time of Brahma, is a period, muhurta, one and a half hour before sunrise or more precisely 1 hour and 36 minutes before sunrise. Considered an auspicious time to practice yoga and most appropriate for meditation, worship or any other religious practice.)

4.20 a.m. – 5.00 a.m. – After preliminary ablutions, he sits for Pranayama and meditation.

5.00 a.m. – 5.20 a.m. – Morning tea with wife Radha

5.20 a.m. – 6.10 a.m. – Read Srimad Bhagavatam (Malayalam lipi–Sanskrit verses. Word by word meaning with commentary. **A book written by Pandit Gopalan Nair and published by Guruvayoor Devaswom.**)

6.15 a.m. – 6.40 a.m. – Watch *Mukthisudhakaram* TV Show

(A spiritual talk by his Guru Swami Bhoomananda Tirtha on the TV channel Asianet)

6.45 a.m. – 7.20 a.m. – Read newspapers of the day in Malayalam and English

7.30 a.m. – 8.10 a.m. – Practice yoga

8.15 a.m. – 8.40 a.m. – Bathe and pray

8.45 a.m. – 9.00 a.m. – Breakfast with wife Radha

9.00 a.m. – 1.00 p.m. – In the Camp Office

1.00 p.m. – 1.30 p.m. – Lunch and midday news on TV

2.00 p.m. – 3.00 p.m. – A short nap

3.00 p.m. – 4.00 p.m. – Back at work in Camp Office

4.15 p.m. – 5.30 p.m. – Evening tea and brisk walk with his wife in the family garden

5.30 p.m. – 6.00 p.m. – Practice Pranayam and physical exercise

6.00 p.m. – 6.20 p.m. – Evening bath

6.20 p.m. – 8.00 p.m. – Read at least one chapter of Bhagavad Gita

8.00 p.m. – 8.15 p.m. – Take a look at news headlines

8.15 p.m. – 8.40 p.m. – Dinner

8.45 p.m. – 9.15 p.m. – Read spiritual magazines and books

9.20 p.m. – Retire to bed

Best Quotes

- *Mukta sango nahamvadi dhrty-utsaha-samanvitah, siddhy-asiddhyor nirvikarah karta sattvika uchyate*—is Sreedharan's all-time favourite shloka from the Bhagavad Gita. It means: if you want to be a virtuous doer, you should not be too attached to the work that you are doing. You should not bother about the results either, whether failure or success. You should have the same attitude about the project. If you are able to assume that status of mind and execute the project, you can never fail
- 'We cannot allow our Parliamentarians to hold the nation to ransom while the nation pays ₹1.5 crore per hour to run the Lok Sabha and Rajya Sabha.' Stated in a public interest litigation filed by the NGO, Foundation for Restoration of National Values
- 'The decision of the Honourable Minister of Railways to devolve full powers to GMs and equal ranks at the field and operating levels is a very welcome and a landmark decision which should be implemented with immediate effect.' Page

12–13, Interim Report of One Man Committee, Delegating Full Powers to GM in Tendering & Commercial Matters, New Delhi, Govt of India, Ministry of Railways (Rly Board)

- 'Integrity is the secret of my success.' Said on TV programme 'Dilli Dil Se' with anchor Mini Mathur, 2013 (@7.01-7.04min, https://www.youtube.com/watch?v=KveGbkfmOeQ)

- 'Measurement Book is the biggest culprit to bring in corruption.' Said on TV programme 'Dilli Dil Se' with anchor Mini Mathur, 2013 (@4:06-4:11min, https://www.youtube.com/watch?v=KveGbkfmOeQ) (Note: payments for all work done otherwise, than by departmental labour, and for all supplies in railways and government bodies in India are made on the basis of measurements recorded in Measurement Books.)

- 'Delhi will need a metro rail network of at least about 500km according to me.' Said on TV programme 'Dilli Dil Se' with anchor Mini Mathur, 2013 (@3.41-3.43min, https://www.youtube.com/watch?v=KveGbkfmOeQ)

- 'My stature grew up along with the metro.' Said on TV programme 'Dilli Dil Se' with anchor Mini Mathur, 2013 @20.34min-20.55min, https://www.youtube.com/watch?v=KveGbkfmOeQ)

- 'Every business has tremendous social impact. And that is where ethics, work culture and organizational values have got great relevance.' Said at Rajagiri Excellence in Leadership Panel Discussion 2012, Kochi (@2.51-3.00min, https://www.youtube.com/watch?v=4jP40D7aH1Y)

- 'Delhi Metro is the biggest urban intervention that has taken place in this country.' Said at Rajagiri Excellence in Leadership Panel Discussion 2012, Kochi (@3.40-3.44min,

https://www.youtube.com/watch?v=4jP40D7aH1Y)

- 'I have no IAS officials, but a project like Metro Railways only technical people can handle. An IAS man cannot handle it. If I ask him to write a specification for metro trains, an IAS man would not be able to do it. If a train is delivered, he would not know the problem. But they had bureaucratic superintendence. My Board of Directors are IAS officers.' (http://www.business-standard.com/article/economy-policy/q-a-e-sreedharan-md-dmrc-111121500006_1.html)

- 'We have engineers but not of good quality. The main reason why the engineering profession has not been able to reach international levels is because of a lack of a regulatory body, like the ones that are there in other professions like medicine.' (http://timesofindia.indiatimes.com/city/delhi/Hand-over-country-to-experts-let-them-work-E-Sreedharan/articleshow/11040705.cms)

- 'Every city of more than three million people needs a metro immediately.' http://www.businesstoday.in/opinion/interviews/e-sreedharan-delhi-metro-interview/story/21128.html

- 'My personal view is that urbanization should be encouraged, mainly because it facilitates access to benefits—health facilities, education, law and all that—by larger sections of the country. In villages, providing all these facilities is a very big task. (http://www.businesstoday.in/opinion/interviews/e-sreedharan-delhi-metro-interview/story/21128.html)

- 'Monorail is a system ideal for a picnic spot, a park or a religious place. The investment in a monorail is same as for light metro, but the operating cost is three times as much. So, it cannot be viable. So many monorails have been planned

because of the monorail lobby. If you ask technocrats, nobody recommends monorail. It is only politicians.' (http://www. businesstoday.in/opinion/interviews/e-sreedharan-delhi-metro-interview/story/21128.html)

- 'I encourage my staff to go for a walk, especially with their spouses as that makes a lot of difference. You relax, you unburden your mind, you share your difficulties and your achievements that way.' Said at CNN-IBN Indian of the Year function where he received the award

- 'A team leader must take full responsibility for the results. He must be given complete freedom to resist political interference. The basic strength of a leader is performance; the results he produces.' (http://www. newindianexpress.com/cities/bengaluru/Namma-Metro-Unsustainable/2015/08/19/article2981338.ece)

- 'A leader has to be a role-model. Everything flows from him.' (http://www.newindianexpress.com/cities/bengaluru/ Namma-Metro-Unsustainable/2015/08/19/article2981338. ece)

- 'The constant news of corruption, lawlessness, poverty and inadequate civic amenities has driven Indians to a state of helplessness and cynicism that nothing can be done to improve the situation. The solution to these problems was in the hands of the people. Every voter should exercise his or her franchise after finding out about the credentials of the candidates. We may not have a satisfactory choice, but we should do our best to ensure we don't allow a candidate with criminal background to rule our nation.' Written in 'Note on appeal to voters for fair elections in 2009', as President of the NGO, Foundation for Restoration of National Values

- 'New railway line construction is indeed a fascinating and often a challenging task. On account of the enormous social and economic benefits that follow, the job satisfaction that one gets on completion of such a project is a rare satisfaction in itself.' Preface, *A Treatise on Konkan Railway*. Page VI, January 1999

List of Awards

1964: Minister of Railways Award for timely completion of Pamban Bridge on Southern Railway

1995: SB Joshi Memorial Award

2001: Padma Shri for Civil Service. The Padma Shri is the fourth highest civilian award in the Republic of India

2002: Shri Om Prakash Bhasin Award for Science and Technology for his significant contributions to rail transport engineering

2002: All India Management Association (AIMA) award for Public Service Excellence (2003)

2002: Man of the Year by *The Times of India*

2002: Chandra Shekharanand Saraswati Swami Award by the South India Vidya Society

2002–03: Juror's Award by Confederation of Indian Industry (CII) for leadership in infrastructure development

2003: Featured in Asian Heroes listing by *Time* magazine ('Getting New Delhi on Track')

2003: All India Management Association (AIMA) award for Public Service Excellence

2005: Knight of the Legion of Honour (Chevalier de la Legion d'Honneur) by the Government of France

2005: Degree of Doctor of Science (Honoris causa) from IIT Delhi

2005: Bharat Shiromani Award from the Shiromani Institute, Chandigarh

2006: Honorary Membership of the Institute of Electrical and Electronics Engineers Inc., Delhi

2006: Honoris causa degree of Doctor of Science (D.Sc) on the occasion of Kurukshetra University Golden Jubilee celebrations, Haryana

2006: India Vision Person of the Year Award for outstanding contribution to public transport system, bestowed by India Vision Television channel

2007: The CNN-IBN Indian of the Year Award for setting a rare work ethic and transforming the face of transportation by effective time-bound execution of the metro rail project

2007: National Statesman award by Qimpro Platinum Standard (Business) for Quality in India

2007: Pinnamaneni and Seethadevi Foundation Award in recognition of his services for executing several railway projects during his distinguished career spanning 36 years in Indian Railways

2008: Padma Vibhushan for Civil Service. The Padma Vibhushan is the second highest civilian award in the Republic of India.

2008: Champion of Project Management in India award by the Project Management Institute (PMI)

2008: Policy Change Agent of the Year award by the *Economic Times*

2008: Lifetime Achievement Award for Translating Excellence in Corporate Governance into Reality by the Institute of Company Secretaries of India (ICSI)

2008: Lal Bahadur Shastri National Award for Excellence in Public Administration, Academics and Management

2008: Lifetime Contribution Award in Engineering by Indian National Academy of Engineering (INAE)

2008: Indian Railway Service of Engineers Officer's Association (IRSEOA) Award

2009: D.Lit. by Rajasthan Technical University, Kota, Rajasthan

2009: Degree of Doctor of Philosophy (Honoris causa) from IIT Roorkee

2010: Indian Institute of Metals–JRD Tata Award for Excellence in Corporate Leadership in Metallurgical Industries

2010: Sat Paul Mittal National Award, Nehru Sidhant Kender Trust, Ludhiana

2010: Construction World Man of the Year Award, by *Construction World* magazine

2010: Sir Jehangir Gandhi Memorial for Industrial and Social Justice Award at the 54th Annual Convocation of premier B-School XLRI, Jamshedpur

2010: Honorary Degree of Doctor of Law, Doctor of Science and Doctor of Letters, Cochin University of Science and Technology

2010: Honorary Degree of Doctor of Science, Rajiv Gandhi Proudyogiki Vishwavidyalaya (Rajeev Gandhi Technical University), Bhopal, Madhya Pradesh

2010: Degree of Philosophy in Management Studies (Honoris causa), Guru Gobind Singh Indraprastha University, New Delhi

2010: Attumalil Georgekutty Merit Award instituted by Mar Thoma Syrian Church of Malabar at Thiruvalla, Kerala

2011: Honorary Degree of Doctor of Science (Honoris causa): Indian Institute of Technology, Delhi (IIT Delhi) for his outstanding contributions to national development

2011: Honorary Doctorate, Visvesvaraya Technological University, Belgaum

2011: ESSAR Steel Infrastructure Excellence Awards 2011, Infrastructure Leader of the Year

2012: Yashwantrao Chavan National Award at the hands of President of India for contribution to the construction of Konkan Railway and transforming urban transport in the national capital through Delhi Metro

2012: Lifetime Achievement in the Forbes India Leadership Awards

2012: Sree Chithira Thirunal National Award

2012: SR Jindal Prize (honorary) awarded by Sitaram Jindal Foundation for leading from the front in building the country's top public transport system

2012: AP Aslam Memorial Award by the Kshema Foundation, Thiruvananthapuram

2012: The first Prathibha Samman Award by State Bank of

Travancore, for outstanding contribution to the society

2012: V. Krishnamurthy Award for Excellence from the Centre for Organization Development, Hyderabad to honour individuals who have set high standards of achievement in pursuit of excellence in their respective professions

2012: India Business Leader Awards, 8th edition, CNBC-TV18, in the 'Outstanding Contribution to the Cause of the Indian Economy' category

2012: The Rotary Club of Madras Award

2012: The *Manorama News* Newsmaker of the Year

2012: Vikram Sarabhai Lifetime Achievement Award by the Consortium for Educational Communication, an Inter-university Centre of University Grants Commission on Electronic Media.

2012: Honorary Doctorate Degree, Sir Padampat Singhania University (SPSU), Udaipur, Rajasthan

2012: D. Litt (Honoris causa), Jadavpur University, Kolkata

2013: Order of the Rising Sun, Gold and Silver Star (Japan), 'Awarded to a Foreigner in Fall 2013 for directing the implementation, operation and management of a large-scale project, creating an organizational culture that always demanded high quality, and excellent leadership'. Japanese Prime Minister Shinzo Abe personally presented the award and certificate to Sreedharan

2013: TKM 60 Plus award for Lifetime Achievement, by Janab Thangal Kunju Musaliar (TKM) College of Engineering, Kollam, Kerala

2013: Degree of Doctor of Science (Honoris causa) by Mahamaya Technical University on its first convocation

2013: Rotary International For the Sake of Honour award by the Rotary Club of Calicut East

2013: The Four-Way Test Award, Rotary Club Kolkata

2013: Lifetime Achievement Governance Award by magazine *GFiles* for building India's largest infrastructure projects without cost overruns

2013: Rotary Club Award, Calicut East for outstanding contribution to railways in the country

2013: Lokmanya Tilak Award, Lokmanya Tilak Trust, Pune, Maharashtra, for outstanding contribution to society

2013: BKS-CETAB-NEXSA Technocrat Award, by the Bahrain Keraleeya Samajam, College of Engineering Trivandrum Alumni

2013: Amrita Award for Outstanding Contribution 2013, instituted by Amrita TV, Kerala

2013: UGMA Award for Excellence by the Sullivan Committee Union of German Malayalee Associations

2013: Sree Sathya Sai Baba Puraskar by the Sathya Sai Orphanage Trust, presented by former President A.P.J. Abdul Kalam

2014: Technocrat of the Year Award, by Keralite Engineers' Forum (KEF) Doha, Qatar

2014: South Indian Bank Excellence Award for Lifetime Achievement presented at the Bank's 85th anniversary celebrations at Thrissur, Kerala

2014: Doctor of Science, (Honoris causa), National Institute of Technology, Rourkela, for his significant contribution to the development of Metro Railway system in India

2015: Lifetime Achievement Award for his lifelong contribution

in the area of public transport, presented at 110th annual session PHD Chamber of Commerce and Industry

2015: Gandhi Smriti Award by Gandhi Smriti Bhavan Trust, Vaikom, Kerala, for outstanding contribution towards the betterment of the society

Timeline

1932: 12 June, born in Pattambi in the Palakkad district of Kerala

1938: First train ride on way to sister's home

1947: Class 10, Indian independence

1949: Student at Government Engineering College, Kakinada, Andhra Pradesh

1953: Joined Mumbai (then Bombay) Port Trust, results of engineering exam conducted by Civil Services, which he clears, with all-India seventh rank

1954: December, Southern Railway as a Probationary Assistant Engineer

1958: Divisional Engineer, Bezawada (now Vijaywada)

1961: 21 October, marriage

1962: Executive Engineer, Hubli

1963: Technical Assistant to Engineer-in-Chief (Construction)

1964: December, assigned Pamban Railway Bridge restoration

1970: Deputy Chief Engineer (Planning & Design) Kolkata Metro

1976: Divisional Railway Superintendent, Mysuru

1978: Additional Chief Engineer, Southern Railway; to Chief Engineer (Construction) Eastern Railway

1979: CMD of Cochin Shipyard

1980: Chief Engineer (Construction), Chennai

1983: Chennai posting, mother passed away at the age of ninety-two

1986: 14 February, Chief Administrative Officer (Construction) Central Railway

1987: 27 July, Promoted as General Manager, Western Railway

1989: July, Member Engineering, Railway Board

1990: June, retired from Indian Railways

1990: 31 October, took over as CMD of Konkan Railway

1997: 5 November, took over as MD of Delhi Metro

1997: 15 December, resigned as CMD of Konkan Railway

2001: Awarded Padma Shri by Government of India

2009: Awarded Padma Vibhushan by Government of India

2011: 31 December, retired from Delhi Metro Railway Corporation Limited

2014: Working for Kochi Metro and Kerala High Speed Railway.

2015: September, appointed as Member of United Nations' High-Level Advisory Group on Sustainable Transport (HLAG-ST) for three years

Author's First Meeting with E. Sreedharan

Ponnani in Malappuram district of Kerala is a peaceful village, centrally located and well connected by all means of transport. Unfamiliar with the terrain and local language, I reached the Kuttippuram station, one of the nearest rail links to the place, as had been guided by Sreedharan's office. Two days before embarking on my first journey to Kerala from Mumbai, I had spoken to his secretary Mr V.V. Govindan. So kind was he that he offered to pick me up from the railway station and take me directly to Sreedharan's camp office at Perumbayil House in Ponnani, and even fix up accommodation, if required; all of which I politely declined. He then guided me with precise details on how to reach there, giving me all important landmarks nearby, the closest bus stops and even the fare.

It was an adventure of sorts. I reached Kuttippuram a day earlier so that I could get time to prepare mentally and catch up with my homework on him. As I stepped out of the station,

there were a host of small colourful buses going to different locations, and though all the signage and shout-outs were in Malayalam, I did manage to get into the right bus. The bus took me there in 20 minutes and I did a quick familiarization trip to the location of Sreedharan's home-office at Perumbayil House. Mr Govindan had told me that it was located inside the Bharat Gas LPG warehouse run by Sreedharan's brother-in-law, and the moment I saw gas cylinders, I knew I had reached the right location.

Perumbayil House is a beautiful and elegant structure, surrounded by the greenery of coconut trees with the sea close-by. A peaceful place in the interiors with no hustle-bustle of traffic and chaos. I booked a hotel room close by, as I knew Sreedharan was very particular about time and I could not be late whenever he called me on the decided days. After I settled down in the hotel room, I sent a message and a mail to Mr Govindan saying I had arrived and was staying at 15 minutes walking distance from the Perumbayil House and he could call me anytime Sreedharan was free.

The next day at 9.00 a.m., I got a reply saying I could come by 10.00 a.m. Throughout the previous night, I had brushed up my information on Sreedharan; information that I had been working on for the past six months, and so I was stressed out even before I could meet up with him. I had taken a summary of the entire book for him in two pages and marked queries. But the tension remained and I could not sleep till the mission was accomplished. As I rushed to his place (and reached before time), I was welcomed by Mr Govindan and asked to sit in the visitors' room.

Perumbayil House is an old style bungalow that had been

inherited by his wife Radha. After retirement, Sreedharan had plans to settle down in Bengaluru, but the illness of his mother-in-law brought him to Ponnani and he has been here since. The classy room with teakwood furniture was full of various awards and trophies that Sreedharan had received throughout his life, and the walls full of photographs of him with various dignitaries at award functions and also a few old black and white early pictures of his family.

As I waited impatiently, the man himself walked up to me and shook hands, requesting me to be seated. He was so humble that he asked me about my journey and made me comfortable. His wife Radha too joined us and asked me for tea and breakfast. 'Are you sure you had your breakfast, if not you can have it here,' she said. I politely refused and got down to work. There were basic enquiries about me, my family and my journalism.

Sreedharan had seen my earlier book *Halt Station India*, the story of India's first train line, and had been impressed with it. I shared details of my railway passion and work, sharing a few common names to start with. I started by showing Sreedharan the summary of the book I proposed to write on him, and what I had gathered so far, and he went on to read it attentively, making corrections and reading it chronologically. As he read it, he remembered things and elaborated on his experience.

I had started a conversation parallel and he began narrating the story of his life from the beginning of his career on how he started his career as an engineer from a job in Butcher's Island, Mumbai, and spoke of his early life and childhood. Then, as the conversation went on, he also shared certain documents on relevant subjects. All through the conversation, his wife Radha was sitting next to us, adding her views and memories:

He could be under stress, but it has never shown on the face. Once he comes back home in the evening, he leaves everything behind in office and nothing is discussed at home. It is only when I used to attend programmes, functions or railway community events, that I used to come to know the kind of pressure and stress he was facing.

It was time for lunch and I joined the family in their dining room which is at the back of the house. The conversation continued sharing many unknown points and facts, from his career in Indian Railways and beyond. Pure vegetarian food was served on a banana leaf with all the traditional south Indian delicacies. We were also joined by Mr Govindan. After lunch, Sreedharan took his medicines and the conversation went on.

Later in the day, I took a few photographs of him at his work desk and a few old ones from his computer. He proudly showed me the first award that he had received from the Indian Railways after the Pamban assignment, which he had kept in the showcase, along with other trophies. He also discussed his itinerary for a visit to Nagpur for the Metro Foundation Day scheduled in February 2016 with Mr Govindan. He planned to go by train to Bengaluru and then by flight.

The wide-ranging conversation continued the next day, with him talking on subjects such as Delhi's odd-even vehicle formula to control pollution, his friendship with IAS officer and former Chief Election Commissioner T.N. Seshan who had been a friend since school days and so on. He agreed to pen down a few lines to inspire for future generations, and did it soon without any reminder.

Armed with all the data and information that he shared each day, I would return to my hotel room and collate it chronologically. I had studied so much about him and yet so much was unknown.

In the town, everyone from the local tea vendor to the most important of person in the neighbourhood was proud of his presence in Ponnani. Whenever I was asked by anyone what was I, a stranger, doing in Ponnani, one word—Sreedharan—connected me to all those who asked, despite my being unfamiliar with the language.

When I was to return, Sreedharan asked me if I had my bookings in place for it and if I required any help. More meetings and interactions happened subsequently, and Sreedharan was patient in answering the smallest of queries each time. He also took all the criticism in his stride and replied to each of them attentively and logically.

So much to learn from this man. Such a towering personality, yet so humble.

ENDNOTES

CHILDHOOD, FOOTBALL AND ENGINEERING

1. Personal interaction
2. http://www.deccanchronicle.com/151111/nation-current-affairs/article/metroman-e-sreedharan-visits-his-alma-mater-koyilandy
3. Today, the Brihanmumbai Electricity Supply and Transport Undertaking

PAMBAN BRIDGE

4. R.R. Bhandari, *Southern Railway: A Saga of 150 Glorious Years 1852–2003*, New Delhi: Publication Division, Ministry of Information & Broadcasting, 2006, p. 141
5. Page C-34, India Weather Review, 1964, Annual Summary, Part C, Storms and Depressions
6. News report on 50 years of Dhanushkodi storm, *Deccan Chronicle* dated December 24, 2014, titled '50 years on,

Dhanushkodi remembers killer cyclone' by S.P. Loganathan
http://www.deccanchronicle.com/141224/nation-current-
affairs/article/50-years-dhanushkodi-remembers-killer-
cyclone Accessed September 16, 2015, 10.30 p.m.

SREEDHARANS' ICONS

7. http://content.time.com/time/magazine/article/
 0,9171,877315,00.html

INDIA'S FIRST METRO

8. Lok Sabha debate. Reply in Parliament, April 24, 1973,
 Written Answer. http://dspace.wbpublibnet.gov.in:8080/
 jspui/bitstream/10689/15456/10/No%2043_Chapter%20
 1_1-154p.pdf
9. http://www.business-standard.com/article/economy-
 policy/kolkata-metro-s-ride-of-neglect-110122200018_1.
 html

FROM RAILWAYS TO SHIPPING

10. http://www.bseindia.com/downloads/ipo/
 20131211125017Cochin.pdf
11. DSC is the Distinguished Service Cross (DSC), a third level
 military decoration awarded to officers, PVSM is the Param
 Vishisht Seva Medal (PVSM), a military award in recognition
 to peace-time service of the most exceptional order, Padma
 Bhushan is the third highest civilian award in the Republic
 of India

12. http://www.thehindu.com/todays-paper/tp-national/ tp-kerala/sailing-successfully-through-a-sea-of-change/ article5021062.ece

13. It proved to be an asset to the country and was scrapped after 20 years of service in 2006

14. The ship was delivered to its client, the Shipping Corporation of India, in July 1981. It was scrapped and sold for demolition to Bangladesh in 2006

CHENNAI, MUMBAI, AND RETIREMENT

15. http://www.newindianexpress.com/cities/chennai/ Let-Chennai-Metro-Rail-Take-Over-MRTS/2015/06/11/ article2859589.ece

16. Indian Railways Budget Speech 1988–89, Speech of Madhavrao Scindia introducing the Railway Budget, 1988–89 on 24 February 1988

17. CST-9 sleeper. Technical full-form is Central Standard Trial-9 sleeper

THE KONKAN RAILWAY PROJECT

18. Chapman, John (1851), *The Cotton and Commerce of India, considered in relation to the interests of Great Britain, with remarks on railway communication in the Bombay Presidency.* George Woodfall and Son, London, pp. 237–238

19. Kerr, Ian J. (1995), *Building the Railways of the Raj 1850–1900, By quoting the Morris and Dudley Railway Statistics*, Oxford University Press, London, p. 211.

20. Correspondence and documents reproduced in the

Maharashtra Archives Bulletin of the Department of Archives No.7, Govt of Maharashtra. Published in 1969, pp. 1–25

21. Shivdasani, Menka and Kane, Raju. *Konkan Railway: A Dream Come True*. Published by the Konkan Railway Public Relations Department, Navi Mumbai. p. 14.

22. Speech by Dr E. Sreedharan at the Civil Service Officers' Institute. Andhra Pradesh and personal letter by E. Sreedharan to Konkan Railway CMD on flashback of events leading to formation of Konkan Railway. DMRC/PON/EX/P/4

23. Continental Construction Projects Ltd website: http://ccpro.in/Gandak.aspx Accessed: November 21, 2015, 7.19 p.m.

24. At that time, Ramakrishna Hedge was the Deputy Chairman of the Planning Commission and Madhu Dandavate, who had once initiated the project, was the Finance Minister. Both, hailing from the Konkan region, were really interested in the project

25. *A Treatise on Konkan Railway*, Annexure 1.01.07, p. 19 Published by Konkan Railway Corporation Ltd

26. First Annual Report, KRCL. Chairman's Speech p. 5

27. *Dream Come True*, published by KRCL

28. Personal correspondence

29. 'Ballast has been an integral part of railway track for many years. It is an economical medium providing an elastic support to the sleepers and absorbs major part of the noise created by passing wheels. Material is locally available. But ballasted track calls for frequent maintenance attention, and periodical screening. It causes dust pollution. Hence, railways all over have been researching and developing a more permanent track base, in form of ballastless track

for their high speed lines. In ballastless tracks the ballast is substituted by support layer of concrete slabs. Though they will be more expensive, they will be most cost effective for such lines.' [Authors: Manu Shivanand and Tom Jacob in 'A Seminar on Ballastless Tracks'. Available at http://www.dss.nitc.ac.in/ivle6/uploading/fact/106/137/LNote/Ballastless%20tracks.pdf; accessed on 30 August 2016]

30. A machine or tool for pressing or tamping down the ballast.
31. Speech by Dr E Sreedharan at the Civil Service Officers' Institute. Andhra Pradesh. Praja website Accessed September 15, 2015, 12:22pm http://praja.in/files/The-Story-of-Toughest-Konkan-Railways-Project-India-by-Its-Project-Director-E-Shreedharan.pdf
32. Treatise on Konkan Railway, published by KRCL.

DELHI METRO

33. Annual Reports 1995–96 and 1996–97, DMRCL
34. Dayal, Anuj (April 2012), *25 Management Strategies for Delhi Metro's Success: The Sreedharan Way*, DMRCL. First Reprint: Jan. 2013, p. 12
35. http://economictimes.indiatimes.com/slideshows/people/lessons-from-dmrc-chief-e-sreedharans-life/the-sreedharan-way-of-life/slideshow/11151767.cms
36. Dayal, Anuj (April 2012), *25 Management Strategies for Delhi Metro's Success: The Sreedharan Way*, DMRCL, First Reprint: Jan 2013, p. 14
37. Ibid., pp. 39–40
38. English civil engineer and mechanical engineer who built the first public inter-city railway line in the world to use

steam locomotives (Wikipedia).

39. http://www.smh.com.au/articles/2002/12/26/1040511133673.html
40. Annual Report DMRC, 2005-06, Chapter 2, Chairman's Letter to Shareholders
41. Dayal, Anuj (April 2012), *25 Management Strategies for Delhi Metro's Success: The Sreedharan Way*, DMRCL, First Reprint: Jan 2013 [no page no. specified in original text]
42. Ibid
43. Ibid
44. https://cb.**hbs**p.harvard.edu/cbmp/product/112013-PDF-ENG

RETIREMENT? WORK, WORK, AND MORE WORK

45. http://articles.economictimes.indiatimes.com/2015-08-20/news/65667029_1_indian-railways-e-sreedharan-konkan-railway
46. http://www.railnews.co.in/sreedharan-committee-expresses-serious-concern-stability-katra-banihal-rail-link/
47. http://articles.economictimes.indiatimes.com/2015-07-22/news/64725464_1_rail-link-railway-board-panel-report

BOUQUETS AND BRICKBATS

48. The article first appeared on *The Quint* website. Published with permission from Ritu Kapur, Co-Founder and CEO, The Quint. http://www.thequint.com/india/2015/06/12/happy-birthday-dr-e-sreedharan-the-person-as-i-know-him#.VXpmTbFIuhA.twitter

49. Will Metro go the Common Wealth Games Way? Editorial by Vinita Deshmukh (Intelligent Pune August 13-19 http://www.webcitation.org/6dropFv7s

50. http://articles.economictimes.indiatimes.com/2012-10-28/news/34766810_1_e-sreedharan-kochi-metro-elattuvalapil-sreedharan

51. www.babusofindia.com/2012/10/who-is-tom-jose-why-is-his-letter-to.html

52. URL:http://epaperbeta.timesofindia.com/NasData/PUBLICATIONS/THETIMESOFINDIA/BANGALORE/2015/08/20/PagePrint/20_08_2015_004_affcfd0d1980d73876c832db31bfed16.pdf. Accessed: 2015-12-30. (Archived by WebCite® at http://www.webcitation.org/6eAlj3ZHl)

Acknowledgments

This book would not have come out without the help and guidance of Dr E. Sreedharan. I am highly obliged to him. It was indeed a matter of pride for me to sit with him throughout the conversations and lunch, and I will never forget the time spent with him in Ponnani, Kerala.

This meeting would not have been possible without the cooperation and coordination of his Secretary, V.V. Govindan, and I am also thankful to Narayanan, his other deputy in Kochi, for all the help.

I am thankful to Sreedharan's daughter Shanthi Menon in Bengaluru, who gave me time, spoke about her father, and also wrote a small piece on him for the book.

I am also indebted to Sreedharan's spiritual guru, Swamiji Bhoomananda Tirtha of Narayanashrama Tapovanam, who took out precious time to write on Sreedharan.

I must then thank the numerous railway men who shared small and big anecdotes and so, helped weave this story together. Many wish to remain anonymous. The Department of Public

Relations, Konkan Railway, led by Siddheshwar Telugu and team, opened their archives for me, sharing rare photographs, technical documents and updates on Dr Sreedharan's contribution. I am thankful to Central Railway Public Relations Officer V. Chandrasekar for helping me in getting the correct dates on Dr Sreedharan's tenure at Central Railway, which helped me put together my timeline on Dr Sreedharan in the early stages of writing this book. I am also thankful to Anuj Dayal, Delhi Metro's Executive Director, Corporate Communications, for his support.

My thanks to Shashikant Limaye and other senior officers of the Indian Railways for their inputs to the book.

I am thankful to Ramdas Haridevan of the *Hindustan Times* and Seema Sanjeev Dasan for helping me understand the Malayalam work on Sreedharan that is out in public domain. I should mention local journalist Govindan Nampoothiry, who kept me updated on Sreedharan. Subhendu Ray, formerly with the *Hindustan Times* and then with the *Mumbai Metro*, offered help to me from time to time to gather numbers and build a database, and I thank him. I also thank Amit Biswas of the *Mumbai Metro* for putting me onto him! *Mid-Day's* Shashank Rao for going over the draft and offering suggestions also needs a mention.

The name of ninety-three-year-old Srinivasa Venkatraman, who did find time to pen down his views on Dr E. Sreedharan, is also important and must be mentioned.

Special thanks to Ritu Kapur, Co-Founder and CEO, *The Quint*, for prompt permission to reproduce an essay on Dr Sreedharan and their Research Team Head, Kirti Phadtare-Pandey for making it happen.

I must mention Sarita M. Warrier and her father Balachandra Warrier, the CEO of Manipal Foundation, Bengaluru, whom I met and who helped me get details on one of Sreedharan's icons, G.P. Warrier, and agreed to pen down a few memories.

I have to thank Rupa Publications' Kapish Mehra for all the support. I would also like to thank Publishing Director Ritu Vajpayi-Mohan and Acquisitions Editor Dharini Bhaskar for having the confidence in me to bring out this biographical work. Not to forget the various people at Ponnani town in Kerala, who cooperated and helped me, making life easier at a place where I was a stranger to the local language.

Last, but not the least, my late parents Dr Bhalchandra P. Aklekar and Sanjivani B. Aklekar remain my inspiration. I have to mention my wife Priya and daughters Tanvi and Vaibhavi, who stood by me when I was tied to the computer, lost in thought about the biography for days together, and my sister Pradnya for bearing with me during the six months of my mental absence.